# SCULPTURE SINCE 1945

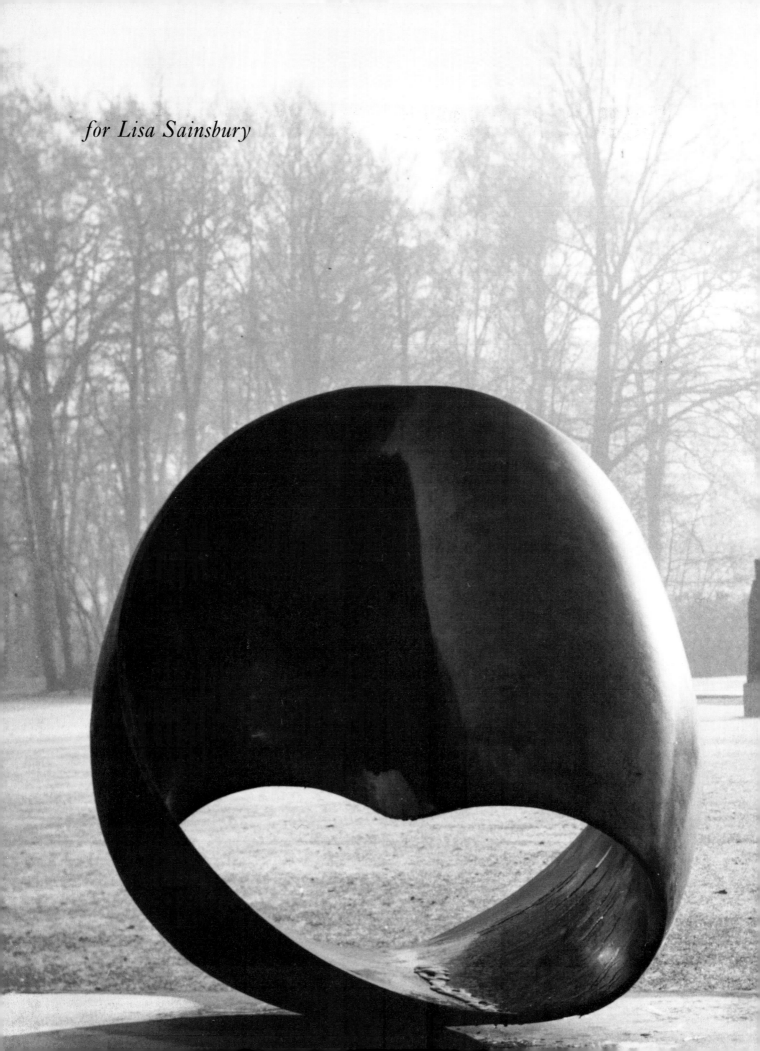

*for Lisa Sainsbury*

# SCULPTURE SINCE 1945

EDWARD LUCIE-SMITH

PHAIDON · LONDON

Phaidon Press Limited, Littlegate House,
St Ebbe's Street, Oxford OX1 1SQ

First published 1987
© 1987 Phaidon Press Limited

British Library Cataloguing in Publication Data
Lucie-Smith, Edward
Sculpture since 1945.
1. Sculpture, Modern—20th century
1. Title
735'.23    NB198

ISBN 0–7148–2451–8

Design by James Campus

Printed and bound in Great Britain by
Butler & Tanner Ltd, Frome and London

TITLE PAGE. View of the Sculpture Garden at
Middelheim Museum, Antwerp, with Max Bill's
*Endless Surface* in the foreground

# CONTENTS

# SCULPTURE IN THE LATE TWENTIETH CENTURY

In Western civilization, the art of sculpture has traditionally fulfilled only a limited number of roles. It has been religious, and served as a vehicle for the sacred and as an object of worship. It has been commemorative, serving as a reminder of notable people or events, or as a symbol of civic or national identity. Or else it has been decorative, allying itself when on a large scale to architecture, and when on a smaller one to the arts of the domestic interior. In the second half of the twentieth century it continues to fulfil these functions, but in the past few decades they have increasingly been pushed into the background. One reason for this is that art, which used to be the servant of religion, has, in a secular society, become a kind of religion in its own right – a development predicted by Sigmund Freud in his essay *Civilization and its Discontents*, first published in 1930.

Most of the sculpture produced from the 1960s onwards has been made to be admired in museums (the outdoor sculpture park, to which it is sometimes relegated, being simply an extension of the museum building). The growth of museums, very much a phenomenon of the past three decades, is intimately connected with a huge upsurge in sculptural energy and the predominance accorded to it among the more avant-garde manifestations of the visual arts. Correspondingly, patronage for sculptors has increasingly tended to come either from museums, or from a small number of private patrons wealthy enough to build up collections of contemporary art which are really to be thought of as museums in their own right, whether or not they are open to the public. Certainly these collections, unlike the great art accumulations of the past, pay little or no regard to sculpture as decoration.

Within the museum, twentieth-century sculpture functions in a number of different ways. Sometimes, but surprisingly rarely, it tries to express a specific meaning, external to the object

itself – a comment on history or current events. This was the case with the entries for the international *Unknown Political Prisoner* competition in 1953. Sometimes it is an attempt to encapsulate a particular emotional state – the kind of effort Auguste Rodin would have recognized and thought legitimate. More often, twentieth-century sculpture is solipsistic, and offers no more than a commentary on the process of making art, on the way an art object functions within a given space, or simply upon the notion of 'art' itself.

Carrying the religious analogy a little further, avant-garde sculpture in a museum setting can also offer itself as a kind of totem object, or else as a sacred relic. Today art critics who deal with avant-garde manifestations are characteristically obsessed with the notion that the material they deal with needs to be 'explained'. This often seems to go contrary both to the fundamental intention of the artist and to the desires of the spectator. The artist, using every means at his or her disposal – strange conjunctions of form, unexpected combinations of materials – tries to make an object which will give the kind of psychic shock produced, for example, by the masks worn by African secret societies. The artist's difficulty in doing this is the lack of the collective consciousness that provides tribal art with its resonance. However, the repeated attempt to create totems for a modern society does demonstrate the continuing need for the sacred and the mysterious.

The idea that the work of art is best apprehended by a single leap of the emotions is not peculiar to the Modern Movement. It is paralleled by the medieval notion of the leap of faith made by the soul towards God and, in its present, secular form, has its roots in the Romanticism of the early nineteenth century. The Romantics were responsible for another development as well. It was they who began to shift the emphasis from the artifact to the artificer. It is from Romanticism that we

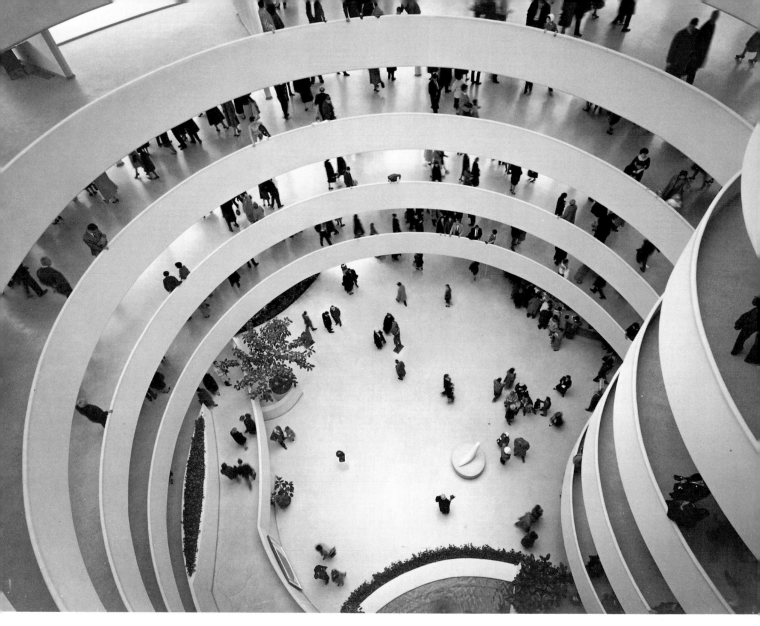

have inherited the idea that the work of art is not an independent entity, but something which is to be valued chiefly as a manifestation of the 'genius' of the individual who produced it. But in recent years there has been a further shift – certain artists have become their own artworks – the producer is indistinguishable from the product. The most celebrated case in point is the German sculptor Joseph Beuys who, as his career progressed, more and more took on the role of a modern shaman. Now that Beuys is dead, the works of his displayed in museums can hardly be thought of as independent entities, with aesthetic statements of their own to make. They are, rather, like the relics of saints that were venerated in medieval churches. It remains to be seen whether faith in their efficacy can be transmitted to future generations. That in turn seems to depend on a stabilization of our attitudes towards works of art, after a period when changes in the way in which they are looked at and

**1. Interior view of the Solomon R. Guggenheim Museum, New York**

used have been more rapid and drastic than at any previous period in western history.

As matters stand at present, one can only say that virtually anything at all can now be described as 'sculpture', ranging in format from three-dimensional forms made of traditional materials – wood, stone or cast metal – to photographs, diagrams, verbal formulations or the actions and gestures of the sculptor himself. The true patrons of this activity are those members of the public (an ever increasing number) who go to museums of modern art, and it is financed largely by the public or private charitable funds that support these institutions. Increasingly, the more experimental the kind of sculptural activity involved, the more dependent it is likely to be on institutional rather than purely individual support – which represents a direct reversal of the situation that prevailed at the beginning of the twentieth century, when the Modern Movement began.

# THE EARLY MODERNISTS

Modernism in the visual arts was undoubtedly the creation of painters rather than sculptors, and its earliest phases are best explained as a dialectic of competing art movements with their roots in painting. Fauves, Cubists, Futurists and Expressionists alike tended to be preoccupied with what happened on a flat surface. The balance only seems to shift when we arrive at the work of the Russian Constructivists. One can explain this emphasis on painting rather than sculpture in several ways. First, there was the decadence of the nineteenth-century sculptural tradition, which offered fewer growing points to radical artists than the painting of the immediately pre-modernist epoch. In nineteenth-century sculpture there is no equivalent for the painters Paul Cézanne, Vincent Van Gogh or Paul Gauguin. Rodin, the greatest sculptor of the transitional phase to modernism, retained many links to the official art world against which the Fauves and their successors rebelled.

The second reason for the dominance of painting was that modernism, at its beginnings, was essentially élitist. It addressed itself to the few rather than the many; the radical new artists produced work which was usually on a moderate scale, and which was intended for private contemplation. The Italian Futurists did envisage artworks which would be bold public statements (though chiefly in the realm of architecture rather than sculpture); but they were never offered an opportunity to carry these projects to completion. It was the Russian Constructivists who, through their link with the Bolshevik Revolution, gave modernism a fully public role, while at the same time identifying it with left-wing politics. But, due to the circumstances of the time, they, like the Futurists, produced little which was physically permanent. Vladimir Tatlin's *Monument to the Third International*, commissioned in 1918 by the Soviet Department of Fine Art, and perhaps the most famous of all Constructivist enterprises, was fated to remain an unrealizable project.

On the rare occasions when public commissions were given to modernist or semi-modernist sculp-

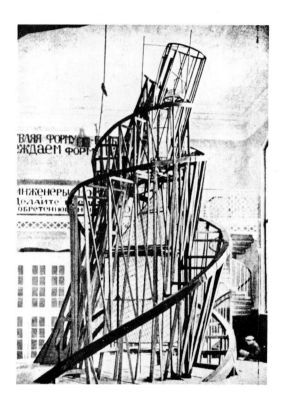

**2. Vladimir Tatlin: Model for a Projected Monument to the Third International** 1919. Photograph of the original model (now destroyed)

tors, they tended to arouse fierce controversy. Aristide Maillol, whose work now seems so conservative in its use of classical forms, suffered a number of rejections from public bodies. The moving war memorials commissioned from Ernst Barlach in Germany, though duly installed on their intended sites, aroused the fierce hostility of the Nazis, who promptly removed them as soon as they came to power and made Barlach a particular target for persecution. The career of Jacob Epstein was marked by one controversy following hot on the heels of another. The works which aroused almost hysterical anger amongst his critics included the tombstone for Oscar Wilde in the Père Lachaise cemetery in Paris; *Genesis*; and two commissions in London: the figure of *Rima* erected as a memorial to the writer W. H. Hudson in Hyde Park, and the *Night* and *Day* for the London Transport Building in St James's. Though greatly talented, neither Epstein nor Barlach rank among

**3. Ernst Barlach: Have Pity**
n.d. Wood. Hamburg, Barlach
Haus

**4. Aristide Mailloi:**
**La Victoire**
n.d. Bronze, 10 × 10¼ in
(25.4 × 26 cm). Montreal
Museum of Fine Arts

**5. Jacob Epstein: Genesis**
1929–30. Seravezza marble,
ht. 62¼ in (158 cm). London,
Granada Television

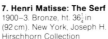

6. **Jacob Epstein: Rima**
1923–5. Portland stone, relief
area 46 × 72 in (116 × 183 cm).
London, Hyde Park, Hudson
Memorial

7. **Henri Matisse: The Serf**
1900–3. Bronze, ht. 36¼ in
(92 cm). New York, Joseph H.
Hirschhorn Collection

8. **Umberto Boccioni:**
**Unique Forms of**
**Continuity in Space**
1913. Bronze, 45 × 33 × 14½ in
(114 × 84 × 37 cm). London,
Tate Gallery

the most 'advanced' artists of the inter-war period. If we compare them, for example, with the Surrealists, who were their contemporaries, their avant-gardism seems comparatively tame.

Perhaps it was the timidity of the sculpture they saw around them that encouraged leading modernist painters to try their hands with three-dimensional work. The most advanced sculptor of the early modernist period was Henri Matisse, who in works such as *The Serf* took his cue from Rodin and also from the handling of forms which he found in the early work of Cézanne. Nearly all his work as a sculptor is on a small scale, suited to the domestic setting envisaged for much early modernist art. A handful of extremely innovative sculptures were also produced by the Futurist painter Umberto Boccioni, who tragically died in a riding accident during the First World War. Pablo Picasso's earliest attempts as a sculptor were comparatively timid, and it was only with the advent of Cubism that he discovered a vein of inventiveness that he was able to follow for the rest of an extremely long career. Picasso found his identity as a sculptor with the invention of collage, which proved to be a technique just as valid in three dimensions as it was in two. His interest in collage led him to break down the existing hierarchy of materials. When he chose to make sculpture, anything could be pressed into service, from a piece of discarded moulding to a toy car, or the saddle and handle-bars of a bicycle. Even more than work on a flat surface, his creations in three dimensions

involved a constant process of metamorphosis, a promiscuous mating of thoughts, ideas and images. Until a comparatively late date, Picasso seems to have thought of his sculpture as being a more private activity than his work as a painter – a paradoxical reversal of the traditional roles of the two means of expression. Much of his production in this field remained unknown and hidden from view until after the Second World War. A few of his ideas were influential immediately, notably his experiments with welded iron, carried out with the help of his Spanish colleague Julio Gonzalez. But though as a painter Picasso was always a central figure in the consciousness of fellow artists, as a modernist sculptor he remained detached from the mainstream.

It was not Picasso's sculptures, but the more publicly accessible paintings and two-dimensional collages produced by himself and Georges Braque that inspired the production of a new 'Cubist'

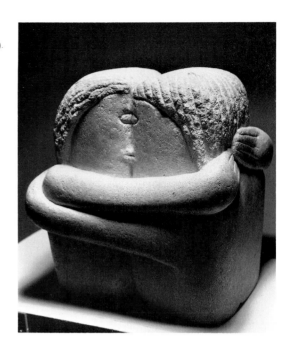

**10. Constantin Brancusi: The Kiss**
1908. Plaster, ht. 11 in (28 cm). Craiova (Romania), Muzeul de Arta

**9. Pablo Picasso: Still Life**
1914. Mixed media, 10 × 18 × 3⅝ in (25.4 × 45.7 × 9.2 cm). London, Tate Gallery

sculpture by artists such as Jacques Lipchitz and Henri Laurens. The early work of both these artists is striking in the way in which it remained intimidated by Cubist experiments on a flat surface. Their first efforts tended to consist of reliefs rather than work fully in the round, and the overlapping planes used in these reliefs are a decorative translation of something which in Cubist painting is firmly structural. In later work such as Lipchitz's *Song of Songs* [Col. Pl. 1] they found a way out of this dilemma by becoming increasingly curvilinear and baroque, and therefore less identifiably Cubist.

There was one completely independent and original sculptor whose work occasionally carries faint Cubist echoes, and this was Constantin Brancusi. Brancusi, who came from a Romanian peasant background, all his life retained links with

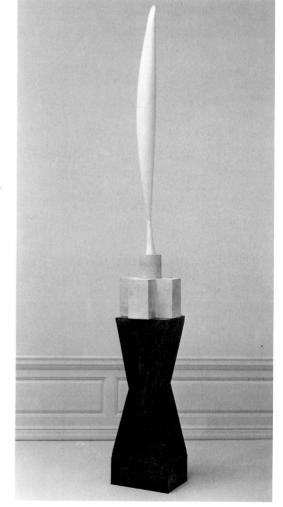

**11. Constantin Brancusi: Bird in Space**
1925. Marble, stone, wood, ht. 136½ in (347 cm). Washington, National Gallery of Art

the idioms of folk art. From this beginning he embarked on a process of radical simplification, at the same time abandoning modelling in favour of direct carving in stone or wood. His sculpture *The Kiss* (first version 1908), which shows two figures embracing, both compacted within a single block, is closely allied to the Cubist experiment, which was then only at its beginnings. Later works employ a slightly different kind of simplification, in which natural forms remain undistorted, but are pared down to their essentials. In some of Brancusi's sculptures, such as the head of *Mlle Pogany*, which, like *The Kiss*, exists in several versions, there is also a hint of the decorative conventions of Art Deco. Finally, with his *Bird in Space* series, Brancusi passed beyond the simplification of what he had observed in nature, and tried to find a shape which would suggest the movement of his subject, and thus its truest essence.

The most important innovation in sculpture

day use, such as the *Bottle Rack* of 1914, and designated them works of art, with the suggestion that they be presented and looked at in the same way as legitimate sculpture. The result was to call into question the whole sculptural aesthetic, as it had been handed down from classical times.

Duchamp's immediate successors were the Surrealists, whose approach to sculpture was somewhat less radical than his own, since they continued to create three-dimensional works of art, instead of merely discovering them in the environment. Like Picasso, the Surrealists often made their three-dimensional works from discarded materials. But Picasso, even when he became loosely associated with the Surrealist Movement, was usually attracted primarily by the forms of what he found, whereas members of the main group of Surrealists were fascinated chiefly by the process of association triggered off by incongruous juxtapositions of recognizable things. The

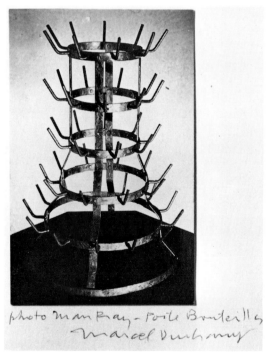

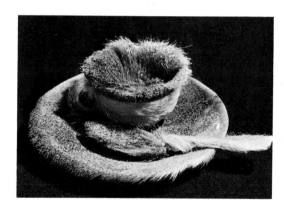

**12. Marcel Duchamp: Bottle Rack**
1914. Ht. 23½ in (59 cm). Photograph, by Man Ray, of the original sculpture (now destroyed). Milan, Schwarz Archive

**13. Meret Oppenheim: Fur Tea-Cup (Le Déjeuner en fourrure)**
1936. Fur, crockery, cutlery, 9½ × 3 in (24 × 7.6 cm). New York, The Museum of Modern Art

during the early modernist period was related to Picasso's use of 'found' materials in two- and three-dimensional collages, yet the attitudes behind it were different from those professed by Picasso himself. Marcel Duchamp's invention of the 'readymade' had a profound impact on the development of modern sculpture, though its effects were not fully felt until after the Second World War. Duchamp took banal items of every-

Surrealists often made play, not only with incongruous juxtapositions, but with the use of apparently inappropriate materials. A case in point is Meret Oppenheim's *Fur Tea-Cup*, often regarded as the quintessential Surrealist object, but not easily categorizable as sculpture. Artworks which made plastic statements, as opposed to purely associative ones, entered the Surrealist consciousness rather belatedly. Hans Arp, for example, developed from making paper collages and reliefs in painted wood to the creation of biomorphic stone carvings which could be read as metaphors for body parts and for the budding and fruiting of plants.

The Surrealist object-makers introduced a division into the sculptural tradition which has persisted until the present day. Some modern sculpture asks to be read in purely formal terms; some has a reduced formal interest, or none at all,

and affects the spectator purely in terms of the associations it arouses. Criticism finds it very difficult to straddle the two genres.

In terms of its immediate impact, Surrealist object-making was important because it was almost the only form of sculptural activity during the inter-war period which represented a genuine attempt to get rid of the whole weight of the past. Unlike painting, most sculpture remained locked in a dialogue with past civilizations – an interchange which was the more seductive because the rapid expansion of archaeological and ethnographical research had greatly widened the range of the sources of inspiration available. The neoclassical style, briefly revived by Picasso in painting immediately following the First World War, but just as rapidly dropped again, retained an extraordinary fascination for many of the sculptors of the inter-war period, even those whose sympathies were basically with the modernists. This style also found favour, because of its associations with a grandiose imperial past, among the dictatorships – in Mussolini's Italy, Stalin's Russia and Hitler's Germany. In Germany the most successful sculptor of the Nazi period was Arno Breker, a close disciple of Maillol, who supplied figures of muscular youths for Hitler's new Reich Chancellery in Berlin. The Italian sculptors connected with the Novecento group, among them artists such as Marino Marini and Giacomo Manzù, who were to become internationally celebrated in the post-war epoch, also worked in a version of neo-classical style, but were also affected by the quirks of Etruscan art and by their knowledge of the great sculptors of the Renaissance.

One way of countering this persistent neoclassical tendency, or so it seemed to many of the avant-garde sculptors of the time, was to seek inspiration in primitive and archaic art, often that produced in cultures not related to the main European tradition. The pioneer modernists had been amongst the first to realize that the tribal artists of Africa and Oceania were capable of producing things which were more than just curiosities, and which were in fact works of art filled with spiritual power. Here, too, the impulse was felt first by the painters – by Gauguin and then by Picasso, who expressed his enthusiasm in the 'Negro' period transitional to fully developed Cubism. Throughout the 1920s and 1930s there was a constant dialogue between contemporary sculpture and archaeology and ethnography. Those with the greatest expertise in these scholarly fields were often keen enthusiasts for the products of the Modern Movement. The influence went in both directions. Primitive artefacts seemed to gain in legitimacy from the comparisons they provoked with the work of modern artists, at the same time as they themselves bestowed this quality of validity to the modern works.

Among the sculptors most deeply affected by the enthusiasm for artworks of this type were Henry Moore, whose early reclining figures were directly derived from ancient Mexican *chacmools* (figures now generally interpreted as 'messengers to the gods'), and Alberto Giacometti. In the earliest phase of his career, Giacometti, then linked to the Surrealist Movement, was greatly interested in the Cycladic stone carvings of the second millennium BC.

The influence exercised by primitive and archaic art was not always the progressive force that historians of modernism have described it as being. While it provided a range of alternatives to the sculptural forms inherited from the nineteenth century, and before that from the Renaissance, it kept sculpture within a conceptual framework which remained surprisingly traditional, despite all the efforts of Duchamp to change the situation. During the inter-war period there was little debate about the nature of sculpture itself – its basic aims were not the subject of dispute, only the forms in which these were expressed.

One obvious alternative to the exploration of the primitive was for sculpture to form a relationship with the machine, as the emblem of modern industry and thus of the transformations to which the whole of western society was being subjected. A machine aesthetic did develop, but where sculpture was concerned it was shallow rooted. The most daring forays into this area were made by sculptors who continued to work in the Constructivist tradition, which survived in western Europe after being stamped out in Russia. Sculptors like Naum Gabo and his brother Antoine Pevsner were too sophisticated to imitate machine forms directly, but in their work, and especially in Gabo's, we seem to see anticipations of the new shapes produced by industrial designers. The link is stressed by the use of new materials, such as celluloid and other forms of plastic. Minor artists connected with the Art Deco movement, such as Gustav Miklos, were content to be more directly mechanistic. Miklos uses the best of both worlds by combining allusions to machine forms with others to African art. It is noticeable that the

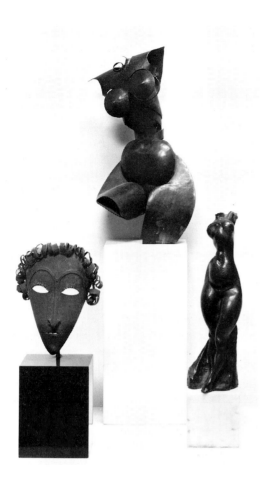

14. **Pablo Gargallo:**
**Mask of a Young Man**, 1911;
**Small Female Torso**, 1915;
**Little Standing Nude**, 1908
Metal. Private collection

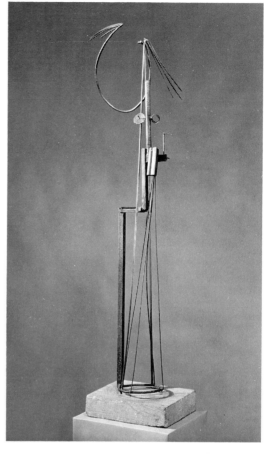

15. **Julio Gonzalez: Large Maternity**
1930–3. Metal, 51 × 15 × 6½ in
(129.5 × 38.1 × 16.5 cm).
London, Tate Gallery

Bauhaus, one of the chief centres for the dissemination of the machine aesthetic, produced important architects and industrial designers, but only one important sculptor, Max Bill, whose main period of sculptural activity falls after 1945.

There was one sculptural innovation which came originally from craft, rather than the industrial tradition, but subsequently became wedded to the latter. This was the use of forged and welded metal. The technique was at first practised almost exclusively by members of the École de Paris who were of Spanish origin, and was rooted in the traditional Spanish craft of decorative metalwork. The first step was taken by Pablo Gargallo, who in 1911 began to make masks from thin sheets of iron and copper, hammered, twisted, cut and fitted together. In the 1920s his example was followed by a compatriot, Julio Gonzalez, an unsuccessful painter who came from a family of artisan metalsmiths in Barcelona. Gonzalez went through a long period of solitary meditation and experiment, but it was only in 1927 that he decided to devote himself entirely to sculpture. In 1928 Picasso summoned Gonzalez to

his assistance, having decided to experiment with sculpture made from rods of welded iron, and needing technical help with this new method. Stimulated by Picasso's example, Gonzalez moved rapidly from a Cubist idiom to producing such works as *Large Maternity* of 1930–3 which made use of open forms which were like three-dimensional drawings. Gonzalez's work was pivotal, and supplied a new starting point for artists like the American David Smith. Unlike the Spaniards of the École de Paris, Smith came from an industrial rather than a handicraft background, and he was already, in the 1930s, making sculptures based on fragments of industrial scrap. Many of his components were mechanical parts, which were allowed to retain hints, and often more than hints, of their previous identity. The Surrealist technique of marrying incongruous fragments to create a new entity, whose chief strength lies in the associations it is able to conjure up, acquired a new dimension in Smith's hands. An important avenue was opened for the sculptors of the post-war period, one of the greatest of whom was to be Smith himself.

# AFTER THE WAR: NEW AND OLD TRADITIONS

The Second World War marks a distinct break in the history of modernist painting. The rise of Abstract Expressionism made New York, rather than Paris, the new focus for artistic activity. In sculpture the break in continuity was not so clearly defined, nor was there such a definitive shift away from Europe – and this in spite of the fact that almost no major sculpture was created in Europe during the war years because of the deprivations and disturbances brought by the conflict.

After the war most of the major sculptors of the first modernist generation continued to be productive – some were offered opportunities they had never enjoyed previously, because the Nazi persecution of the Modern Movement had now endowed it with a belated respectability. One case in point is Ossip Zadkine's *Commemorative Monu-*

*ment to the Destruction of Rotterdam* (1947) – a surprisingly emotional and rhetorical work for a sculptor who had begun his career as an orthodox Cubist. Julio Gonzalez died in 1942, and Maillol in 1944. Brancusi, after the creation of the *Flying Turtle* in 1943, ceased to be active, though he lived on until 1957. Among the established modernists who continued their careers in the post-war period were Arp, Epstein and Gabo. Arp and Epstein present a contrast. Epstein's creative vitality started to flag – his major works for the post-war period, even the *Christ in Majesty* for Llandaff Cathedral (1954–5) or the *Madonna and Child* for the Convent of the Holy Child Jesus in Cavendish Square, London (1952), lack the impact of earlier work on the same scale. One reason for this was Epstein's switch from stone to cast metal when

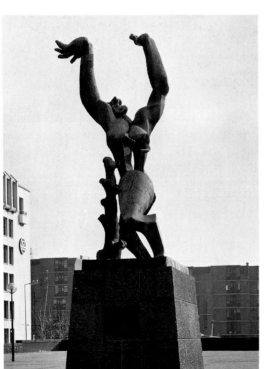

**16. Ossip Zadkine: The Destroyed City (Commemorative Monument to the Destruction of Rotterdam)** 1947. Bronze, ht. 21½ ft (6.5 m). Rotterdam, Leuve Haven

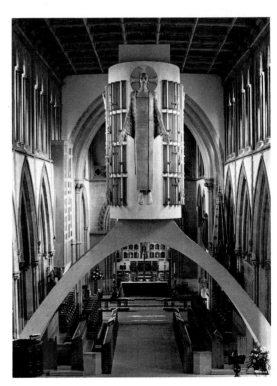

**17. Jacob Epstein: Christ in Majesty** 1954–5. Aluminium, ht. 14 ft (4.3 m). Llandaff Cathedral

**18. Alberto Giacometti:**
**The Palace at 4 a.m.**
1932–3. Wood, glass, wire,
string, 28 × 15¾ × 25 in
(71 × 40 × 63.5 cm). New York,
The Museum of Modern Art

making monumental sculpture, though he had always used bronze for the portrait busts that sustained his reputation even amongst the most violent of his controversies. Arp's career was given a new lease of life by the award of the major prize for sculpture at the Venice Biennale of 1954. He made the most of the opportunities which were offered to him as a result (they included the commission for a series of metal reliefs for the University of Caracas, 1956); but his very originality and lack of roots in the main sculptural tradition helped to keep him isolated – his work inspired a number of imitators, but no really creative disciples.

Post-war sculpture was dominated by two artists who had indeed made considerable reputations during the inter-war period, but who did not then rank among the absolutely major figures. These were Henry Moore and Alberto Giacometti. Fundamentally different, they also had certain things superficially in common. Before the war, both had had ties with the Surrealist Movement, though these links were much closer in Giacometti's case than they were in Moore's. During the war years, each underwent a process of self-transformation, and emerged ready to confront the demands of a world which had itself been greatly changed by the conflict. Their work gave people the feeling that sculpture was once more a central rather than a marginal means of artistic expression, communicating things that the contemporary audience could empathize with and understand. Better still, they left the impression that the art of sculpture had accomplished this move to the centre without

becoming academic, with no return to the clichés of the nineteenth century.

Alberto Giacometti was by far the more private of the two artists, and had always eschewed the public role that Moore had already begun to assume in the war years with his *Shelter Drawings* recording the courage and suffering of Londoners under the Blitz. Born in 1901 into a family of Swiss artists, Giacometti underwent a long period of development that spanned the whole of the inter-war period and embraced the wartime years as well. His earliest inspiration had been Rodin, and for five years during the 1920s he studied with Rodin's direct heir, Antoine Bourdelle. Giacometti first showed his work in 1928 at the Galerie Jeanne Bucher in Paris, and attracted immediate attention. During this period he reflected the influence of Cubism and also that of primitive and ancient, particularly Cycladic, art. His sculpture was admired by leading Surrealists, and as a result Giacometti became more and more intimately involved with the official Surrealist Group. An exhibition shared with Hans Arp and Joan Miró in 1930–31 marked his acceptance as a member, and for a while he participated dutifully in the group's activities, though never with the absolute loyalty required by the dictatorial leader of the Surrealists, André Breton.

The sculptures Giacometti made during his fully Surrealist period were direct transcriptions of things dreamed or imagined. 'I have restricted myself', Giacometti declared at this time, 'to reproducing them in space without changing anything and without asking what they might signify.' Among his creations from this time are *The Palace at 4 a.m.* (sometimes claimed to be a paraphrase of Arnold Böcklin's Symbolist painting *The Isle of the Dead*), and the horrifically violent *Woman with her Throat Cut*. With these pieces Giacometti committed himself firmly to the notion that sculpture should express emotional states, rather than being exclusively an exploration of formal relationships – the idea central to Constructivism and to certain kinds of Cubist sculpture.

By the mid–1920s Giacometti had become increasingly impatient with the artificiality of Surrealist procedures, and also with the lack of contact with observed reality which Surrealist doctrine imposed. He therefore returned to the study of the model, thinking that it would be a simple matter to root his work again in the visible world. He worked from the model continuously for five years, from 1935 to 1940. 'Nothing', he said, 'was like

what I imagined it to be. A head (I soon left the figure aside, it was too much) became an object completely unknown, and without dimensions.' The Surrealists expelled him from their ranks, since they considered his activity reactionary. Giacometti ceased to exhibit, and he and his brother Diego lived by making decorative objects, working in particular for the leading Parisian decorator of the period, Jean-Michel Frank.

When he stopped working from the model, and began instead to make figures and heads from memory [Col. Pl. 3], Giacometti found his sculptures were becoming inexorably smaller and smaller. 'Only when small were they like, and all the same these dimensions revolted me, and tirelessly I began again, only to end up a few months later at the same point.' In 1942 he paid a visit to his native Switzerland and was unable to get a visa to return to Paris. While in Geneva he did manage to produce one big figure – a woman standing on a sort of cart which has an affinity to certain Etruscan votive bronzes – but he did not pursue this line and returned instead to working on a minuscule scale. A small hotel room was his only studio. It is said that when he packed up his things to return to Paris in 1945, his entire production for the period (the large female figure apart) fitted into a single matchbox.

In Paris, Giacometti at last found a way to increase the scale, but now his sculptures were very thin – attenuated, almost stick-like figures which were to establish his post-war reputation. He returned to the scene with an exhibition held at the Pierre Matisse Gallery in New York in 1948, and rapidly became one of the most celebrated of post-war sculptors. This celebrity was fuelled by his association with the Existentialists. Giacometti had become friendly with their leader, Jean-Paul Sartre, during the war years, and their friendship was renewed on his return from Geneva. He is even said to have contributed to the development of Sartre's thought, which was certainly very much in tune with his own long-standing preoccupations. One crude interpretation of his work, current at that time, was that the thinness of his figures was a response to post-war *misérabilisme*. They were even seen as a kind of oblique homage to the concentration camps. The truth was that they represented a dialogue with perception – Giacometti wanted to render not merely the thing seen, but the effect of the atmosphere surrounding it. His thin figures were armatures which accumulated a shimmering atmospheric veil and used it

to cloak themselves. The concern with the mechanism of perception was the quality which saved Giacometti's work from becoming academic in the nineteenth-century sense – there can be no doubt that his methods, in his later sculptures, had a strongly academic basis.

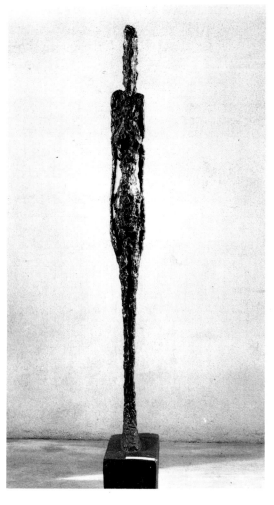

**19. Alberto Giacometti: Large Figure**
1947. Bronze. Private collection

**20. Alberto Giacometti: La Forêt**
1950. Bronze, $22\frac{7}{8} \times 25\frac{3}{8} \times 23\frac{5}{8}$ in (58 × 64.5 × 60 cm). Saint-Paul (France), Collection Fondation Maeght

One of the things Giacometti had in common with Henry Moore was an interest in making monumental public sculpture – a fact which may come as a surprise, as he left no sculptural legacy of this sort. The one commission of this kind which was actually offered to him – it came from the Chase Manhattan Bank in 1958 – proved abortive. The client's suggestion that he simply make an enlargement of an existing piece was unacceptable to the artist, and though he later did considerable preliminary work with the architect of the building, Gordon Bunshaft, the project was never carried through. Yet Giacometti often used integral settings to provide a kind of stage for his

figures' actions, and manipulated them to control the viewer's sense of scale. Many of his sculptures, such as *La Forêt* (1950), appear as if seen through the wrong end of a telescope – the emotional impact they make is like that of lifesize sculptures, though physically they are very small.

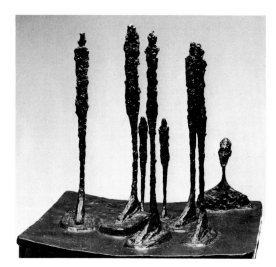

Moore had already established himself, in the decade before the war, as the most important and original sculptor in England, outstripping even his older contemporary, Jacob Epstein. But this reputation was largely confined to his own country and, even there, to an inner circle of *cognoscenti*. For the public at large it was Epstein who continued to be the real centre of attention, making headlines with his large carvings, which, often combining biblical subject matter, sexual aggressiveness and a fierce expressionist style, received a predictably controversial reception from the press. But Epstein was also able to attract the famous in large numbers to his studio, to sit for the portrait busts which provided his bread and butter. It was difficult at that time to imagine that a British sculptor who did *not* make portraits would enjoy a reputation on a similar scale; and more difficult to foresee that sculpture from England, where there was no continuous sculptural tradition, would be capable of building a major international reputation.

From the beginning of his career Moore was energetic and productive; the early part of the war imposed a frustrating hiatus on his activity. Unable, because of wartime restrictions, to work in three dimensions, he made a series of drawings of *Ideas for Sculpture*, but this was hardly a satisfactory substitute for the real thing. On the point

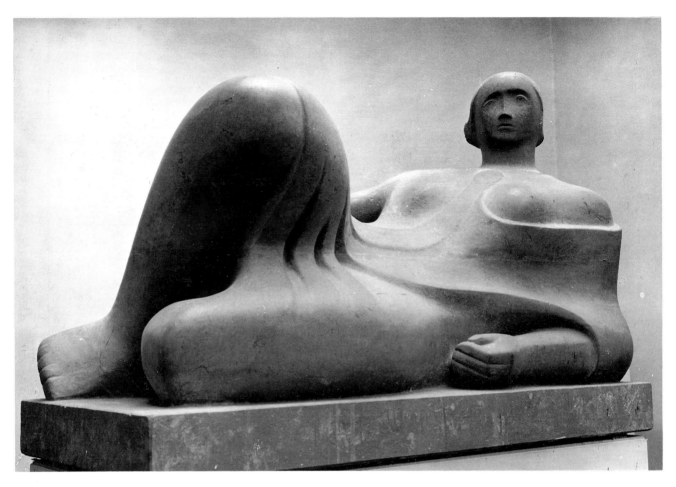

of going to work in a munitions factory, he was rescued by an appointment as an Official War Artist, and embarked on the famous series of *Shelter Drawings*. Though modest in scale, the drawings turned Moore into a public figure. As John Russell wrote: 'With the *Shelter Drawings*, Moore became what he has been ever since: one of the keepers of the public conscience.'

Moore marked his return to sculpture in 1943 by undertaking a commission of a kind he had never tackled before – a *Madonna and Child* for the church of St Matthew's, Northampton. The figure signalled a decisive change of direction. Moore took one of the most central and traditional images of pre-modernist art, and gave it a personal nuance, while still managing to produce something which was completely recognizable even to that part of the public which knew little of modernism and its development.

The *Northampton Madonna* was the beginning of a classical phase in Moore's sculpture, equivalent in some respects to Picasso's neo-classical phase in the years immediately following the First

**21. Henry Moore: Memorial Figure**
1945–6. Hornton stone, ht. 56 in (142.2 cm). Devon, Dartington Hall

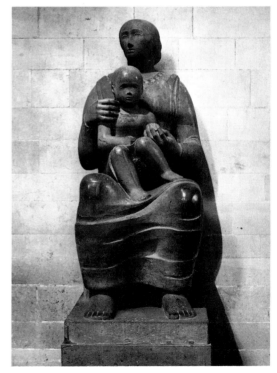

**22. Henry Moore: Madonna and Child**
1943–4. Hornton stone, ht. 59 in (150 cm). Northampton, St Matthew's Church

World War. Among the sculptures which belong to this period are the draped *Memorial Figure* at Dartington Hall, and the Stevenage *Family Group* (1948–9) – a direct development of the *Madonna*. One may guess that Moore and Picasso proceeded from a similar impulse – the need to reaffirm traditional values after the shock of a world-wide catastrophe.

At this time Moore's reputation was growing very rapidly – he was achieving an international status accorded to no other British sculptor since the time of the neo-classicist John Flaxman. Much of this was due to official agencies, and in particular to the support offered by the British Council. In 1946 a retrospective exhibition of Moore's work was held at the Museum of Modern Art in New York. In 1948 he was awarded the International Prize for Sculpture at the XXIVth Venice Biennale. In the same year he had a further retrospective at the Musée National d'Art Moderne, Paris, and at the Palais des Beaux-Arts, Brussels. His first British retrospective took place at the Tate Gallery in 1951; in 1953 Moore was awarded the International Sculpture Prize at the São Paulo Biennale.

He began to be offered not only honours and prizes of all kinds, but a stream of public commissions. Temperamentally he was much better equipped to cope with these than Giacometti. In

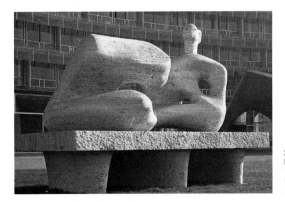

1957 Moore carried through a commission for the new UNESCO Building in Paris, producing a seventeen-foot long reclining figure in travertine marble, which competed successfully with the rather restless architecture of the façade. A novel aspect of these commissions was that Moore's figures were not usually expected to symbolize anything but the power of art itself. In this sense he was much freer than his pre-modernist ancestors. Yet there were aspects of his post-war work

**24. Henry Moore: Time-Life Screen**
1952–3. Portland stone, 26½ × 10 ft (8.1 × 3 m). London, Time-Life Building

**23. Henry Moore: Reclining Figure**
1957–8. Travertine marble, length 16½ ft (5 m). Paris, UNESCO House

which looked back directly to the nineteenth-century academic tradition which the earliest modernists had vehemently opposed [Col. Pl. 8].

Moore's post-war neo-classicism inevitably provoked comparisons with nineteenth-century artists such as Antonio Canova and Bertel Thorwaldsen. Stylistically these comparisons are misleading, since Moore never practised the classical style exclusively even when he was most interested in

it. One striking thing about his post-war output is its eclecticism. He ranged through a variety of idioms – the span included Biomorphic Surrealism, as in his early composition *Leaf Figure* [Col. Pl. 2]; allusions to Cubism, in the screen for the Time-Life Building in London (1952); and even a kind of Expressionism in the *Glenkiln Cross* (1953). Moore had never lacked ideas, and now he seized on the opportunities he was being given to express himself fully. Inevitably this led to change in his method of working. In the pre-war period he had been regarded as an apostle of direct carving and 'truth to materials'. The laborious methods of this phase were too slow for his new situation, and an ever larger proportion of his work was now cast in bronze. Even when he continued to work in stone, the projects he undertook, such as the UNESCO figure, were frequently so ambitious that it was unthinkable for Moore to tackle them unaided. He made growing use of assistants, and had to make preliminary models, often several of them, before embarking on the final work. His studio methods, therefore, increasingly approximated to those of

**25. Barbara Hepworth:
Group I (Concourse)**
1951. Marble, base: 20 × 11½ in
(50.8 × 29.2 cm); ht. 10 in
(25.4 cm). Private collection

pre-modernist sculptors – those of the great neo-classicists such as Thorwaldsen. In later works, especially the largest commissions, Moore was forced to pay a price for facility – his surfaces became less sensitive, and the idea of the sculpture often seemed superior to its physical embodiment. The neo-classical sculpture of the early nineteenth century suffers from identical faults. But, like the artists of this period, Moore had acquired an ability to make convincing public statements, plus a sense of what was appropriate to a particular occasion, even though he, unlike these predecessors, could not rely on a shared education and culture.

One persistent and very English theme in Moore's work is landscape imagery – the idea that there is an equivalence to be found between the planes and hollows of the human body and forms to be found in landscape. He also suggests that there is a parallel between the way flesh and skin cover the bones and the way earth and vegetation cover the primeval rocks. In England, during the 1920s and 1930s, there had been a tendency to

reach back to the early nineteenth-century Romantics. Graham Sutherland, for example, began his career as a close imitator of Samuel Palmer. Moore was affected by this movement and carried it with him into the post-war epoch.

Another British sculptor who was affected by the same influences, and who also built a substantial international reputation in the post-war years, was Barbara Hepworth. Moore and Hepworth were closely associated in their youth, and their early work shows many similarities of form and technique. Hepworth was, however, much more influenced by Constructivism than Moore, thanks to her artistic association with her second husband, Ben Nicholson, the chief English apostle of the Constructivist Movement. For Hepworth, as for Moore, the war meant a dramatic break with the past. Immediately war broke out, she moved from London to St Ives with her young family. The move was meant to be a temporary one, but her association with Cornwall survived her divorce from Nicholson in 1951, and it became the essential background to her later work.

26. Barbara Hepworth:
Single Form (Memorial to
Dag Hammerskjould)
1962–3. Bronze, ht. 21 ft
(6.4 m). New York, United
Nations Building

a renewed interest in the workings of nature itself, prompted by the splendour of her surroundings. 'From the sculptor's point of view', she wrote, 'one can be either the spectator or the object itself. For a few years I became the object. I was the figure in the landscape and every sculpture contained to a greater or lesser degree the ever-changing forms embodying my own response to a given position in the landscape . . .'

In the 1940s and 1950s, as her international reputation grew in step with that of Moore, Hepworth responded to the opportunities she was offered. Her work, like his, showed a revived interest in the human figure, though her version of it as seen, for example, in *Two Ancestral Figures* [Col. Pl. 6] was always much more simplified and abstract than his. A few pieces, such as *Group I* (*Concourse*), were inspired by groups of people moving through Piazza San Marco, Venice, and have a kinship with the groups of striding men produced by Giacometti.

The chance to make larger works prompted Hepworth to move into bronze, a medium she had previously avoided, and for which she had once professed a definite dislike. The results were not always happy. The large architectural commissions she executed in the latter part of her career, such as *Meridian* for State House, Holborn, are the least interesting part of her production. The best of these big bronzes is the *Single Form* of 1962–3, designed as a memorial to Dag Hammerskjould, Secretary General of the United Nations, who had been killed in an air crash in the Congo. It is sited outside the United Nations Building in New York.

For a long period after her arrival she was too much occupied with the needs of her family to produce sculpture; like Moore, she found a creative outlet in making drawings. The forms she drew were crystalline – complex crystals are nature's nearest approach to orthodox Constructivism. But in fact the drawings represented

In 1953 Hepworth's elder son Paul, the child of her first marriage to the sculptor John Skeaping, was killed in an aerial collision over Malaya. They had not always been close, and Paul had rejected the artistic milieu inhabited by his parents in favour of a career in aircraft engineering. Yet the shock to Hepworth was considerable, and in 1954 she made a recuperative visit to Greece, which she had never previously seen. The large wood carvings that resulted from this visit demonstrate the way in which she now aspired towards the sublime, approaching nature and the feelings inspired by it in thoroughly Romantic fashion, and trying to find an equivalent for these feelings in simple, majestic forms. In these pieces she moves away from Moore, and seems to look back to the work done by Brancusi, who sought a similarly charged simplicity.

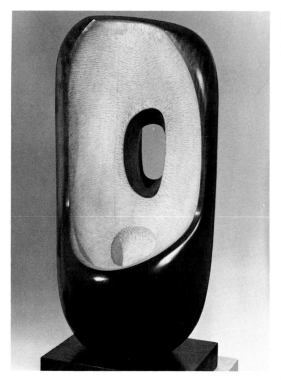

27. Barbara Hepworth:
Curved Form (Oracle)
1960. Wood, ht. 52½ in
(133.4 cm). London,
Marlborough Fine Art

Giacometti and Moore helped to create the post-war climate for sculpture, and were to a degree themselves influenced by it. To a slightly lesser extent the same can be said about Hepworth.

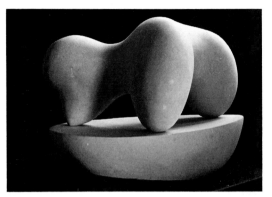

**28. Hans Arp: Human Concretion**
n.d. Marble, 22 × 32 × 21¼ in (56 × 81 × 54 cm). Zurich, Kunsthaus

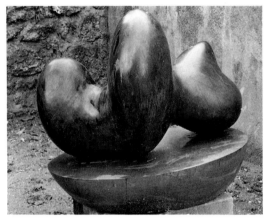

**29. Hans Arp: Human Concretion**
1935. Bronze, 26 × 29 × 21 in (66 × 73.7 × 53.3 cm). Estate of the artist

There were also two senior sculptors who exercised a major influence, but they were themselves little altered by the new situation. They were Hans Arp and Max Bill, both of whom have already been mentioned.

Of the two, Arp is the more difficult to assess. His work is isolated stylistically, but nevertheless gave other sculptors the stimulus to imagine more freely, to invent forms that seemed 'natural', but that were not to be found in nature. Arp had been one of the founder members of the Dada Group in Zurich during the First World War. In the earlier part of his career he did not really define himself as a sculptor, and the three-dimensional part of his output consisted of painted wooden reliefs which were almost as much paintings as they were sculptures. He only began to make work in the round after 1930. Some of this was more or less figurative; in the rest, the connection with the natural world was tenuous, but it nevertheless

expressed a feeling of organic growth. In its simplification and smoothness Arp's sculpture can be compared to that of Brancusi, but the comparison is misleading because Arp was not a carver – he did not envisage the form within the block, and then seek to free it. His technique was that of the academic sculptors of the nineteenth century – he modelled the sculpture in plaster, and this was then copied in stone or metal in a more or less mechanical fashion. When Hepworth visited Arp's studio in the 1930s, she was disconcerted to discover that he did not carve directly, as she herself did – everything she saw was in plaster, a material she abhorred because of its dead surface. It was only later that she began to appreciate the originality of his forms.

Perhaps because they arose from a process of modelling rather than carving, Arp's shapes, even when translated into bronze or marble, often gave the impression of being soft [Col. Pls. 4, 5]. They are reminiscent of the biomorphic forms which populate the desert landscapes of the Surrealist painter Yves Tanguy. Despite Arp's lack of direct stylistic progeny, certain echoes of his work can also be found in post-war sculpture. The early reliefs, which make use of only one or two forms, and which deliberately avoid complex formal relationships, are among the ancestors of Minimalist sculpture. The mature Arp has a link with the tumescent squashiness of Claes Oldenburg's sculptures made of kapok-stuffed vinyl, and an even closer one with the mysterious fruit-like

**30. Max Bill: Endless Surface**
1953–6. Bronze, 49 × 49 × 31 in (125 × 125 × 80 cm). Antwerp, Middelheim Museum, Sculpture Garden

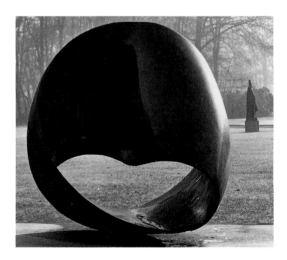

objects produced by the young Indian sculptor Anish Kapoor.

Max Bill is a formidable polymath – an architect, industrial designer and theorist in addition to

being a sculptor. Born in 1908, he studied at the Bauhaus from 1927–9, absorbing the influence of Laszlo Moholy-Nagy and Joseph Albers, who were responsible for the Foundation Course, the bedrock of Bauhaus teaching. The Bauhaus launched Bill into the European Constructivist Movement of the time, which took ideas from Russians such as Vladimir Tatlin, Aleksandr Rodchenko and El Lissitzky, and also from members of the Dutch avant-garde movement De Stijl. In 1936 Bill adopted and started to publicize the term 'Concrete Art', first proposed by Theo van Doesburg as an alternative to the word 'abstraction'. Van Doesburg's point was that abstract art at its purest made no reference to anything outside itself – it echoed neither what the artist had observed in nature, nor his subjective emotions, but was a logical ordering of materials in space. As his adoption of the term implies, Bill's definition of the characteristics proper of abstract art was of the severest kind. He relied on mathematical formulae

**31. Max Bill: Twins as Quarter Spheres**
1967. Wood, 8 × 11 × 15¾ in (20 × 28 × 40 cm). Zurich, Galerie Bischofsberger

to engender the relationships between the various parts of a sculpture, and applied this idea to painting as well. Many of the forms Bill found for his sculptures were already fully elaborated, at least in intellectual terms, before the outbreak of war; it remained only to find opportunities to have them embodied. Though the formal basis of his work is the product of intellect, there is often something playful about Bill's sculptures. He has a particular fondness, for example, for the paradoxical quality of the Moebius strip – a three-dimensional object possessing only a single surface.

One of the things Bill inherited from his Constructivist forebears – from the Russians, as well as from his tutors at the Bauhaus – was the idea that art should be directly functional and subject to the demands of industrial production. This led him to accept the headship of the Hochschule für Gestaltung at Ulm, conceived as a new Bauhaus. He designed the buildings at the school and remained at his post from 1951–6, taking responsi-

bility for the departments of architecture and product design. But Bill's time at Ulm was marked by a violent controversy between himself and his deputy, the Brazilian Tomàs Maldonado. Maldonado felt that designers must find the flexibility to fit in with the new and more complex demands being made by post-war technology. Bill's vision of industry remained that of the pre-war Bauhaus. Almost inevitably, he lost the struggle, and was forced to resign.

The extreme simplicity of much of Bill's sculpture, for example in his *Twins as Quarter Spheres*, and his avoidance of emotional expression, would seem to make him a more obvious predecessor of Minimalism than Arp. Surprisingly enough, the connection has been denied by leading Minimalists such as Donald Judd and Robert Morris, perhaps because of their desire to make Minimalism appear to be something entirely *sui generis*. Where Bill's influence has been generously acknowledged,

however, is in Latin America. He was awarded the first prize for sculpture at the São Paulo Biennale of 1951, and since that date has had disciples throughout the various Latin American countries. In Colombia, they include Edgar Negret (born 1920), Eduardo Ramirez Villamizar (born 1923) and Carlos Rojas Gonzalez (born 1933). Both Ramirez Villamizar and Carlos Rojas originally studied architecture, which is true of many Latin American sculptors. A number of them, particularly the Venezuelans and Brazilians, have since become members of the Kinetic Art Movement which has been re-exported to Europe. In Latin America, however, Constructivist sculpture in the tradition of Bill is large-scale and monumental, a symbol of commitment to the modern and a complement to the ambitious modern architecture of the region. Not only Bill's stylistic mannerisms but also his fundamental doctrines have been successfully absorbed.

# POST-WAR SCULPTURE IN ITALY

The immediately post-war years were marked by a rediscovery of contemporary Italian art, sculpture in particular. The Italian post-war sculptors who attracted international attention were divided into two groups – the figurative and the abstract – and the figurative artists were then considered more 'typical' of the Italian temperament in general.

The two leading figurative sculptors of the day, Giacomo Manzù (born 1908) and Marino Marini (born 1901), were already well-established in Mussolini's Italy, and the work they produced in 1945 was in many respects not very different from the sculpture that had won them acclaim in the 1930s. One of Marini's earliest successes was a figure of *Italy Armed*, produced in 1932 for the official exhibition celebrating the tenth anniversary of Fascism. In 1935 he was awarded the First Prize for Sculpture at the second Rome Quadriennale, founded by the regime as one of the principal showcases for Italian artists. He also taught at state-supported institutions almost throughout the Fascist period. From 1929–40 he was at the art school in Monza; and from 1940 onwards at the prestigious Brera Academy in Milan. During the 1930s Marini was associated with members of the Novecento Group, which had received Mussolini's personal support at its foundation. Fellow signatories to a manifesto published in the literary magazine *L'Ambrosiano* in 1934 were Carlo Carrà, Achille Funi and Mario Sironi.

Simply because he was seven years Marini's junior, Manzù was less closely identified with the Fascist regime, but in essentials his early career followed a rather similar pattern. He scored a major success at the Venice Biennale of 1938, held under Fascist auspices, and in 1941 was appointed to a teaching post at the Accademia Albertina in Turin.

During the 1930s the Italian art scene, though never subject to the kind of repression visited upon German artists by the Nazis, became increasingly closed and nationalistic, and this tended to divert foreign attention away from it. This may be one reason why Marini and Manzù struck the inter-

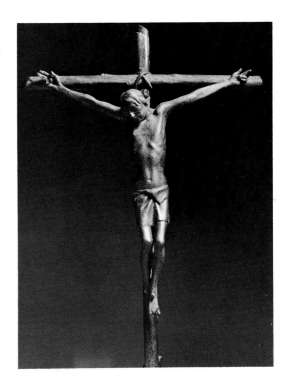

**32. Giacomo Manzù: Crucifixion**
1937. Bronze, ht. 24 in (61 cm).
Rome, Musei Vaticani

national post-war public as new – they were mature artists who had never till then had the opportunity to make their full impact, though Manzù in particular had exhibited quite extensively abroad during the late thirties, showing work ih Paris, New York and San Francisco.

In 1939 Manzù had embarked on a series of reliefs of religious themes – *Crucifixions* and *Depositions* in a refined, very shallow bas-relief technique derived from Donatello. He had been able to continue with the series even when he took refuge from the war in the remote mountain valley of Clusone. The compositions contained many topical allusions – in particular, German soldiers often played the part of executioners. In one typical work Christ's emaciated body dangles by one arm from the Cross, surveyed complacently by a gross half-naked German wearing a helmet. Sculpture of this kind had a painful immediacy in 1947 – it recalled the ferocious partisan war which had raged in northern Italy, as the allies advanced

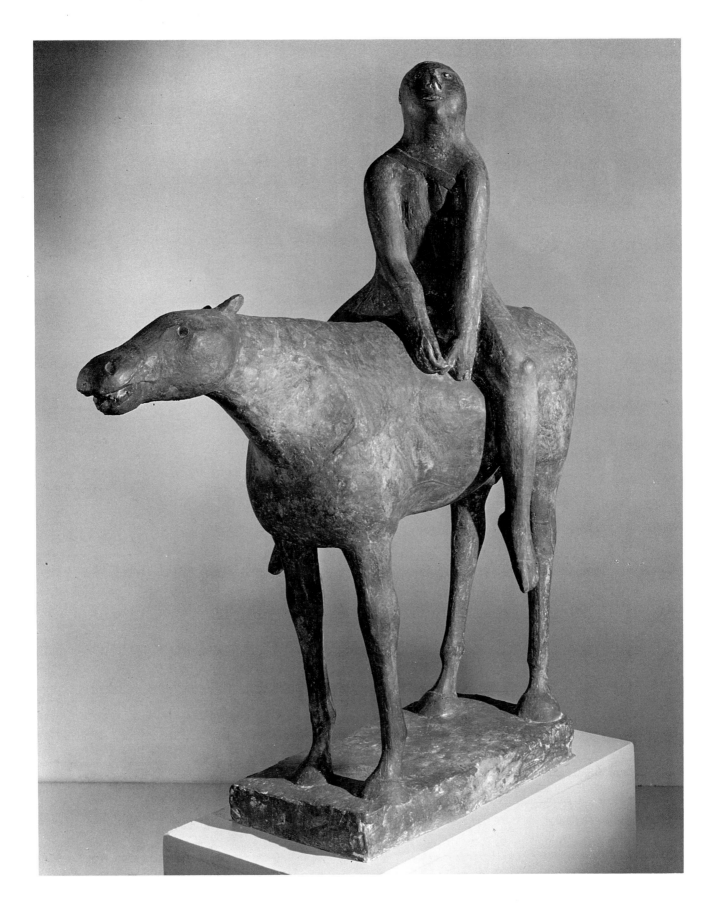

from the south. An Italian critic, Carlo Ragghianti, has spoken of the 'fluent passage into immediate experience' which characterizes Manzù's art, and this is certainly much in evidence in the reliefs I have been describing.

In his post-war work particularly, Manzù drew on a wide variety of sources, but these remained within the main European tradition. In addition to Donatello and other artists of the Renaissance, he paid close attention to Etruscan art, particularly its later phases, when it was influenced by Hellenistic naturalism. He also looked at Edgar Degas – the famous *Little Girl on a Chair* of 1949 is a close cousin of Degas's *Petite Danseuse de Quatorze Ans*. Another obvious source is the Italian Impressionist sculptor Medardo Rosso, whose dissolving, light-eroded surfaces reappear in Manzù's work, though in less extreme form. Much of Manzù's appeal is quasi-literary – he is not a great formal innovator, but he is on the other hand a ravishingly delicate craftsman who keeps an ever-threatening sentimentality at bay by his sophisticated sense of irony. His attitudes towards the church are ambiguous, despite his frequent use of sacred subject matter. It is difficult to tell whether his depictions of *Cardinals* are intended as tribute or criticism [Col. Pl. 9] – they partake of both attitudes, as do the versions of Passion scenes. In one that dates from 1940 (that is, from before the outbreak of partisan warfare) it is a skeleton rather than a corpse which hangs helplessly from the Cross. The scene is surveyed by a young boy with a dog on a leash and by a naked old man who fails to conceal his genitals with a cardinal's hat. Perhaps surprisingly in the circumstances, the Vatican in 1949 decided to commission Manzù to make a new set of bronze doors for St Peter's in Rome.

Marino Marini's work is sometimes very close to Manzù's in style but contains a more pronounced modernist element. The sources he shares with Manzù are Etruscan art, the sculpture of the Renaissance and the work of Medardo Rosso. But he is more eclectic – one can also find in him the influence of Chinese art, especially T'ang tomb statuettes and Cubism. The Cubist element enters Marini's work very late, and does not become pronounced until the 1950s and 1960s.

While Manzù became celebrated for his images of cardinals, Marini caught the public imagination with those of horses and horsemen. His first horses date from 1935, and have nothing non-European about them. Marini had been impressed by the great equestrian statues by Donatello and Ver-

*Opposite*
**33. Marino Marini: Horseman**
1947. Bronze, $64\frac{1}{2} \times 61 \times 26\frac{1}{2}$ in ($164 \times 155 \times 67.5$ cm). London, Tate Gallery

rocchio which were a direct part of his heritage, and also by the *Bamberg Rider* in Germany, which he first saw in 1934. His early horses also seem to owe something to Italian popular art. He continued to work on the theme in the war years, and in works such as *Cavaliere* the Chinese element becomes noticeable. Marini's later riders, like Manzù's religious reliefs, drew on the experience of war. With their arms flung wide, often leaning backwards at an exaggerated angle, they recall memories of the peasants watching allied warplanes flying over their fields in the Po valley [Col. Pl. 7]. The idea of the 'watcher' was one which Marini shared with many other sculptors working at this time.

For Marini, as for so many other sculptors of his generation, the war years imposed severe restrictions. In 1938 he had married an Italian–Swiss woman, and when his studio was destroyed in the bombing of Milan, he retired across the frontier to live with his wife's family. In Switzerland he was not allowed to accept commissions or to cast bronze; he therefore worked mainly in clay and plaster. But he did come into contact with important non-Italian sculptors who had also taken refuge on neutral territory – chief among them were Fritz Wotruba from Austria and Germaine Richier from France. The academic elements still discernible in Marini's earlier work were refined away during this period, and the immediately post-war sculptures are notable for their freshness of response and purity of feeling. There is one thing that gives Marini's sculpture a special nuance – the fact that he often makes use of colour. Clay or plaster portrait heads are painted in imitation of Etruscan terracottas, and there are pieces in painted wood or even in painted bronze.

Though Marini does not rely overtly on sentiment in the way that Manzù does, he too is an artist who must be read in terms of feeling rather than in those of formal experiment. The Cubist-inspired works of the 1960s clearly reveal the limitations of his sense of form, and they seem naïve compared to Picasso's works in the Cubist idiom. The paintings and drawings Marini produced at this time are openly derived from Picasso.

Marini and Manzù were both enthusiastically welcomed after the war. Their work appealed because of its accessibility and direct communicativeness, and also because it was thought to mark a return to the true Italian tradition – though, ironically enough, this was also what Mussolini had called for. It was felt that the two artists had at last found a convincing way of marrying

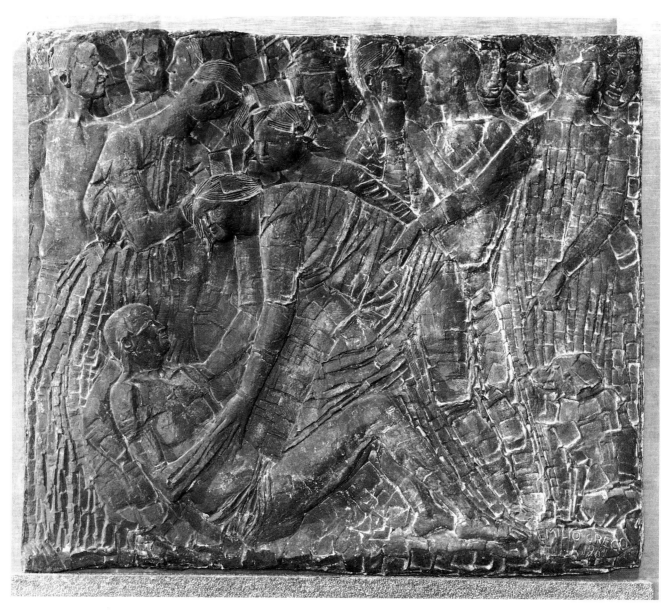

**34. Emilio Greco: Religious Scene**
1961–4. Bronze panel from the doors of Orvieto Cathedral

the Renaissance heritage to the modernist one. They did not, however, succeed in forming a durable school. If one looks, for example, at the work of an Italian figurative sculptor who is only slightly younger, Emilio Greco, born in 1913, one sees the humanist impulse already veering into a kind of brittle mannerism. Greco was a slow starter; he did not exhibit during the Fascist period, but his first one-man show, held in Rome in 1946, caught the wind of a new epoch. One work which demonstrates the difference in quality between him and his two seniors is the bronze doors made in 1961–4 for Orvieto Cathedral. Compared with those made by Manzù for St Peter's, these seem crowded, insensitive and harsh.

The problems faced by Italian sculptors as they emerged from the long Fascist period can be gauged by looking at a few other members of a very numerous school. One choice of direction is represented by Pietro Consagra (b. 1920), whose work, like that of a number of American and French sculptors, is an attempt to find an equivalent for the freely gestural painting of the time. Consagra's sculpture is typical of this tendency not only in its irregular forms, but because it is flattened out, with superimposed planes hardly, if at all, separated from one another. The abstract sculpture of Arnaldo (b. 1926) and Gio Pomodoro (b. 1930) is closely related both to 'painterly' painting and to design. Arnaldo Pomodoro specializes

in solid forms – columns and spheres – with brilliantly polished surfaces which are split open to reveal intricate, organic patterns, rather like a pomegranate split open to reveal pith and seeds [Col. Pl. 19]. The true plasticity of these pieces is suspect, like stage scenery; they tend to look well only when seen from one carefully chosen viewpoint. Even then, they seem to have little to offer beyond their opulent decorativeness.

The strangest and most intriguing personage among the Italian sculptors active at this time was the Argentinian-born Lucio Fontana (1899–1968), now chiefly remembered for the 'slashed' canvases which made him a predecessor of Minimal Art. Before the war Fontana, who had originally been educated at the Brera Academy, pursued an erratic career, producing work which was sufficiently abstract to win him membership of the Abstraction Creation Group in Paris, and also sculpture in

**35. Pietro Consagra: Transparent Iron, Lilac**
1966. Painted iron, 80 × 78 × 2 in (202.5 × 198 × 5 cm). Buffalo, Albright-Knox Art Gallery

**36. Lucio Fontana: Bozetto for the Bronze Doors of Milan Cathedral**
1951–2. Milan, Museo dell'Opera del Duomo

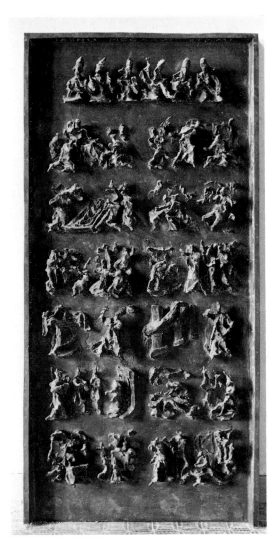

orthodox classical style. He was even employed as one of the artists who produced classical decorations for the new Fascist Palazzo di Justicia in Milan. The war years he spent back in Argentina, and there, too, he produced work in Novecento style, already familiar to the Argentinian public. He returned to Italy in 1947, and established a reputation as an extreme avant-gardist with a liking for the limelight. The slashed canvases were sometimes made in public. At the same time, Fontana produced other kinds of art, sometimes very far removed from the image he was now cultivating. In 1951–2, for example, he took part in a competition to provide bronze doors for the Milan Duomo. His designs were close to nine-

teenth-century academic sculpture in conception, and in particular to the flickering, illusionistic virtuosity of the Italian artists of that period, such as Carlo Marochetti. Fontana was placed equal first in the contest, sharing the prize with Luciano Minguzzi, but the doors were never executed. Some of Fontana's *bozetti*, originally made in plaster, were later cast in bronze, and can be seen in the Museo dell'Opera del Duomo in Milan and in the Vatican's Museum of Religious Art. They are among the strangest artistic souvenirs of the immediately post-war period.

# POST-WAR SCULPTURE IN BRITAIN AND FRANCE

The work of most of the sculptors already discussed is deeply rooted in the pre-war epoch, even if the full flowering of their reputations had to wait until after the war. This is as true of Moore and Giacometti as it is of Marini and Manzù. The post-war years also produced a crop of completely new names. People in the late 1940s and 1950s were convinced that they were witnessing a powerful revival of the art of sculpture, and they saw this as being led not only by Henry Moore but by a whole group of younger British artists. But the revival was curiously self-enclosed. Though many of the British sculptors who were much talked about and praised in the 1950s continue to be known and respected today, it is significant that they no longer occupy the central position in the history of modernist sculpture which was once given to them. Many seem to have ossified creatively; those whose work has changed significantly have achieved this transformation only at the price of making a decisive break with their own beginnings.

The international success of the post-war generation of sculptors in Britain was marked by a number of events which seemed perhaps more significant at the time than they do now. First came the triumphant appearance of a group of young British sculptors at the Venice Biennale of 1952 – among them were Kenneth Armitage, Lynn Chadwick, Reg Butler, Eduardo Paolozzi and Bernard Meadows. Though they were often classified as followers of Henry Moore, and though some did indeed borrow elements from Moore's work, it was only Meadows, who had served as Moore's assistant, who was really especially close to the older sculptor. It was significant that many members of the younger group turned to sculpture comparatively late. Both Chadwick and Butler trained as architects. Chadwick began making mobiles (inspired by the work of Alexander Calder) on an almost amateur basis, after war

service in the Fleet Air Arm. Butler first practised as an architect, and later served as Technical Editor of the *Architects' Journal*. He only began to work seriously as a sculptor in 1944. The work of both men is marked by a kind of *ad hoc* ingenuity – Butler was to invent and patent a new method of casting bronze – but both lacked the solid academic training that was the foundation of Moore's experiments. Early success was not altogether a benefit in these circumstances; Butler certainly, and Chadwick probably, suffered from gnawing uncertainties.

**37. Reg Butler: Working Model for the Monument to the Unknown Political Prisoner**
1953. Bronze, metal, plaster, 89 × 34½ × 33½ in (227 × 88 × 85.5 cm). London, Tate Gallery

Butler achieved a major position when he won the *Unknown Political Prisoner* competition in 1953 against the opposition of nearly every well-known sculptor in the world, including some of the original modernist masters. Chadwick was also a major prize-winner in this competition, and was awarded the International Sculpture Prize at the Venice Biennale of 1956, in succession to Moore. The maquette which Butler produced aroused high passions when it was first shown, so much so that it was attacked by an angry member of the public and badly damaged. It was uncertain whether the attack was provoked by the political content of the piece or by its style, but the incident was, in a backhanded way, a tribute to Butler's power to communicate. He caught the liberal aspirations of his time, and the lingering anguish of the war years (combined with some of the uncertainties of the Cold War), while remaining deliberately unspecific about political circumstances.

In Butler's conception, the prisoner himself – or herself – is absent. The piece consists of a kind of watchtower in welded metal, reminiscent perhaps of the towers which guarded German concentration camps and forced labour camps in the Soviet Union, with three figures of women beneath, looking upwards. The monument Butler envisaged was never built, though at one time a site was set aside for it in West Berlin, overlooking the Soviet Zone. The maquette is more like a model for stage scenery than an orthodox sculpture. The true sculptural opportunity would have presented itself with the female figures. Full-scale studies for the heads of these show that they would have borne a resemblance to other figures of 'watchers' – a type of sculpture produced by quite a number of artists at this period, among them both Armitage and Chadwick. Watchers, predatory birds and winged figures were all of them very much part of the imagery of the 1950s. One finds incorporated in them the fears and hopes of post-war society, and in this sense the sculpture of the period is closely related to the general cultural atmosphere of its epoch. The same cannot always be said for the sculpture produced later.

Following the success which established his reputation, Butler's career pursued an irregular and somewhat disappointing course. It soon appeared that the *Unknown Political Prisoner* did not reflect his central preoccupations, though the tower-like form which was the most prominent feature of his maquette was a direct development of the González-derived pieces in wrought and

welded iron which Butler had been making since the late 1940s. As soon as he could afford to have his work cast, however, it became more volumetric and in a sense more conventional. The distinguishing characteristic of many of his middle-period bronzes is a rather strained eroticism, and this was greatly intensified in what he made during his last phase. After a period of uncertainty in the 1960s, in the 1970s he produced a small series of exquisitely crafted female nudes in painted bronze, none much larger than lifesize, and the majority a good deal smaller. There is an elusive resemblance between these nudes and the nude and semi-nude female figures to be found in erotic Japanese prints designed by Utamaro and others – Butler in fact said that he had been influenced by the appearance of the women he saw when on a visit to Japan. The bronzes, in addition to being painted to resemble life, are provided with real hair and glittering glass eyes, and they are thus, superficially, comparable with the female nudes produced by the American Super Realist sculptor John de Andrea at the same epoch. But it is only the details which are naturalistic in Butler's case. The

**38. Reg Butler: Girl on Red Base** 1968–72. Painted bronze, 32 × 43 × 63½ in (81.3 × 109.2 × 161.3 cm). New York, Pierre Matisse Gallery

anatomy is deliberately distorted, and the limbs turn and twist wilfully, in a way which accentuates the resemblance of Japanese erotic prints. Butler's late sculptures were not well received in the artist's lifetime. His early fans considered them vulgar and they were for some reason ignored by enthusiasts for Super Realism. Their status remains unsettled after his premature death.

Chadwick's early mobiles in wrought and welded iron developed into sculptures with welded iron frameworks but no moving parts. The frameworks, in turn, were filled with a compound of gypsum and iron filings, which gave the pieces a new solidity and bulk. Eventually it seemed logical

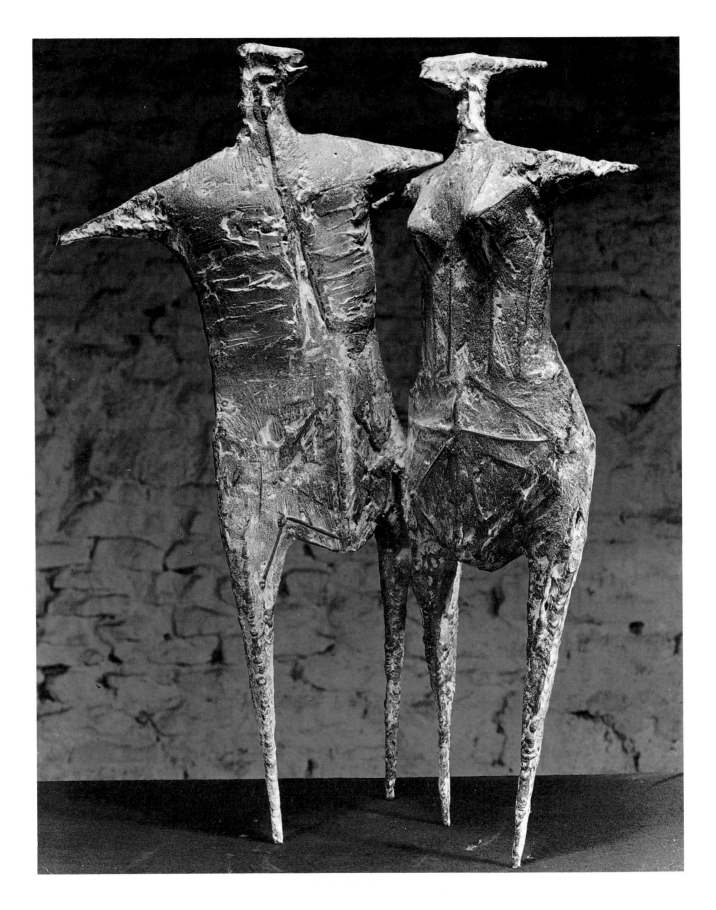

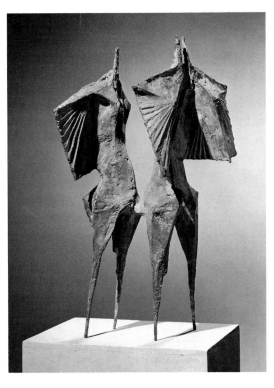

**40. Lynn Chadwick: Winged Figure**
1955. Bronze, 22 × 17 × 14 in (56 × 43 × 36 cm). London, Tate Gallery

*Left*
**41. Kenneth Armitage: Chair**
1983. Bronze, ht. 60 in (152.4 cm). Private collection

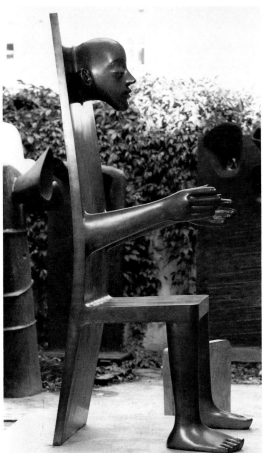

*Right*
**42. Kenneth Armitage: Family Going for a Walk**
1951. Bronze, ht. 29 in (74 cm). Private collection

*Opposite*
**39. Lynn Chadwick: Two Dancing Figures No. 6**
1955. Iron and composition, ht. 22½ in (55 cm). Private collection

to cast these unique pieces, but their conception has little to do with the modelling techniques generally associated with sculptures in bronze. They also lack the density associated with carving – Moore's preferred technique during the earlier part of his career.

During the 1950s, Chadwick's work had an element of the journalistic which was quite alien to Moore and anything he stood for. Rather than searching for archetypes based on the hidden correspondences between the female nude and landscape, Chadwick turned to social observation. Some of the most typical sculptures made by Chadwick in the 1950s are almost caricatures of the Teddy boys and Teddy girls who aroused so much comment at the time. They now seem like period pieces in almost every sense.

Having established a very recognizable but rather restrictive idiom, Chadwick was unable to break out of it and his later work has become increasingly mannered as a result. Many of the conventions he employs now seem especially typical of the post-war epoch – there are elements

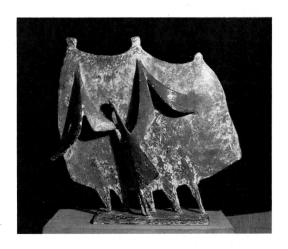

which can also be traced, in transmuted form, to the domestic design of the 1950s. In *Winged Figure*, a typical work, one notes the small, stylized heads of Chadwick's figures (like the knobs on fifties furniture), the spindly legs or supports, and the bulky, fluttering wings or draperies.

The sculpture of Kenneth Armitage exhibits many of the same mannerisms. In his case the bulky draperies just mentioned are sometimes ingeniously used as a means of uniting several figures and turning them into a single group, as in *Family Going for a Walk*, which takes on the slab-like or screen-like form so popular in the 1950s. Armitage's work does nevertheless differ from

Chadwick's in several important respects. It is never certain that the caricature-like quality of Chadwick's sculpture is meant to be humorous; in Armitage the humour is unmistakable – he has a definite liking for the grotesque, and his figures and animals often seem to be struggling vainly but endearingly with the burden of their own ungainliness.

Armitage's work, like Butler's but unlike Chadwick's, has tended to become more rounded and volumetric in the latter part of his career. He has exploited to some effect the device of seeing the human trunk as the metaphorical equivalent on a tree trunk, with limbs and breasts serving as knobs and branches. The comparison becomes explicit in a series of sculptures made in the 1970s. Entitled *Richmond Oaks*, they were inspired by the splendid old trees in Richmond Park south-west of London [Col. Pl. 10]. Where Butler's late figures are realistically painted, Armitage's trees are patinated to resemble life, though they also retain a charming

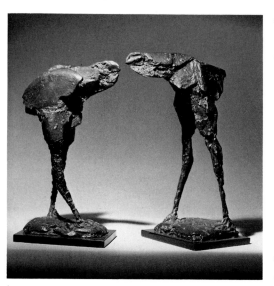

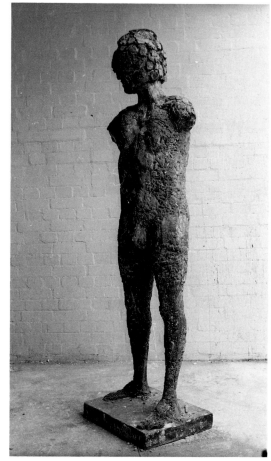

**43. Elisabeth Frink: Bird** and **Harbinger Bird IV** 1960. Bronze, marble bases, ht. 19¼, 18 in (49, 46 cm). Private collection

**44. Elisabeth Frink: Warrior** 1957. Concrete. Private collection

built major careers for themselves are Elisabeth Frink and Eduardo Paolozzi. Frink, born in 1930, held her first exhibition in London in 1952. The slashed surfaces of her early pieces now seem very typical of the decade when she first caught public attention: her animals, and especially her birds, of which *Harbinger Bird IV* is a characteristic example, speak a language which was elaborated at that time. But when directly compared to other

toy-like quality. These works are an example of the way post-1945 sculpture has addressed the problem of representing landscape – not traditionally considered part of the sculptor's business. Other examples are Moore's *Reclining Figures* already described, some works by the British sculptor Hubert Dalwood, and many of the early pieces by the American David Smith.

The 'fifties style', though it gives a pervasive and instantly recognizable flavour to the British sculpture of the decade, must not be thought of as a rigid strait-jacket. Two of the sculptors who first established themselves at that time and who have

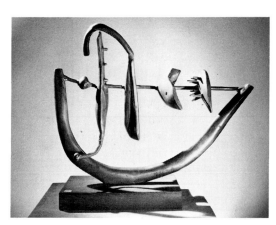

**45. Eduardo Paolozzi: Forms on a Bow.** 1949. Bronze, 20¼ × 24¾ × 8¾ in (51.5 × 63 × 25 cm). London, Tate Gallery

artists who emerged at the same moment Frink seems to owe far more to the past than they do – her male nudes and helmeted warriors have more than a touch of nineteenth-century heroics. This nineteenth-century element has proved to be a strength rather than a weakness. Frink's work now does not seem nearly as mannered as that of either Chadwick or Butler, and she has consistently been able to communicate with a wide audience.

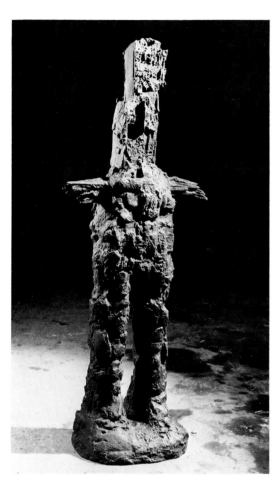

realism prevailed, more particularly that of Giacometti's Surrealist phase. This is clearly detectable in one of Paolozzi's best early pieces, the *Forms on a Bow* of 1949, which also has an affinity with early works by the American sculptor David Smith, whose development Paolozzi was in many respects to parallel.

Later, Dada strengthened its grip on Paolozzi's imagination, and so did Jean Dubuffet's *Art Brut*, in many respects Dadaism's true successor. There is an evident resemblance between Paolozzi's *Heads* of the early 1950s and the graffiti-inspired portrayals of his literary friends which Dubuffet made just after the war. In the 1950s Paolozzi

**46. Eduardo Paolozzi: Icarus II**
1957. Private collection

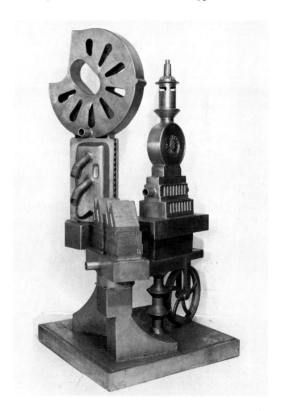

**47. Eduardo Paolozzi: Towards a New Laocoon**
1963. Aluminium,
79 × 59 × 36 in
(201 × 150 × 91.5 cm).
London, British Council

Occasional weaknesses of form are compensated for by the fact that her sculpture is unmistakably the vehicle for powerful feelings.

Paolozzi is a different case – an extremely inventive artist who has often been at the cutting edge of innovation, although some of his innovations have not always seemed in harmony with the true nature of his talent. His earliest work was influenced by direct contact with the rump of the old Surrealist Movement in Paris directly after the war. At that time he also saw much of Duchamp's work in the apartment of the latter's ex-mistress Mary Reynolds. At first the influence of Sur-

evolved a technique whereby he imprinted small 'found' items – cogwheels, electrical parts, toys, natural objects such as pieces of bark – into plaster surfaces in a development of Surrealist collage. From these matrices he cast intricately textured sheets of wax that could be cut up with a hot knife and shaped into sculptures and finally cast in bronze. The imagery he evolved at this time ranged from swollen, menacing-looking animals, such as dogs and frogs, to crude humanoids. *Icarus II* seems like the maimed survivor of an atomic holocaust (fear of the atomic bomb haunted sculptors as it haunted everyone at this period); other works

are more like robots, inspired by the pulp science fiction that Paolozzi had read avidly since childhood.

Paolozzi was one of the founder members of the Independent Group which met at the Institute of Contemporary Arts in London from 1952 onwards, and he thus formed part of the preliminary cultural stirring which led to the birth of Pop Art. His own work took on Pop overtones in the crucial year 1960; instead of simply texturing his surfaces with small mechanical items, he began to make use of ready-made machine parts as buildings blocks for sculpture. His development paralleled, but more hesitantly, the work being done at the same moment by Anthony Caro and David Smith. The mechanical agglomerations were followed later in the 1960s by chromed metal sculptures, such as *Towards a New Laocoon*, whose shiny surfaces and decoratively scalloped edges seem to effect the interest in Art Deco characteristic of the later and more decadent phase of Pop. But Paolozzi by this stage in his career was gradually transferring much of his creative energy to graphic art and to projects for architectural decoration. In doing so he moved towards the periphery, and has never recovered the pivotal position he enjoyed in the late 1950s.

Two French sculptors did work that was closely related to that of British artists during the first fifteen years after the war. One was Germaine Richier, who died prematurely in 1959. Before the war she had exhibited with some success in Paris, but her work retained an academic tinge. The war years were spent largely in Switzerland (her husband was a Swiss citizen) and this hiatus gave her time to reconsider her approach. From 1948 onwards she attracted considerable attention with a series of large allegorical sculptures which depicted nature as being always in a state of flux. The technique of those pieces was basically traditional but their content was not. Richier took the ambiguities of Surrealist imagery and linked then to a stormy romanticism. Her sculptures, instead of mimicking the painterly freedom of her contempories working in oil on canvas, interpreted the notion of fluidity in a different and more fundamental way. A piece like *The Storm* seemed to be in the very process of transforming itself as one looked at it. Her images are some of the most memorable and poetic of their time, and her work has dated less than that of most of her contempories.

César (César Baldaccini), though twenty years younger than Richier, was establishing a major

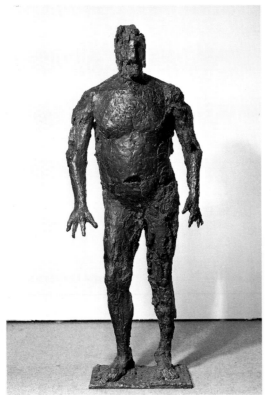

**48. Germaine Richier: The Storm**
1947–8. Paris, Musée Nationale d'Art Moderne

**49. Germaine Richier: The Ant**
1953. Metal. Munich, Bayerische Staatsgemäldesammlungen

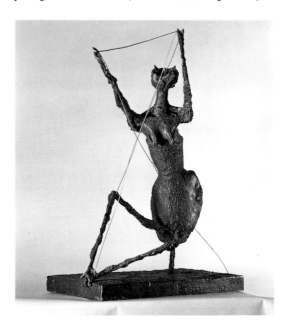

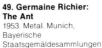

reputation in Paris at the same period. Some of his imagery has a superficial resemblance to Richier's, but there is an even closer one to that of Chadwick and Paolozzi. Like Chadwick, César worked in welded metal, and like Paolozzi he made much

use of fragments of industrial detritus, combining these with virtuoso skill. His images covered the standard range of the time. Among his creations were predatory birds, winged figures, and strange semi-mechanical beings.

César was a lively personality and rapidly became a hero of *le tout Paris*. In 1960 he was an important recruit to a new art movement, Nouveau Réalisme, formed under the leadership of the critic Pierre Restany. At the Salon de Mai of 1960, before the official formation of the group, César caused a scandal by showing two pieces which he dubbed *Compressions* – blocks of multi-coloured metals made from old cars with the help of one of the vast compressors used in junk yards. These *Compressions* took a more and more prominent place in his work [Col. Pl. 13], though he continued to make ambitious figurative sculptures in his old

manner until 1965. One of their attractions seems to have been the fact that the new technique was so facile, and invited a kind of mass production. In 1967 César embraced a new technique for making instant sculpture. Now his enthusiasm was for *Expansions*, which relied on the special properties of polyurethane, a material that foams up and expands violently when treated with the correct additive. César turned the creation of his *Compressions* and *Expansions* into spectacular public events that garnered him worldwide publicity. But the end products look sad and tarnished now – curiosities rather than fully fledged works of art. They wholly lack the intricacy, poetry and fantasy which marked his earlier work. Like Paolozzi, César formed an intellectual relationship with the Pop sensibility of the 1960s, but was somehow unable to use it to vivify his own production.

# THE AMERICAN TRADITION

So far, nothing has been said about the condition of sculpture in America in the years following the Second World War. The upsurge in American painting during the 1940s was not matched by comparable developments in sculpture, and it took some time for the situation to resolve itself. Sculptors were confronted by the demand that they should find an equivalent for the Abstract Expressionist style in painting, and the quintessentially 'painterly' nature of this made the demand seemingly impossible to fulfil.

There were indeed two American sculptors of international reputation at work when the Abstract Expressionists changed the face of American art. Neither responded positively to the new climate, though the work they did in the 1940s and 1950s often contained the seeds of the future. The better known of the pair was the inventor of the mobile, Alexander Calder. While acknowledging his importance, historians of modern art have found it difficult to locate Calder's work as part of a continuing process of stylistic development, with each new generation of artists either developing from or refuting the efforts of its predecessors. Calder himself would have found such academic categorizations ludicrous and beside the point. In later life he was notoriously reluctant to give serious answers to earnest interviewers, or to make pronouncements of any kind about his work.

Calder was born in 1898, and both his father and grandfather were professional sculptors. He himself originally chose to study mechanical engineering and only turned to art in 1922, at first studying to be a painter. Calder's nature was always sunny and playful, and he expanded his activity from making illustrations (many for the *Police Gazette*) to making mechanical toys. He created a miniature circus with which to entertain his friends, and this entertainment was also shown to new friends and acquaintances in Paris, when he made his way there at the end of the 1920s. It was contact with Piet Mondrian's work which suggested to Calder that he should become an abstract artist; but when he began to make abstract

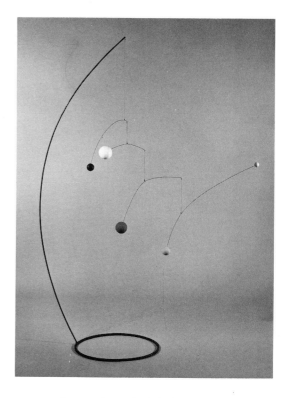

**50. Alexander Calder: Constellation**
*c.*1950. Standing mobile, ht. 63¾ in (161 cm). Private collection

constructions, using principles borrowed from the toys created previously, his chief inspiration was the painting of Joan Miró, with its bright colours and sparse, scattered forms. Marcel Duchamp, who had long been interested in the idea of movement in works of art, visited Calder's studio in 1932 and provided the name 'mobile' for the constructions the American was making. Hans Arp, by analogy, suggested that the pieces which did not move should be called 'stabiles'. The mobiles were at first motor-powered, but in 1934 Calder abandoned this idea as being limiting in one sense and over-complex in another, and he began to make spidery constructions which moved apparently of their own volition, responding to the slightest gust of air. He described these works as 'four-dimensional drawings'; a large part of their attraction lay not merely in the fact that they moved but in the way they occupied space while having neither weight nor bulk [Col. Pl. 12].

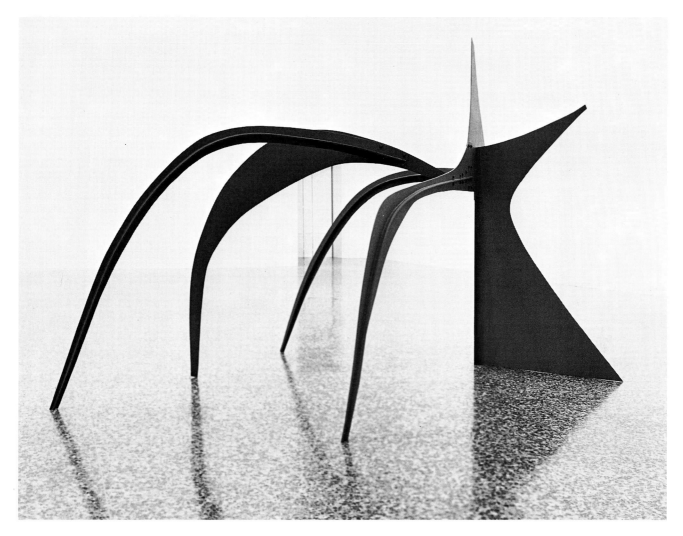

Having established the basic principles of his art before the war, Calder did not vary them greatly in the post-war years, though he was now sometimes given the chance to work on a very big scale. Enlarged, his mobiles remained much the same in effect. The stabiles of painted and riveted metal sheets did, by contrast, acquire a different presence when they became very large – they provided prototypes for some of the large steel sculptures produced by American artists of a younger generation during the 1960s [Col. Pl. 11]. But Calder, even in old age, had none of the solemnity of these disciples. His work remained as quirky and humorous as his actual presence, and he felt free to switch from purely abstract forms to figurative images of delightful grotesquerie. The *Critters* of the 1970s, vast hobgoblins in sheet metal, are ancestors of some of the sculpture of the 1980s – in particular they have close resemblances to the work of Jonathan Borofsky.

**51. Alexander Calder: The Crab**
1962. Painted steel, 10 × 20 × 10 ft (30.5 × 61 × 30.5 m). Houston, Museum of Fine Arts

Also busily at work during the immediately post-war years was the Japanese-American sculptor Isamu Noguchi. Noguchi, born in Los Angeles in 1904, had a Japanese father and an American mother and spent his childhood in Japan, returning to the USA in 1917 to attend an American school. He had early aspirations to be an artist and in 1921 worked briefly for the academic sculptor Gutzon Borglum (later famous for turning Mount Rushmore into the gigantic likenesses of four American presidents). Borglum told him he had no talent, and Noguchi briefly tried medical school instead. But he soon reverted to sculpture and acquired a solid academic foundation, plus a temporary dose of arrogance, at the Leonardo da Vinci School in New York, before making his way to Paris in 1927 on a fellowship from the Guggenheim Foundation. Here he had the good fortune to work for two years under Brancusi, who exercised an important influence over his development. The

late 1920s and 1930s were a period of travel and experiment. Noguchi returned to America, then went to Japan, somewhat against the wishes of his father and other Japanese relatives, to explore his cultural heritage; he also travelled to Mexico, where he made a large wall sculpture in coloured cement in the then fashionable social realistic style. He did theatre designs for the great choreographer Martha Graham, and produced sensitive portrait heads in order to earn his living.

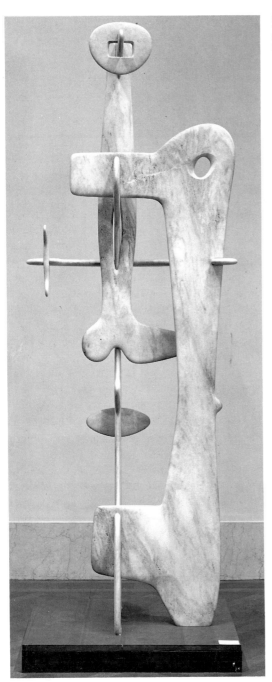

**52. Isamu Noguchi: Kouros**
1944–5. Marble, ht. 117 in (297 cm). New York, Metropolitan Museum of Art

**53. Isamu Noguchi: The Japanese Garden**
1955. Paris, UNESCO House

During the war Noguchi identified himself with the cause of the Nisei – the Japanese–Americans brutally removed from the Pacific coast to inland internment camps by the American government. In 1941 he voluntarily entered one such camp, at Poston, Arizona, to do what he could for the internees, and he had some difficulty in regaining his liberty. In the late 1940s he was peripherally involved with industrial design (though never deeply committed to it, unlike Max Bill). He designed a successful coffee table for Herman Miller and an equally successful lamp for Knoll. His practical approach to problems and materials was impressively exemplified in the sculptures he produced in the 1940s, which are still some of his best-known works. Having discovered that marble was cheap when bought in slab form (because slabs were in constant demand for the building industry) he made a series of pieces built up of interlocking flat elements of marble. *Kouros*, in nine parts, is

one of these works. The shapes are typically post-Surrealist and can be compared to those used by Arp, but technically the sculptures are highly original because they reconcile two opposing traditions in modern sculpture – that of the carved and that of the constructed.

A Bollingen Foundation Grant in 1950 for research into leisure enabled Noguchi to renew his restless travels after the war. He went to India and Bali, and revisited Japan, where he designed two bridges for the Peace Park in Hiroshima. Noguchi had always been interested in sculpture as something which created a complete environment – his stage designs for Martha Graham were based on this concept, and so were early designs for children's playgrounds. He explored the Japanese tra-

dition of garden-making, and was soon able to put this knowledge to good use with a series of commissions for gardens and outdoor environments. One was for the Connecticut General Life Insurance Co., another for the Chase Manhattan Bank in New York, and a third for the UNESCO building in Paris. The last, one of his best-known works, dates from 1955. Noguchi also designed the terraced Billy Rose Sculpture Garden for the National Museum in Jerusalem. All of these works

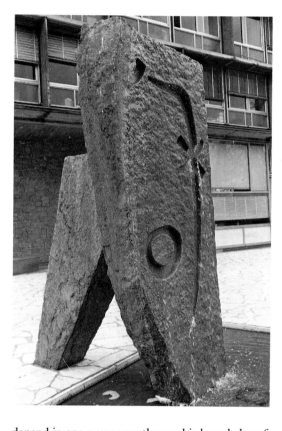

**54. Isamu Noguchi:
The Fountain of Peace**
1955. Paris, UNESCO House
(Japanese Garden)

depend in one way or another on his knowledge of the tradition of Japanese garden design, though only the garden for UNESCO is specifically Japanese. His work in this field laid the foundation for the Land Art movement which flourished in the United States during the late 1960s and 1970s. Almost equally seminal were a group of works which Noguchi made in sheet aluminium in 1958. These, like Calder's large stabiles, anticipate some of the most characteristic developments of the following decade.

A third American occupied an important but somewhat peripheral position, not only in terms of sculpture, but in terms of American art as a whole. Joseph Cornell is an unclassifiable figure – an artist without true predecessors and without

recognizable progeny. He was born in 1902 into a middle-class family which later came down in the world, and he had no formal artistic training. His early adulthood was spent peddling samples for a New York textile company. He did not begin his career as an artist until 1932, when he showed a few collages at the Julien Levy Gallery, then the focus of Surrealist activity in New York. These collages were influenced by the work of Max Ernst, but Cornell soon decided that he was not cut out to be an orthodox Surrealist. 'I do not share in [their] subconscious and dream theories', he wrote in 1936. The exemplar he chose for himself was Marcel Duchamp, with whom he eventually formed a personal friendship which lasted until Duchamp's death in 1968.

Long before his meeting with Duchamp, Cornell had taken to making small (often tiny) three-dimensional assemblages, often contained in glass-fronted wooden boxes. These constructions became the expression of a very personal world of fantasy [Col. Pl. 17]. Found objects were assembled magpie-like as a way of celebrating ideas, creating visual poems, and paying tribute to people whom the artist admired. He devoted many constructions, for example, to the world of ballet – to legendary dancers of the past, such as Marie Taglioni, and to others who were his contemporaries, such as Tamara Toumanova.

While the main purpose of his juxtapositions was associative, Cornell developed certain techniques that foreshadowed what American sculpture was to do in the future. The most significant of these was an insistent repetition of images – his boxes often have a grid-like structure, with the same, or closely similar, objects appearing in a series of identical compartments. This seems to look forward to one of the favourite procedures of Minimal Art.

In the 1940s and 1950s, however, it was not Calder and Noguchi, and certainly not Cornell, who belonged to the mainstream of development in American art. Critics looking for sculptural equivalents for Abstract Expressionism fixed their attention elsewhere, on sculptors such as Seymour Lipton, Theodore Roszak, Ibram Lassaw and Reuben Nakian. Lipton is the one with the closest links to what was happening in Europe at the same period. He was without formal art training (he began as a dentist, like a number of other American sculptors working at this time), and, after a period as a carver, turned to cast, then to forged and welded metal. His most typical sculptures are

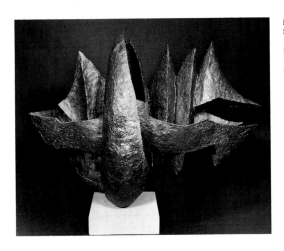

**55. Seymour Lipton:
Sea King**
1955. Nickel-silver over monel
metal, 30½ × 42 × 20 in
(75 × 108 × 51 cm). Buffalo,
Albright-Knox Art Gallery

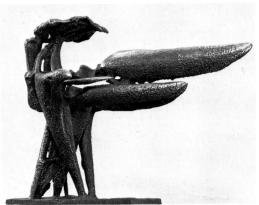

**56. Theodore Roszak:
Whaler of Nantucket**
1952–3. Steel, 34½ × 45¾ in
(88 × 116 cm). Chicago, Art
Institute of Chicago

made of sheets of monel metal fashioned into
curving shells and spirals, then coated with nickel
silver. The bird-of-prey imagery popular with
European sculptors such as Frink and César
reappears in Lipton's work, and in the 1950s he
also made abstractions based on the human figure.
The spiky, restless, baroque outlines of works such
as *Tower of Music* echo the forms which appeared
in Abstract Expressionist painting about a decade
earlier, when the painters were still in the process
of separating themselves from the Surrealism of
Roberto Malta and André Masson. As Lipton's
career demonstrates, the American sculpture
affiliated to Abstract Expressionism made its
appearance only when the movement in painting
was already at or even past its peak, and it never
took things as far as the painters were able to
do. The only sculptures which can be described
as fully Abstract Expressionist are certain late
works by celebrated painters – the extraordinarily
fluid figurative bronzes of Willem de Kooning,
and Barnett Newman's strange and not wholly
successful attempts to translate his 'zips' into
three dimensions.

Theodore Roszak, whose work is closely com-
parable to Lipton's, wavered between Surrealism
and Constructivism during the earlier years of his
career. During the early and mid 1940s Con-
structivism had the upper hand. From 1946
onwards Roszak began to work in a more
Expressionist idiom, using welded steel and bronze
to make jagged, quasi-organic forms which, like
Lipton's work, echo what the Abstract Expression-
ist painters did before their style was fully formed.
Roszak's work often has a somewhat rhetorical
air – his style in the 1950s is summed up by one
of his best-known works, the *Whaler of Nantucket*
now in the Art Institute, Chicago.

Ibram Lassaw, another member of the group,
began producing abstract sculpture in the 1930s,
one of the first American artists to do so – just as
he was one of the first American sculptors to make
regular use of welding. Lassaw's earliest welded
sculptures date from 1936. He was one of the
founder members of the American Abstract artists
group, and served as its president from 1946–9.
Despite his prominence in New York artistic
circles, Lassaw developed slowly; he did not hold
his first one-man exhibition until as late as 1951.
The typically open, grid-like structures of works
such as *Untitled* (1958) are a rather literal attempt
to reproduce in three dimensions certain paintings
by Jackson Pollock and Mark Tobey where an
intricate tracery of markings floats in front of an
indefinite background. The comparison with
Tobey is especially apposite, as both he and
Lassaw were deeply influenced by Eastern phil-
osophy. Lassaw's sculpture demonstrates, even
more clearly than that of Lipton and Roszak, the
limitations imposed by trying to render one form
of art in terms of another, whose rules are in fact
quite different.

Though also in the broad sense a painterly
sculptor, the late Reuben Nakian produced work
which was much more complex in its references
and therefore more interesting. Like many Amer-
ican artists of his generation, his career flowered
late. Born in Long Island in 1897, he received a
thorough academic training at various New York
art schools, among them the Art Students' League,
in the years immediately preceding the First World
War. He then served an apprenticeship with Paul
Manship, the chief exponent of the Deco style in
American sculpture, and during the early 1920s
shared a studio with Gaston Lachaise, whose vol-
uptuous female nudes left a permanent mark on
his own work. In the mid 1930s Nakian got to

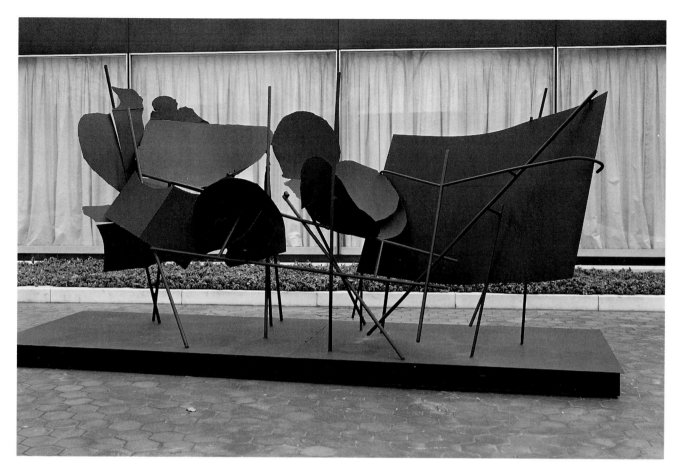

**57. Reuben Nakian:**
**Mars and Venus**
1959–60. Steel,
84 × 180 × 72 in
(213 × 483 × 183 cm). Buffalo,
Albright-Knox Art Gallery

know Willem de Kooning, Arshile Gorky and Stuart Davis, and these three leading painters led him in the direction of European modernism. Sculpture in clay was popular during the New Deal years in America, both because the medium was cheap and because it had a 'popular' accent; but Nakian did not begin working regularly in terracotta until the late 1940s. The small-scale pieces he produced then – goddesses, nymphs, cupids and animals – show the impact of Wiener Werkstätte ceramicists such as Valli Wiesthieler, who had settled in the United States during the 1930s and spawned a whole new movement in the American Arts and Crafts. Wiesthieler's work was liked for its charm and wit; Nakian's mythologies share these qualities and have a freedom and directness which enlarge the scope of what Wiesthieler and her closer followers produced. Their brimming good humour does not conceal Nakian's respect for the great themes of classic European art.

Nakian's chief period of technical inventiveness came in the mid 1950s. Like Lassaw, he was attracted by the vitality of the new American paint-

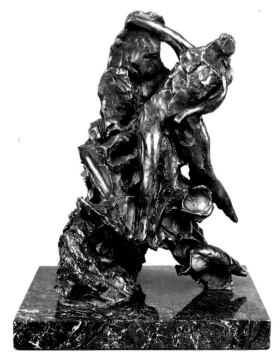

**58. Reuben Nakian: Europa**
**with Dolphin**
1969. Bronze on marble base,
ht. $11\frac{3}{4}$ in (30 cm). Private
collection

ing of the time, but it took him some time to devise an equivalent in sculpture. His method was to spread thin coats of plaster over cloth which was then attached to an armature of steel pipes and wire mesh. The resultant model could be cast in bronze. The billowing, baroque forms thus achieved do have some of the sweeping energy of Abstract Expressionist brushwork. In the late 1950s Nakian also produced some ambitious abstract constructions in which curved steel plates were attached to a complex framework of metal pipes. These pieces look both forward and back. The technical formula Nakian devised skips over the work of David Smith (to be treated in the next chapter) and is close to that adopted by some of Smith's English disciples, such as Tim Scott. But, subjected to formal analysis, the sculptures themselves turn out to be arrangements of overlapping planes in which a painterly impulse seems to overpower a more purely sculptural one. After producing these experimental works Nakian reverted to the classical themes which had attracted him in the 1940s. A series of small bronzes created in the late 1970s, using subjects such as *Leda and the Swan* or the *Birth of Venus*, reveal him at his most attractive. Unlike the majority of post-war sculptors, his work is often at its happiest on a small scale.

# DAVID SMITH AND THE NEW AMERICAN SCULPTURE

The most important American sculptor of the post-war period was David Smith, but it took him a considerable amount of time to establish a major reputation. When he did so, the effect on modern sculpture, not only in America but throughout the world, was tremendous. Smith was born in 1906 in Decatur, Indiana. His father was a telephone company official and his mother, the stronger character of the two, a school teacher. As a child he showed no particular aptitude for art, though he was fascinated by mechanical things. However, in addition to the usual high-school course, he did mechanical drawing for two years, and this seems to have awoken a slumbering interest in art. Smith went to university, but was unhappy there. At the end of his freshman year he spent a summer working at the Studebaker plant in South Bend, Indiana, and this experience made a deep impression on him – forever afterwards he identified himself with American industry and the American blue-collar worker. He dropped out of university and made his way to New York, where he enrolled in the Art Students' League: a classic mode of entry to the New York art world. There he studied intermittently for five years, but had not as yet decided that his true vocation was sculpture rather than painting. He met the Russian emigré painter John Graham, who showed him illustrations of Julio Gonzalez's welded sculptures. These inspired him to try the same technique himself, and when his landlord objected to him doing work of this kind in an apartment he moved round the corner to a local iron works, where once again he savoured the working-class cameraderie around him. He travelled to Europe, introduced and guided by Graham, visiting France, Greece and the Soviet Union, then returned to New York and worked as a sculptor on the Federal Art Project.

For Smith, as for many American artists who came to prominence after the Second World War, the 1930s were a prolonged period of experiment, partly financed by public funds. He tried a number of different styles, based on European Constructivism and Cubism. He was modestly successful: he had a one-man show in 1939, and two more in 1940 – the year in which he decided to move away from New York and base himself at Bolton Landing, a resort village near Lake George which he had been visiting almost every summer since the late 1920s, and where he already owned a piece of land. At first his finances did not allow him to live there permanently. During the war years he worked as a machinist then as a welder in the American Locomotive Company plant at Schenectady, which was producing tanks as well as locomotives. When he settled full time at Bolton Landing in 1944 he entered a highly prolific period. Many of the pieces still have derivative elements. Cage-like and box-like structures seem to refer to Giacometti's universally influential *The Palace at 4 a.m.* References to Miró can be seen in *The Garden* (*Landscape*) of 1949, and some sculptures, such as the *False Peace Spectre* of 1945, use the bird-of-prey motif so popular at the time. The finest works of this period are concerned with landscape – they are, in effect, brilliantly free and inventive landscape drawings in space. Two of the most effective are *Forest* of 1950 [Col. Pl. 14] and *Hudson River Landscape* of 1951.

By the early 1950s Smith had deservedly built up a considerable reputation in America. He had twice held Guggenheim Fellowships, was a well-known teacher and lecturer, and in 1953 had been represented by six works in the important travelling exhibition which the Museum of Modern Art sent to Europe. This played an important role in establishing the international reputation of the American post-war school. In 1957 MOMA gave him a retrospective, and in 1958 his sculpture was shown in the Venice Biennale. During this decade his work grew steadily simpler and more monu-

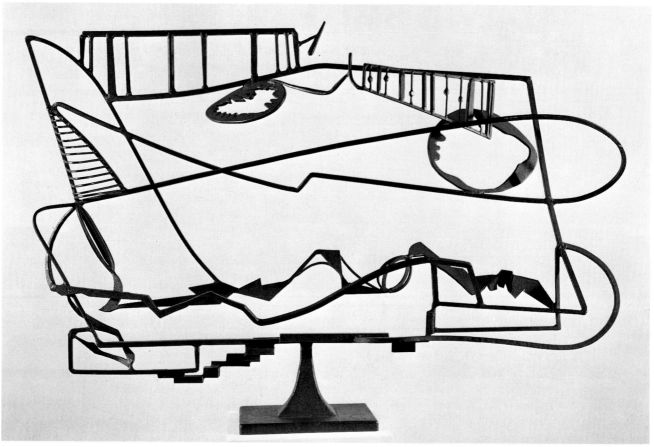

mental, but the real change did not come until the beginning of the 1960s. In 1961 Smith embarked on the *Cubi* series. These were huge pieces made of stainless steel. As the American critic Barbara Rose remarks, they 'give full play to three-dimensional volume, basing the relationships and epic scale on architecture rather than the human figure'. The *Cubi* sculptures undoubtedly juggle effortlessly and majestically with cubes and beams of polished metal, but arguably Smith also lost something by taking this new tack. Certain effects of scale and mass were now within his reach, but there was a loss of metaphorical suggestiveness and a cooling of the emotional temperature. The permutations he found for his ready-made parts were almost endless, but the materials remain ready-made parts none the less, and the artist has to be content to play with what is 'given', rather than constructing forms completely afresh.

The same criticism can be made of the other series of monumental sculptures which Smith embarked on subsequently – the *Voltri-Bolton* group and *Zig*. The *Voltri* pieces, begun in 1962, were a characteristic enterprise [Col. Pl. 15]. In

**59. David Smith: Hudson River Landscape**
1951. Steel, 49½ × 75 × 16¾ in (125 × 190 × 42.5 cm). New York, Whitney Museum of American Art

**60. David Smith: Cubi XXVII**
1965. Stainless steel, 111½ × 87¾ × 34 in (339 × 223 × 86.5 cm). New York, Solomon R. Guggenheim Museum

*Opposite*
**61. David Smith: Zig II**
1961. Steel, 100½ × 59¼ × 33½ in (255 × 150.5 × 90 cm). Des Moines, Iowa, Des Moines Art Center

that year the artist was invited by the Italian government to make sculptures for the Festival of Two Worlds at Spoleto. To save shipping costs, it was arranged that they should be made in Italy. David Smith went to Voltri, near Genoa, and factories, tools, machine parts and a work crew were put at his disposal. Within a month he had created twenty-seven massive sculptures. The series was later continued at Bolton Landing. Smith's combination of fecundity and rapidity aroused huge admiration at the time – but so, too, in a different age did rather similar qualities in second-rank Baroque artists like Luca Giordano, whose brush galloped over a vast acreage of walls and ceilings to the astonished applause of his contemporaries. Later, Giordano was condemned for superficiality.

The *Voltri* series differed from the *Cubi* sculptures because it assembled found rather than newly-manufactured materials. The procedure was not new in Smith's work – he had employed items of industrial scrap for quite a long time previously. Nor was it novel in more general terms, as one can see from the early work of César. But techniques of this sort now became an important focus for sculptural activity. In 1961 the Museum of Modern Art organized an exhibition called *The Art of Assemblage* with an influential catalogue written by William C. Seitz, and 'assemblage' duly became a vogue-word among art critics. In Smith's hands assemblage led to an unexpected conjunction between Cubism and Surrealism – this, indeed, is one of the reasons for his importance. Surrealism had been hostile to the whole notion of plastic values; forms and images were valued for their emotional suggestiveness, not for weight, shape or relationships between themselves. Classic Surrealism conjoined objects purely for their emotional power, not their formal appropriateness. Smith did not ignore the associations of the material he used; he prided himself on being an artist who expressed the nature of America's industrial civilization. But formal relationships played a preponderant part in what he did, especially in the late work, and these, as is evident from the *Cubi* sculptures in particular, were derived from Cubism.

At the same moment a number of other American sculptors were applying assemblage techniques to industrial scrap. The two most interesting, though they are minor artists in comparison to Smith, are Richard Stankiewicz and John Chamberlain. Stankiewicz, born in 1922,

**62. Richard Stankiewicz: Our Lady of all Protections**
1958. Iron, steel, 51 × 31 × 32 in (130 × 79 × 81 cm). Buffalo, Albright-Knox Art Gallery

belonged to a much younger generation than Smith. His first sculptures were produced while he was still serving in the Navy during the Second World War. After the war he studied with the Abstract Expressionist painter Hans Hofmann, and then in Paris with Fernand Léger and Ossip Zadkine. Despite the sophistication implied by this background he tended to stick very closely to his originally narrow impulse, which was to redeem and transform industrial detritus. His sculptures nearly all have a figurative impulse behind them.

Chamberlain's art was considerably more complex. Born in Indiana in 1927, he studied at Black Mountain College from 1955–6 and came into contact with the most ebullient and original part of the American avant-garde at that epoch. His most typical sculptures are, like César's *Compressions*, made from wrecked automobiles, but Chamberlain uses the material in a billowing baroque fashion that can remind one of Nakian [Col. Pl. 16]. The metal surfaces, still wearing their original paint, heave and surge in a way that prompts comparison with Abstract Expressionist painting. But if Chamberlain is an Abstract Expressionist he is extremely belated. His first one-man show was not held till 1957, and his first exhibition in New York did not take place until 1960. Essentially what he did was to find a convincing solution to a problem which was on the brink of becoming irrelevant – that of translating

*Opposite*
**63. Louise Nevelson: Sky City**
1957. Wood, 27½ × 23⅝ × 4¾ in (70 × 60 × 12 cm). Private collection

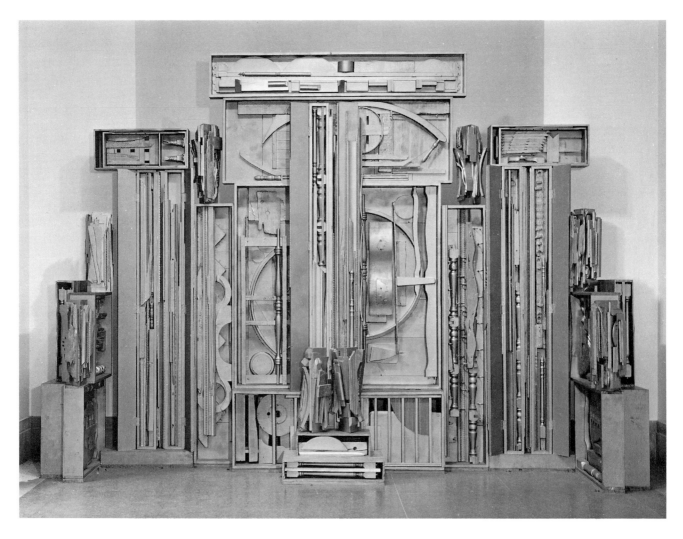

the Abstract Expressionist style into three dimensions.

Louise Nevelson, the most celebrated female sculptor in the history of American modernism, can also be connected to this group of assemblagists, though her characteristic material is wood rather than metal, and architectural and domestic rather than industrial. Born in Kiev in 1899, she moved with her family to the United States in 1905, marrying and settling in New York in 1920. She first studied painting at the Art Students' League and at Hans Hofmann's school in Munich, which she attended when she visited Europe in 1931. Her first sculptures were primitivist figures inspired by the African art she saw on this European visit. She worked for the WPA (Works Project Administration) Federal Art Project during the 1930s, and achieved limited recognition through regular exhibitions in New York, but she did not begin making constructions of archi-

**64. Louise Nevelson: An American Tribute to the British People**
1960–4. Wood, 122 × 171 × 46 in (305 × 434 × 117 cm). London, Tate Gallery

tectural elements until the 1950s.

The practical starting point for this new phase of her work was provided by the immense energy of the New York building industry, then busy tearing down and replacing large numbers of nineteenth-century brownstones. In works such as *Sky City* of 1957 Nevelson recycled pieces of moulding, laths, discarded balusters, chunks of wood randomly joined together, all taken from buildings which had fallen into the hands of the wreckers. These discarded parts were assembled in shallow trays or boxes, in a fashion which may have owed a little to the work of Joseph Cornell. But Nevelson was more ambitious than Cornell – she saw that her boxes could be put together to form larger sculptures which often took the form of walls or screens. The busy surfaces were unified by being painted a single hue – at first either black or white, as in *Dawn's Landscape XXI*, though later Nevelson experimented with gold.

Carter Ratcliff well summarized the effect of Nevelson's work when he wrote in a 1981 catalogue introduction:

Nevelson's works are congeries of echoes, conflations of half-recalled memories. Whether found or manufactured, each of her sculptural bits or collage pieces hints at another life. One feels the auras of other times or places, intangible energies Nevelson has commandeered for her art . . . Nevelson attempts to impose meaning on the chaos of her past, which was often a very difficult period. This effort must be made in a symbolic manner, if it is to count as art.

Another woman sculptor to whom recognition was even slower in coming than it was to Nevelson was Louise Bourgeois, born in France in 1911. Bourgeois studied mathematics at the Sorbonne, and later attended various art academies in Paris. She did not settle in America until 1938. One reason why her work failed to attract attention was its lack of an immediately recognizable signature style such as Nevelson achieved with her architectural collages. Bourgeois' sculpture varied widely in appearance in response to the meanings she wanted to convey. These meanings were themselves convoluted: works such as *Nature Study* are a blend of eroticism, depth psychology and a fascination with the mathematics of topology, a science in which there are no rigid bodies, no fixed

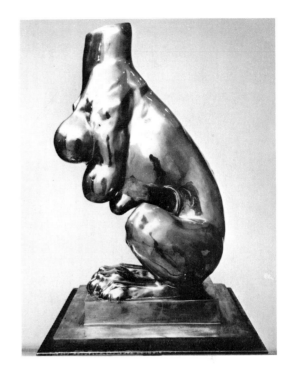

**65. Louise Bourgeois: Nature Study**
1984. Bronze, 30 × 19 × 15 in (76 × 48 × 38 cm). London, Serpentine Gallery

relationships and therefore no consistency of form. The experiments Bourgeois made with unconventional materials such as latex make her one of the obvious predecessors of Eva Hesse. She has also been seen as an influence on American sculptors otherwise as different from one another as Charles Simonds and Jonathan Borofsky.

# THE REVOLUTION OF THE 1960s

Stankiewicz, Chamberlain and Nevelson can be thought of as artists who pursued parallel paths to David Smith rather than being directly influenced by him. His work exercised greater direct influence in Britain than it did in his own country, through the British artist Anthony Caro. Caro, born in 1922, had worked as one of Henry Moore's assistants. His early sculpture was figurative – female nudes with heavily textured surfaces, in a style linked to that of the other British sculptors of the 1950s who were his contemporaries. In 1950 Caro went to the United States and met David Smith, and in addition he met the influential critic Clement Greenberg, one of the most passionate supporters of Abstract Expressionism and later the virtual inventor of its successor style, Post Painterly Abstraction, practised by artists such as Morris Louis and Kenneth Noland. Under the influence of what he had seen and heard in America, Caro began making large steel constructions. A key work symbolizing this change

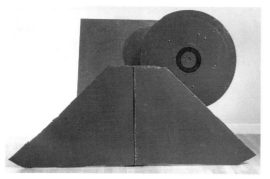

**66. Anthony Caro: Twenty-Four Hours**
1960. Acrylic on metal supports, 54½ × 88 × 33 in (138.5 × 223.5 × 84 cm). London, Tate Gallery

of direction is his *Twenty-Four Hours* of 1960. Greenberg was later to say that 'the far out as an end in itself' made its appearance in the work Caro produced during this crucial year. Greenberg continued: 'But it came to him as a matter of experience and inspiration, not of ratiocination, and he converted it immediately from an end into a means – a means of pursuing a vision that required sculpture to be more integrally abstract than it had ever been before.'

One of the things Greenberg particularly noted in Caro's work was the absence of a base or pedestal, which marked an immediate break with the tradition of Henry Moore. The forms of pieces such as *Early One Morning* are freely improvised from sheet steel, I beams, mesh and other industrial materials. Though the new sculptures Caro was producing were very large, they were not dependent on the presence of nature and certainly not intimately related to it after the fashion of sculptures by Moore. They seemed to make their greatest effect when they were shown in enclosed spaces, as this situation allowed their function as space modulators to appear at its purest and most powerful. Their separation from nature was emphasized by the bright colours in which they were often painted [Col. Pl. 25].

Though Caro did not uproot himself completely from England, he spent a great deal of time in America after his initial breakthrough. He taught sculpture at Bennington College in Vermont in 1963–4 and again in 1965, and thereafter crossed the Atlantic once or twice each year. He became identified with the American art scene to an extraordinary extent, to the point where he was the sole British artist invited to take part in *American Sculpture of the Sixties*, an ambitious survey show organized by the Los Angeles County Museum of Art in 1967. No one seems to have remarked on the anomalous nature of his inclusion. At the same time he continued to teach in England, at the St Martin's School of Art in London, where he remained active until 1967. A whole new generation of British sculptors grew up there under his influence.

Caro's later development has been unexpected. He returned to the use of the pedestal in a slightly clandestine way, by making a series of small-scale table pieces, where the viewer was required to think of the table-top as a kind of floor in its own right, rather than as something which raised an object off the floor. Then in the later 1970s Caro started making sculptures cast in bronze. These were of moderate scale, and combined what were

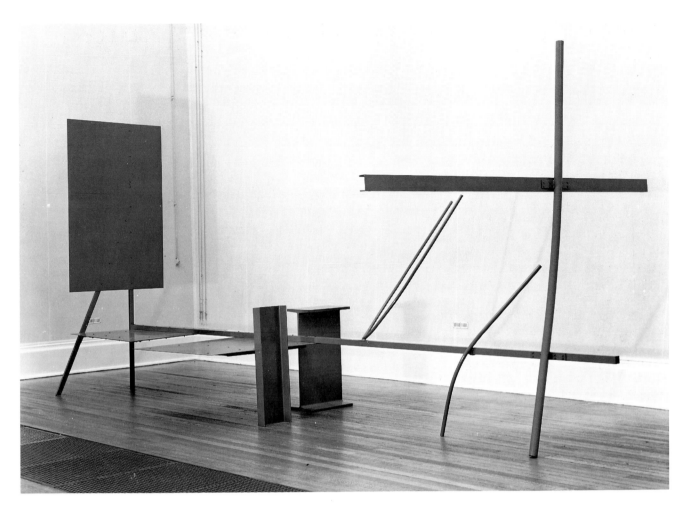

evidently metal armatures, somewhat in his old style, with found elements such as earthen chimney pots and plastic washing bowls, all of them transmuted but still perfectly recognizable after the sea change of the casting process. These new pieces were often shown on low bases, though these were not integral to the sculpture itself. Later still, in the 1980s, Caro startled his admirers by reverting to figurative sculpture – nudes of the type he had been making at the beginning of his career.

The emergence of a new group of British sculptors was signalled by an exhibition called *The New Generation* held at the Whitechapel Art Gallery in London in 1965. This survey show followed an exhibition held two years previously that had made the British Pop artists known to a broad public. Because this was its context, it was assumed by many reviewers that the work they were now confronted with was in some way a three-dimensional equivalent of Pop. In fact, as the introduction to the catalogue made plain, its lineage came directly

**67. Anthony Caro:**
**Early One Morning**
1962. Painted metal,
114 × 244 × 132 in
(290 × 620 × 335 cm). London,
Tate Gallery

**68. Anthony Caro:**
**Midnight Gap**
1976–8. Private collection

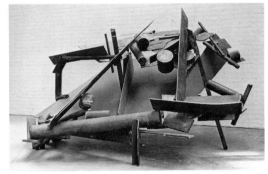

from Caro, David Smith and the Post Painterly Abstractionists in America.

Compared with Caro's work, that of his followers seemed considerably lighter and more frivolous. This was due in part to a difference in materials. Painted sheet metal was still in evidence, but so were fibre glass, polyurethane, glass, hardboard and wood. In fact, the sculptures included in the exhibition were made of all the materials normally used in commercial display work.

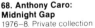

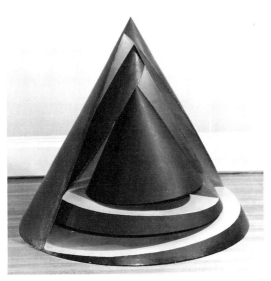

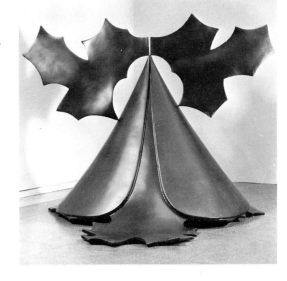

**69. Philip King: And the Birds Began to Sing**
1964. Painted metal,
71 × 71 × 71 in
(180 × 180 × 180 cm). London,
Tate Gallery

**70. Philip King: Genghis Khan**
1963. Fibre glass and plastic
with steel support,
41 × 56½ × 34½ in
(104 × 144 × 88 cm). London,
Tate Gallery

The sculptures most remarked about in the exhibition were undoubtedly those by Philip King. Particularly praised were the baroque exuberance of his *Genghis Khan*, made of fibre glass and suggesting an oriental figure wearing a robe and sporting a pair of sweeping wings, and the witty insouciance of *And the Birds Began to Sing*, with several cutaway cones in metal, one inside the other. These exhibits did not much resemble his later work, and such *jeux d'esprit* soon gave way to a much more serious, sometimes indeed rather

dour, architectonic sculpture which sometimes seemed almost indistinguishable from the work Caro himself was producing. King nevertheless established himself as an artist of international stature.

Another sculptor who was to have a remarkable career was the most intellectual of the group, William Tucker. Tucker's contributions to the exhibition partook of the general ethos of the mid 1960s. Slightly restless in outline, his sculptures look like enlarged versions of the puzzles pro-

**71. William Tucker: Gymnast III**
1984–5. Plaster,
90 × 60 × 33 in
(239 × 152 × 84 cm). New York,
David McKee Gallery

**72. William Tucker: Persephone**
1964. Painted plastic and
aluminium, 71 × 54 in
(180 × 137 cm). Minneapolis,
Walker Art Center

gressive parents give their children as an aid to the learning process. But the guiding principle underlying the shapes chosen is an interest in making logical permutations on one basic form. Tucker's *Anabasis I* of 1964 was made up of three Maltese crosses with rounded ends. One of these was three-dimensional but squared off in section; one was smoothly rounded; the third was a flat, transparent sheet. In the later 1960s and early 1970s Tucker proved himself to be an acute analyst of contemporary sculpture. He published an important series of articles in *Studio International*, and in 1974 a book entitled *The Language of Sculpture*. These analytical studies, combined with a move from Britain to North America, made his own sculptural procedures considerably less rigid than they had been, and recent work such as the *Guardian*, *Victor* and *Gymnast* series has consisted of simple, subtly organic shapes, with the emphasis placed on the form itself rather than on its relationship to neighbouring form.

More typical in its development was the sculpture of Tim Scott. *Peach Wheels* of 1961–2 is characteristic of his first phase – an arrangement of forms, with a large pair of simplified wheels and a smaller one separated by a vertical sheet of glass. The hue chosen for the wheels marks the connection with advertising design and display. There followed pieces such as *Bird in Arras* of 1969,

**73. Tim Scott: Peach Wheels**
1961–2. Mixed media, 48 × 54 × 36 in (122 × 139 × 91 cm). London, Tate Gallery

which consists of sheets of plastic fastened to steel tubes. These made a somewhat lightweight effect, both physically and in terms of content. Scott, apparently sensing this, reverted to a much denser kind of work in welded steel. But these later sculptures reveal their dependence on Caro all too clearly. With few exceptions, William Tucker most conspicuous among them, Caro's followers have been unable to break out of the confines of the idiom he established. Even after he left St Martin's his immediate disciples continued to teach there, and the school turned out several generations of young sculptors, all from much the same mould. At group exhibitions their works were more or less indistinguishable from one another. The breakthrough heralded by Greenberg in the 1960s thus, in the strictest sense, turned out to be a dead end, and Caro's own sudden reversion to figurative sculpture may be read as an acknowledgement of this.

There is, however, another way of looking at the development of sculpture during the late 1950s and early 1960s. What David Smith did with sculpture, and what Caro in turn made of Smith's achievement, marked an important shift in the centre of gravity. Sculpture had throughout the post-war years taken second place to painting. Now the hierarchy was reversed. Sculpture became the point of reference, and (to change the metaphor) was regarded as the arena for everything truly innovative. In time this development was to be carried so far that almost every form of extreme avant-garde activity would insist on describing itself as 'sculpture', to the confusion of the lay public.

**74. Tim Scott: Bird in Arras VI**
1969. Painted steel and plastic, $106\frac{1}{4} \times 114\frac{3}{4} \times 85\frac{3}{4}$ in (270 × 291.5 × 218 cm). London, Tate Gallery

At the same time there was a cultural shift as well as a purely stylistic one. The work of David Smith can be traced to its ultimate source in Julio Gonzalez, who exercised a quite specific, fully acknowledged influence on the development of the American artist. But there was, nevertheless, a crucial difference between the two men. Gonzalez's work refers to an artisan tradition that, in his native Barcelona, can be traced back to the Middle Ages and that still exists, though in attenuated form, in many parts of Europe. Smith, as I have noted, was very conscious of the fact that he was a sculptor working in an industrial context. The industrial aspect of their work was something which his American and English colleagues and followers took for granted, though sometimes their enthusiasm for new 'technological' materials led them astray. One reason why the British sculptors of the post-Caro group abandoned fibre glass, which they had initially taken up with much enthusiasm, was that they found its colours tended to fade. Ephemerality was one aspect of modern industrial design which they were not prepared to welcome.

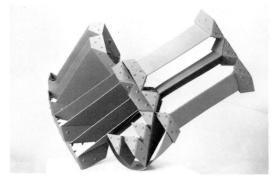

ment. Another artist who has been given less than sufficient credit for anticipating major developments in the 1960s is the Dane Robert Jacobsen. Self-taught, Jacobsen was born in 1912, and by the late 1940s he was producing highly original forged metal sculptures. These received a good deal of exposure in the survey exhibitions of the immediately post-war period, and still look interesting and quirkily original today. Jacobsen dropped from view because he belonged to a small country and was working in an off-centre style. The makers of reputations in the post-war art

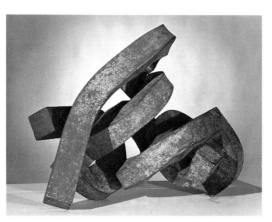

However, the general emphasis on industrial aspects inevitably placed the mainstream of sculptural development in those countries that were highly industrialized – in Britain and, most of all, the United States. Countries where the artisan tradition was still strong tended to produce work which looked slightly peripheral. This is true even of artists of the quality of the Spaniard Eduardo Chillida and the Colombian Edgar Negret. Their work in the 1950s anticipated some of the main developments of the 1960s – Negret even made use of industrial components. But, compared to Caro, both look over-polished technically and perhaps a little timid in terms of formal experi-

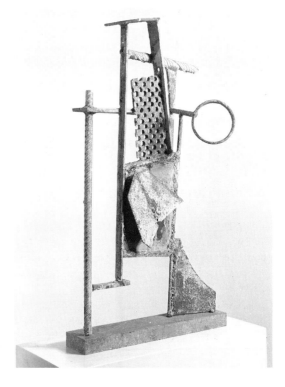

world – the directors of major museums of modern art and the organizers of large thematic exhibitions – have found it increasingly difficult to make room for artists of this type.

# POP, NEW REALISM AND SUPER REALISM

The sculpture described in the last two chapters was sometimes presented as an answer to Pop, which was at its beginnings, and indeed for long afterwards, a style which attracted collectors and social commentators but which was greeted with scorn by many leading critics. One reason for their dislike was that Pop seemed a kind of *trahison des clercs*, a betrayal of modernist intellectuality. Yet Pop was not an art style without an ancestry, nor did this ancestry consist entirely of images taken from urban mass-culture. It grew out of Dada, and in America its appearance was prepared by

by the original Surrealists during the inter-war period, it would look perfectly at home if placed beside Salvador Dali's notorious lobster-telephone.

Johns's sculpmetal *Flashlight* and *Lightbulb* of 1968 and his slightly earlier painted bronze ale cans come much closer to the ready-mades of Marcel Duchamp than they do to Surrealist assemblages. In particular they prompt a comparison with Duchamp's notorious *Bottle Rack* of 1914. But they do not reflect an identical process of thought. Duchamp's aim was to ask questions

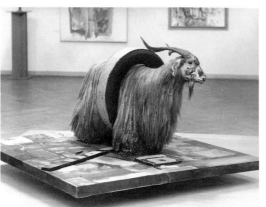

**78. Robert Rauschenberg: Monogram**
1955–9. Stuffed painted goat, ht. 48 in (121 cm). Stockholm, Moderna Museet

**79. Jasper Johns: English Lightbulb**
1968–70. Metal, wire, polyvinylchloride, 5 × 3 in (12.7 × 7.6 cm). New York, Leo Castelli Gallery

the Neo-Dadist art of Robert Rauschenberg and Jasper Johns. While these two artists are primarily painters, each has produced three-dimensional objects in fair quantity.

Rauschenberg's *Monogram* (1955–9), a stuffed angora goat with paint on its nose, standing on a collaged and painted platform and with its body encircled by a car-tyre, is one of the icons of post-war art – an image which has left a small but indelible mark on the public consciousness. Rauschenberg himself seems inclined to categorize the piece as being on a par with other assemblage-paintings produced at the same period, but it does have an unmistakable kinship with objects made

**80. Jasper Johns: Ale Cans**
1964. Painted bronze, 3 × 6 × 2 in (7.6 × 15.2 × 5.1 cm). New York, Leo Castelli Gallery

about the nature of art, while leaving the answers entirely to the judgement of the spectator. He confronted his audience with an object whose associative and formal qualities were apparently nil, but which by means of a simple change of context (hardware store to art gallery) seemed to acquire them. Was the change, Duchamp asked, purely a temporary illusion? Johns, on the other hand, subjects the found object itself to change – his *Flashlight* is transmuted into a different material; the ale cans are not real ale cans but are re-created in painted bronze. The style of the painting is particularly significant, since the design and lettering of the labels, while remaining perfectly recognizable, are given a subtly hand-made look. Far more than the *Bottle Rack*, these are art in a perfectly traditional sense, since the business

of art has long been transmutation – living flesh into marble, for instance. Johns asks a more specialized question than Duchamp: when does art cease to be art and take its place in the banality of the ordinary world?

The artist who came closest to Duchamp among the post-war Americans was neither Rauschenberg nor Johns but Andy Warhol, with his meticulously reproduced Brillo boxes and Campbell's Tomato Juice cartons. These can be, until actually touched or handled, indistinguishable from the originals. One underemphasized aspect of them is that the environmental works made using these imitations, such as Warhol's installation at the Stable Gallery in New York in 1964, are links between Dada and Pop on the one hand and Minimal Art on the other.

**81. Andy Warhol: Brillo**
1964. Silk-screened wood,
17 × 17 × 14 in
(43.2 × 43.2 × 35.6 cm). New
York, Leo Castelli Gallery

When at its most characteristic, however, Pop was more inclusive, positive and exuberant than its Dadaist pedigree might suggest. A number of artists connected with the Pop movement in America produced three-dimensional work, though there was little or no Pop sculpture of importance in Britain. In some cases what they did was clearly dependent on the painting which was the artists' primary product. Roy Lichtenstein's sculptures and cut-outs, for example, have little independent existence when viewed in isolation from his painted work. They do nevertheless raise interesting questions about the nature of sculpture. Lichtenstein has in recent years been especially fascinated by the problem of giving concrete existence to phenomena which are by their very nature elusive – for example, the rays of light streaming from a table lamp or the water shimmering in a glass. Using the comic-strip convention which he long ago adopted for his paintings, he employs the heavily drawn lines as the armature for open-work constructions [Col. Pl. 18]. These lines make no distinction between palpable and impalpable, so the sculptural framework often, and paradoxically, consists of things which in life are evanescent – the ripple of a passing reflection in a mirror; the movement of liquid in a transparent container. In the last analysis, however, the structure remains pictorial. If the spectator shifts his or her viewpoint by even a few inches to one side or the other, the illusion dissolves into chaos.

There are, however, American Pop artists who have made the creation of objects in three dimensions a primary rather than a secondary activity. The two best known are Claes Oldenburg and George Segal.

Oldenburg made his New York debut in 1959 with fragile sculptures constructed from paste-soaked paper modelled on chicken wire. The results bore some resemblance to Dubuffet's *Art Brut* – they were expressionist and occasionally scatological. Oldenburg's next significant works were props created for his environmental exhibitions *The Street* and *The Store*. The second of these was a brash celebration of mass-consumerism for which Oldenburg made deliberately crude imitations of everyday articles. It was followed by an exhibition at the Green Gallery in New York in 1962 where he showed giant soft sculptures for the first time. These flouted the spectator's expectations in three different ways: by their subject-matter, by their scale, and by the

**82. Claes Oldenburg: Falling Shoestring Potatoes**
1965. Painted canvas, kapok, ht. 108 in (274.4 cm). Minneapolis, Walker Art Center

**83. Claes Oldenburg: Hamburger**
1963. Painted plaster, 6 × 6 × 6 in (15.2 × 15.2 × 15.2 cm). New York, Sidney Janis Gallery

materials of which they were made – painted canvas loosely stuffed with foam rubber and paper cartons. These pieces, among them *Falling Shoestring Potatoes* and the giant hamburger which became one of the emblems of the Pop movement and of which he also produced versions in other media, were inspired by the three-dimensional advertising signs familiar in America.

Following this, Oldenburg began to make ver-

sions of household fittings and domestic machines in vinyl. The forms were not merely soft but deliquescent — light switches and electric beaters thus took on an erotic aspect which would no doubt have surprised their original designers. In the mid 1960s the artist, who is a superb draughtsman, began work on a series of 'colossal monument proposals', fantasies involving grotesque enlargements of trivial objects. One of these fantasies was realized in the *Lipstick Mounted on Caterpillar Tracks* donated to Yale University by the artist and a group of students in 1969; the proposal had originally been to erect a giant lipstick to replace the statue of Eros in Piccadilly Circus, London. Oldenburg's monuments would, perhaps, have been better left on paper, where his drawing style imbued them with a glamour they did not necessarily possess in reality, but the increasing acceptability of Pop as a now 'historical' style produced opportunities in the 1970s and 1980s that had been refused to him earlier. Examples are *Giant Trowel* and the enormous *Stake Hitch*, an object symbolic of the state of Texas, which now dominates the atrium of the new Dallas Museum of Art.

Segal, unlike Oldenburg, deals directly with the human figure. He originally attracted attention because of his uniquely laborious way of creating his personages, which were cast from life by wrapping plaster-soaked bandages round the body of the model, cutting the resultant shell away once it was dry, and then re-assembling it. The Pop element in Segal's earlier work was its literalism — the white, doughy-looking figures were presented in carefully conceived settings, such as that of the city square [Col. Pl. 20], like actors on a stage.

As Segal's career has progressed, he has been drawn further and further away from the Pop ethos. Content has become increasingly important to him, and so has his own relationship with the art of the past. He has tackled biblical subject-matter, such as the legend of Lot and Jacob's dream; he has tackled political and social protest themes of a kind that would have interested American artists in the 1930s; fragmentary figures such as *Fragment: Lovers* pay an obvious tribute to Rodin; and he has experimented with still-life sculpture, with witty translations of some of Cézanne's compositions into three dimensions which expose the contradictions in the great painter's compositional set-ups. Originally Segal was not a truly public sculptor for one very practical reason: his work could not be placed outdoors

because it was not resistant to the weather. This problem has been overcome by casting some of his work in bronze, which is then sometimes patinated so as to resemble the original plaster. This technical concession has freed Segal to assume a role for which he is ideally suited – that of artistic spokesman for liberal causes. His current sculpture, warm, humane, and occasionally sentimental, is unique in America because of the ease with which it communicates to a wide, non-specialist audience.

**85. George Segal: Execution**
1967. Plaster, rope, metal, wood, 96 × 132 × 96 in (243.8 × 335.3 × 243.8 cm). Vancouver, Vancouver Art Gallery

**86. George Segal: Fragment: Lovers**
1970. Plaster, 25 × 16½ × 5 in (63.5 × 42 × 12.7 cm). New York, Sidney Janis Gallery

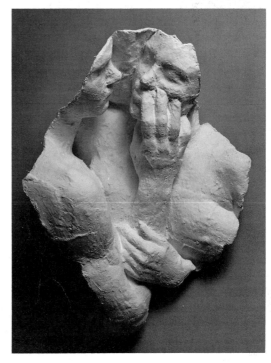

*Opposite*
**84. Claes Oldenburg: Giant Trowel**
1971. 144 × 46 in (365 × 117 cm). Otterlo, Rijksmuseum Kröller-Müller

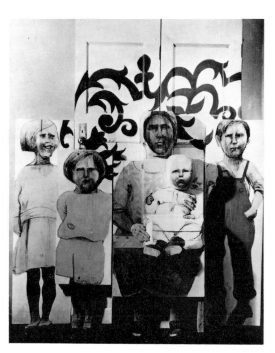

**87. Marisol (Marisol Escobar): The Family**
1962. Wood, 82½ × 65½ × 15½ in (208.3 × 166.4 × 39.4 cm). New York, The Museum of Modern Art

**88. Ed Kienholz: Five Card Stud**
1969–72. Kassel, Documenta (installation, 1972)

It is instructive to compare Segal's work with that of the Venezuelan artist Marisol who, during a period of residence in New York, found herself linked to the Pop Art movement. Marisol's figures are essentially caricatures, brilliantly clever evocations of contemporary personalities and types, carried out in a style which somehow evokes the fairground. These figures are usually a mixture of sculpture and painting, with painting perhaps predominant. The sculptured parts (heads and other details) add a sudden grotesque emphasis to the main design, which is painted on a series of wooden blocks. Marisol exploits the conventions of popular art, but makes little reference to urban mass culture (an essential ingredient in the work of Oldenburg), and does not explore the boundary between art and life, as Segal originally set out to do. Her nearest equivalent is Larry Rivers, who also occupies a peripheral position in relationship to the Pop sensibility, reinterpreting objects such as the Camel cigarette packet in a style borrowed

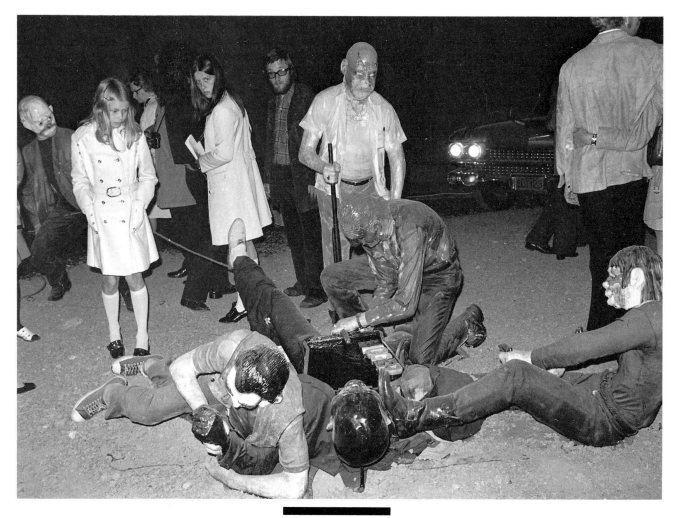

from Edouard Manet. The comparison of Rivers and Marisol is reinforced by the close resemblance in the seductive way they handle their materials.

Another sculptor sometimes associated with the Pop Art movement by its chroniclers is the West Coast artist Edward Kienholz. This is an error. Throughout the heyday of the style Kienholz lived in Los Angeles not New York, where Pop was based. When he left Los Angeles in 1973 he divided his time between Hope, Idaho, and West Berlin. Kienholz uses life-size figures in realistic settings, and this has inevitably prompted comparisons with Segal, though in most respects the two artists differ widely. Kienholz's personages are often monstrous hybrids, reality in the process of becoming metaphor. He is thus more like a traditional Surrealist. Much of his work is powered by a savage social indignation, which reaches a climax with *Five Card Stud*. This tableau showing a lynching in the American Deep South created a sensation at the Kassel Documenta of 1972. If

Kienholz has a strong Surrealist component, he also resembles the satirists of the Weimar period in Germany. Later assemblages, such as *Night Clerk at the Young Hotel* (1982–3), could be John Heartfield collages in three-dimensional form.

The makers of Pop objects and Pop tableaux were nearly all Americans. Even Britain, which had a parallel Pop movement of its own, did not produce three-dimensional work in any quantity. One exception to the rule was Allen Jones – like Roy Lichtenstein, primarily a painter. In 1965 he made a series of totemic self-portraits in painted wood and plexiglass; these are amongst the most abstract of his works. In 1969 he took a different direction and made a group of three realistic fibre-glass figures – females dressed in fetishistic leather accessories, which have since earned considerable notoriety thanks to the indignation they have aroused in the feminist movement. Each figure is conceived as an item of furniture, and to the feminists they seemed to be an emblem of female

**89. Allen Jones: Hatstand, Table, Chair**
1969. Fibre glass, leather, and hair, life-size, 72 × 30 × 24 in (184 × 76 × 62 cm). Aachen, Neue Galerie

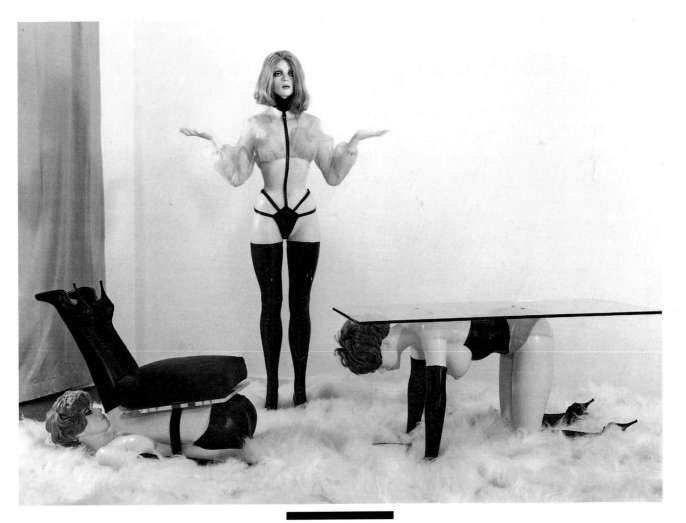

subjection and of continuing male violence towards women. The artist has denied that this was in any way his intention. According to the catalogue of the retrospective of his work at the Walker Art Gallery, Liverpool, in 1978, he saw himself as 'consciously working within a tradition of human figures as structural architectural elements which can be traced back at least as far as the Caryatids or the Erectheum in Athens.'

In France a different kind of sensibility prevailed during the 1960s. Its progenitor was Jean Dubuffet, whose own art was influenced by what he dubbed *Art Brut* – the 'raw art' of the untutored, especially children and the mentally ill. Dubuffet, born in 1901, took a long time to establish himself as a professional artist. His first success came only after the Liberation in 1944, but once his career was established there was no restraining his inventiveness. From painting, he branched out into the creation of three-dimensional objects – strange figures and heads made of clinker, sponge or charcoal, and later of metal foil, driftwood or papier-maché. In 1962 he began work on his *L'Hourloupe* series (the word was an invented name for a grotesque figure made of multi-coloured patches). In 1966 he began to make *L'Hourloupe* objects in painted styrofoam or polyester [Col. Pl. 22] and later still these developed into

sculptures, often of monumental size, in steel and fibre glass. Many of the works of this time invite comparison with Alexander Calder's *Critters*, as they are inspired by a similar sense of humour.

Dubuffet's deliberately garish sculptures seem to have been an important source of inspiration for an artist of a younger generation, Niki de Saint Phalle. Saint Phalle became well known in the 1960s for her *Nanas* – bloated humanoid creatures painted with dazzling patterns in primary colours which at first were often used to emphasize a joyous, carefree sexuality. These creations – the liberated great-grandchildren of Alfred Jarry's monstrous Père Ubu – were, like Dubuffet's sculptures, made in 'new' materials such as fibre glass, which seemed in tune with the spirit of the decade. In certain circumstances the artist had no objection to having her work mass-produced – the Nanas were also presented in multiple form as inflatable balloons.

Niki de Saint Phalle was a member of the group of Nouveaux Réalistes organized in the 1960s by the critic Pierre Restany. There were also other members who made three-dimensional objects. One was César, whose work has already been discussed. Another was Jean Tinguely, who is more conveniently included among the Kineticists. A more purely Dadaist strain is represented by Daniel Spoerri and Arman (Armand Fernandez), neither of whom really fits even the loosest definition of sculpture, though both made three-dimensional objects. Spoerri is best known for his *Tableaux-pièges* (trap-pictures) made from things such as a discarded breakfast tray in a hotel room. Every object, down to the empty shell of a boiled egg, is fixed in the position where chance placed it at the end of the meal. Arman, working in the tradition of Duchamp, made accumulations of everyday objects. The earliest of these were the

*Poubelles* (dustbins) of 1959 – random collections of debris shown in glass-sided boxes. Later, Arman made accumulations consisting of objects of a single category – half-squeezed paint-tubes, for example – embedded in plastic. He also used familiar objects sawn into strips – *Subida al Cielo* of 1962 features a bass viol [Col. Pl. 23]. Some pieces have been cast in bronze, and some accumulations of objects have been of monumental size – an example is *Long Term Parking* of 1982, a concrete monolith with scores of old car bodies embedded in it which adorns the headquarters of the Fondation Cartier, just outside Paris.

In the United States Pop Art spawned a successor movement, Super Realism, and this too produced a small group of sculptors. The two

most prominent are Duane Hanson and John De Andrea. Both use a version of the technique of life-casting pioneered by George Segal, but the results they obtain are very different from anything to be found in Segal's work. Segal's figures never pretend to be real human beings who might at any moment move and speak to us. They preserve the distance between art and life, however close they come to the barrier which separates the two. Hanson and De Andrea both make polyester resin figures using silicone rubber moulds. The casts thus obtained are pieced together and carefully painted to resemble life, and are provided with real hair and glass eyes. But though their technical methods are similar and though the result in each case is a startling and often deceptive lifelikeness,

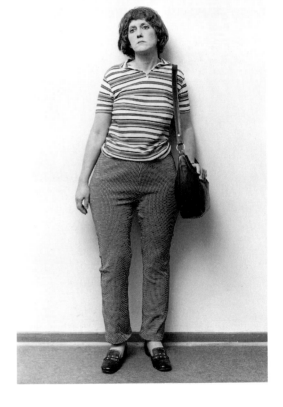

**93. John De Andrea: Standing Man**
1970. Polyester, fibre glass, life-size. New York, O. K. Harris Gallery

**94. Duane Hanson: Woman with a Purse**
1974. Polyester, fibre glass, life-size. Cologne, Museum Ludwig

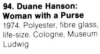

the two artists are very different in intention. Hanson is a sharp-eyed, mordant observer and social commentator. Some of his early work is as savage as that of Kienholz and tackles similar subject-matter. One can compare Hanson's *Race Riot* of 1967 with Kienholz's *Five Card Stud*. Hanson's seven-figure tableau has been separated and partially destroyed. Later works are less polemical but render contemporary individuals in society in all their unattractiveness – but not

without a certain sympathy for their fate in being what they are. The effectiveness of many of his works comes from the meticulous care with which he chooses and poses his models, and from his knack of choosing exactly the right clothing and accessories [Col. Pl. 21].

John De Andrea explores very different territory. His concern is with the gap between the real and the ideal. His subjects are invariably young and good-looking, and they are nearly always shown nude. At first the spectator is struck by the physical beauty of the figures, but then their immobility provokes one to assess the ways in which they differ from the rules of classical perfection. One of De Andrea's most effective statements on this theme is *Standing Man*, where he

shows a male figure in the pose made familiar by Greek Kouroi, and invites the spectator to make a point-by-point comparison between art and life.

A sub-department of American Super Realism is sculpture devoted to the theme of still life. This has especially attracted ceramicists, since glazed clay can be used to produce uncannily deceptive imitations of a very wide range of materials. One of the best-known ceramicists working in this field is Marilyn Levine, who specializes in replicating objects made of leather. Another, more various in what he attempts, is Victor Spinski, whose noisome trashcans in glazed ceramic have a startling verisimilitude. It seems reasonable to relate work of this sort to the well-developed American tradition of *trompe l'œil*, as exemplified in the work

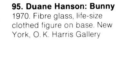

**95. Duane Hanson: Bunny**
1970. Fibre glass, life-size clothed figure on base. New York, O.K. Harris Gallery

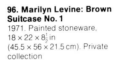

**96. Marilyn Levine: Brown Suitcase No. 1**
1971. Painted stoneware, 18 × 22 × 8½ in (45.5 × 56 × 21.5 cm). Private collection

of nineteenth-century artists such as William Harnett. *Trompe l'œil* is an essentially popular form of art addressed to an audience impatient with complex cultural references but perhaps disproportionately impressed by displays of technical skill. Super Realist still-life sculpture in glazed ceramic still seems to function in this way.

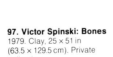

**97. Victor Spinski: Bones**
1979. Clay, 25 × 51 in (63.5 × 129.5 cm). Private collection

**98. Robert Graham: Lise II**
n.d. Bronze, 68 × 13¾ × 13¾ in
(172.7 × 34.9 × 34.9 cm). New
York, Robert Miller Gallery

An American sculptor peripherally connected with Super Realism, but becoming increasingly isolated stylistically as his career progresses, is Robert Graham. Graham began as a maker of tableaux featuring miniature wax figures, modelled with meticulous realism and housed under plastic domes. At the beginning of the 1970s Graham began to work in bronze. He provided his figures such as those in the *Lise* series with integral bases much larger than themselves, and they became reminiscent of Giacometti, who used the same device. But Graham was not tempted by Giacometti's distortions. His style moved towards a cool classicism, still with every detail in place. Over the years his nude figures have gradually grown larger, though they have never reached full life-size. For this reason alone they cannot be thought of as being 'realistic' in the sense that one applies that word to John De Andrea's nudes. Graham differs from De Andrea in other important ways. There is the classicism already mentioned, which comprises a subtle tendency to physical idealization. And though he paints the surface of his bronzes, rather than patinating them, he does not do so naturalistically. In addition, he is usually content to leave his nudes quite bald, though occasionally they are supplied with silk for hair.

Graham's work is perhaps the most complete expression in contemporary sculpture of the post-modern spirit now prevailing in architecture. Like the buildings designed by Michael Graves and his colleagues, the sculptures Graham produces are not afraid of making historical allusions. They refer to ancient Greek art and also (despite their classicism) to the statuettes of dancers made by Degas. The perfection of detail and surface fends off emotional involvement and invites the spectator to approach each piece as a deliberately considered intellectual statement – the kind of analytical response demanded by post-modernism in general.

**99. John Davies: For the Last Time**
1972. Mixed media, life-size.
Location unknown

The work of John Davies, the British sculptor, has links both with that of Robert Graham, and with that of orthodox American Super Realists such as Hanson and De Andrea, while at the same time retaining a very distinct personal flavour. Davies too, in his earliest work, made use of the life-casting technique as a way of making figures. His first one-man exhibition, at the Whitechapel Art Gallery in 1972, caused a sensation in the British art world because of its eerie power. The show consisted of figures shown singly and in groups, and also of single heads. The figures were clad in dark garments – something between a business suit and a concentration camp uniform. Strange masks, or 'devices' as the artist called them partially concealed their features. As at the 84 Biennale in Paris later that year, where Davies showed *For the Last Time*, the effect was haunting: it was like entering a dream or nightmare the artist had consented to share with his audience, offering no guarantee of escape. Subsequent shows have seen a stiffening and hardening of Davies's art. Like Graham he now often reduces his figures to miniature scale. And like Graham he has become interested in a kind of classicism – in the case of works such as *Four Figures* this is apparently derived from the conventions of Egyptian Old Kingdom sculpture. But while the heads (bald, like Graham's) remain impassive and immobile, the figures are often the very opposite – the figurines swing from trapezes or slither down a rope.

**100. John Davies: Four Figures**
1977–80. Mixed media, life-size. London, Marlborough Fine Art

There is a conflict of classic and romantic impulses in Davies's recent sculpture, which makes it seem a good deal less assured than his early work, but he remains one of the most interesting figurative sculptors now working in England.

# KINETIC ART

No post-war art movement has fallen from favour quite as drastically as Kinetic Art. To some extent it was the victim of a simple change of climate. The technological ethos of the 1960s, with its excitement both about technology as a thing in itself and about new, slickly designed consumer products, was replaced in the sour and dis-illusioned 1970s with an atmosphere hostile to technology and consumerism. Kinetic Art was also the victim of its own sudden success. As museums of modern art blossomed, it was seen as an ideal offering to the mass public whom these institutions hoped to attract. It was avant-gardism in a form which was guaranteed to be immediately enter-taining. Spectacular exhibitions – the most am-bitious was the *Lumière et Mouvement* show at the Musée d'Art Moderne de la Ville de Paris in 1967 – did indeed attract large numbers of spectators. But these visitors were often dis-illusioned by what they found. Having experienced the technology of the world outside, they found the technology of the museum was jejune and childish. Another factor, influential but less univ-ersally significant, was the developing geography of the world of contemporary art. Most of the leading Kinetic artists were Europeans or Latin Americans who based themselves in Europe. The increasing predominance of New York had become a sore point with European critics, and Kinetic Art was promoted, somewhat factitiously, as an answer to this – as a renewal of European creativ-ity. But it was essentially less radical than what was happening in America, and was thus easily swept aside by the rise of Minimal Art.

The movement had a mixed pedigree, and Kinetic artworks were often so widely different in intention that it did violence to their meaning when they were all thrust together in the same category. Taken as a whole, it was a late offshoot of Constructivism. Some of the original Con-structivists had in fact already experimented with works of art incorporating movement. One was Aleksandr Rodchenko, with a hanging construc-tion which consisted of a series of open rings,

**101. Sergio de Camargo: Relief No. 282**
1970. Wood, $26\frac{1}{2} \times 22\frac{1}{2}$ in (67.3 × 57.2 cm). London, Gimpel Fils Gallery

swivelling one inside the other. Another was Naum Gabo, whose vibrating rod of 1920 is generally considered the ancestor of all subsequent artworks incorporating motors.

The link with Constructivism was so strong that certain artists whose work had little to do with either real or apparent movement were swept up into the excitement about Kinetic Art. A case in point is the elegant Brazilian sculptor Sergio de Camargo. The compartmentalization of some of Camargo's works makes clear his relationship to the Uruguayan painter Joaquín Torres-García, one of the founders of the *Cercle et Carré* group in Paris in 1930, and later largely responsible for the propagation of Constructivist ideas throughout Latin America. Camargo is primarily a maker of reliefs in wood. He covers the surface thickly with small cylindrical forms sliced off at an angle, or fills it with a multitude of tilted rectangular planes. The result is to break up the unity of this surface and make it extremely sensitive to the slightest shift in light. Camargo himself sees his work chiefly as a focus for meditation, comparable with the

**102. Gunther Uecker:
Untitled (for Hannah)**
1963. Nails, canvas, plywood,
13¾ × 13¾ in (35 × 35 cm).
Private collection

**103. Jesus-Rafael Soto:
Cardinal**
1965. Painted wood,
chipboard, painted metal
rods, nylon threads,
61½ × 41¾ × 10 in
(156.5 × 106 × 25.5 cm).
London, Tate Gallery

background – the more we attempt to focus on them, the more immaterial they seem to become. But the works are scarcely three-dimensional, and are best regarded from a fixed viewpoint directly in front of them. Soto constructs physically the zone of 'shallow space' which first appeared in Cubist paintings and which can be found in works by painters otherwise as different from one another as Bridget Riley and Jackson Pollock.

liberation of the mind which we sometimes feel when looking at nature. He says: 'Perhaps what happens in my work is that it liberates, releases in whoever approaches it some diffuse emotion, something like what we occasionally experience in front of certain spaces or landscapes, or when we feel space, sound or the wind.' While Camargo's busy surfaces do tend to have an unfocusing effect, this is scarcely more pronounced than similar effects produced by the work of Louise Nevelson, and it is difficult to think of him as a true Kinetic artist, or even as one working in that branch of the style that relies on inducing the illusion of movement rather than upon movement itself.

Gunther Uecker, a member of the German Zero group (composed of himself, Heinz Mack and Otto Piene – they first exhibited together in Piene's studio in Düsseldorf in 1958) has also used broken-up surfaces to dematerialize the artwork and stress the visual energy it releases rather than its physical weight and presence. The means Uecker employs are very simple. He studs his surfaces with closely set nails that diffract the light and create inter-ference patterns. These nails make wall-reliefs, but Uecker has also used them on three-dimensional objects, such as a free-standing cube. Sometimes the reliefs take the form of spinning motorized discs, in which the physical movement intensifies the diffraction of light.

Camargo's fellow Latin American, the Venez-uelan Jesus-Rafael Soto, makes constructions where the optical effects are far more violent. His most typical works have rods and plates of metal suspended a little way in front of fine strings or lines. These forms are optically eroded by their

**104. Julio Le Parc:
Continual Mobile,
Continual Light**
1963. Painted wood,
aluminium, nylon threads,
63 × 63 × 8¼ in
(160 × 160 × 21 cm). London,
Tate Gallery

There is genuine three-dimensionality in the mobiles of the Argentinian Julio Le Parc. As in *Continual Mobile, Continual Light*, these often consist of small reflectors suspended from strings, which cast rays of light in all directions – this pattern of light, rather than the mechanism that produces it, constituting the work. But it is hard not to find effects of this kind trivial, almost on a par with the faceted mirror balls one finds in dance halls, spinning merrily above the dancers.

The Greek artist Takis pursues a different line, and is altogether a more substantial and interesting figure. He has yoked the idea of the work of art in movement to a Zen-influenced reductivism that can also be found in the work of Yves Klein.

**106. Takis (Panayotis Vassilakis): Signals**
1966. Metal. Multiple

**105. Takis (Panayotis Vassilakis): Silver Magnetic**
1970. Aluminium, diam. 12¼ in (31 cm). Zurich, Galerie Bischofsberger

simple to sustain the idea that they are models of the cosmos. They are, rather, witty demonstrations of the nature of certain well-known physical forces which would be admirably suited to enlivening a school science course.

Duchamp himself from time to time experimented with works incorporating movement, and Dada and Surrealism are also part of the background of the Kinetic Art movement. The Frenchman Pol Bury's constructions, for all their use of geometrical forms, are basically more Surrealist than they are Constructivist. The point about these objects is the stealthiness of the movement, which seems to try to escape the spectator's eye – to plunge him into a world where inanimate objects are secretly hostile and engaged in some kind of conspiracy against the human race.

Takis's sculptures are demonstrations of the power of usually invisible forces such as magnetism. A magnetic current will induce needles to defy gravity and hang quivering in a void; or an electro-magnet switched on and off will cause positively and negatively charged pendulums to perform a random dance. Takis's work attracted some of the leading avant-garde writers of the 1960s, among them William Burroughs. Gregory Corso and Allen Ginsberg, and these attached quasi-mystical meanings to his work. 'You hear metal think,' Burroughs wrote, 'as you watch disquieting free-floating forms move and click through invisible turnstiles.' Marcel Duchamp, one of the founders of Dada, also approved. In a characteristic phrase he called Takis a 'tiller of the magnetic fields'. The difficulty perhaps was, and is, that Takis's works are basically rather simple mechanisms – too

**107. Pol Bury: 7 Pyramides**
1965. Motorized wood, 22¾ × 15¾ × 17 in (56 × 40 × 43 cm). Private collection

**108. Nicolas Schöffer: The Liège Tower**
1961. Liège

**109. Liliane Lijn: Woman of War and Lady of the Wild Things**
1986, 1983. Steel, aluminium, synthetic fibres, laser, audio system, computer, ht. 9 ft (2.75 m). London, Fischer Fine Art

a whole was the fifty-two-metre tower that he constructed at Liège in 1961 – this used light, movement and sound. Schöffer's ambitions extended well beyond this. Like the original Russian Constructivists such as Tatlin, he envisaged cities in future raised on pylons above the ground, with the human environment controlled by technology. These plans have not come to fruition, but Schöffer received international recognition when he was awarded the major prize for sculpture at the Venice Biennale of 1968.

One of the few Kinetic artists to have made an impact in the 1970s and 1980s is the American-born, British-domiciled Liliane Lijn. She was already recognized as an important figure in the

Kinetic Art movement at the time of the *Lumière et Mouvement* exhibition held in Paris in 1967, and since then she has executed a number of commissions for fountains and other public sculptures. A recent project (executed in 1983) is *Lady of the Wild Things* – a larger-than-life, winged, female figure, which responds with light signals to the sound of the human voice. Lijn envisages this as an emblem of the unconscious mind speaking through the machine. The *Lady of the Wild Things* has a planned companion entitled *Woman of War*. When this is completed the two sculptures will converse.

Perhaps the most substantial survivor of the Kinetic Art movement is Jean Tinguely. His pedigree is different from that of the other Kineticists, whose work stems from Constructivism whereas early pieces such as *Metamecanique à Trepied* clearly show that Tinguely is a descendant of the Dada movement. His ramshackle machines sometimes make a melancholy effect, but are often uniquely joyful and anarchic. One of the most celebrated of his creations, the *Homage to New*

Some Kinetic artists actually think of their sculptures as being essentially mechanical actors, programmed to give a performance of a particular kind, with the performance rather than the object as the true work of art. One of the first to approach sculpture in this way was Nicolas Schöffer, who was born in Hungary in 1912 and moved to Paris in 1937. Here he began working as a Constructivist in the tradition founded by Naum Gabo and Moholy-Nagy, and he turned to making what he described as 'spatiodynamic' sculptures as early as 1948. These were open vertical towers which reflected light. Schöffer added movement and sound to these structures in the 1950s; and in 1956, in collaboration with the electrical firm of Philips, he created a sculpture which responded to light and sound. His most spectacular achievement and a peak point for the Kinetic Art movement as

*York* created for the Museum of Modern Art in 1960, made its comment by being programmed to destroy itself. Tinguely's description of his own work process makes it apparent that his procedures are far from scientific:

It's a very personal thing. I need to be able to hesitate a bit, have doubts, try this and that, to do something and then not know if it's any good ... I couldn't work with someone else ... I'm better off alone in my turmoil.

**111. Jean Tinguely: Metamechanical Sculpture with Tripod**
1954. Motorized metal, wire, cardboard, $43\frac{1}{2} \times 35\frac{1}{2} \times 12$ in ($110 \times 90 \times 30$ cm). Private collection

*Opposite*
**110. Jean Tinguely: Homage to New York**
1960. Painted metal, ht. approx. 24 ft (7.3 m). New York, The Museum of Modern Art (event)

I couldn't get into a turmoil with someone else, or two others ... I mean, I get into this sort of turmoil when I work because I have ideas, say even three ideas at once, and I don't know what to do with them all.

Where so much Kinetic Art has seemed to involve a naïve worship of science and technology, Tinguely gleefully mocks and at the same time expresses a certain sympathy with the imperfection and fallibility that lie at the heart of many machines:

Perhaps I'm not anguished at all ... but the work is ... The result is full of *Angst*, but I'm not. I try to distil the frenzy I see in the world, the mechanical frenzy of our joyful industrial confusion: I express it by means of this rather hopeless machine, a lunatic, crazy machine which stands there attached to its platform ... a sort of Sisiphus machine, blocked, totally useless ... of course I try to express this hopeless, despairing quality, but the despair that it expresses is more like a sort of material, like a colour, as if I were a painter and had painted a lovely blue sky.

Tinguely's link is not only with Dada but with the art of Paul Klee (who once invented a *Twittering Machine*). He also has an affinity to Calder, often cited as one of the fathers of Kinetic Art, but in general rather divorced from it. He shares a saving sense of humour with these two artists, as well as a feeling for intricacy. Tinguely's machines fascinate because of their complexity, which seems to express the artist's commitment to what he is making. Minimal Art, the subject of the next chapter, takes a very different stance.

# MINIMAL ART

Minimal Art represented a major revolution in the post-war art world, a profound questioning of the work of art in its relationship to the individual spectator and to society. It opened a split in the modernist cosmos which shows no signs of being healed. Both Pop and Super Realist Art can be thought of as containing Minimal elements, in their refusal to edit the images provided to the artist by the society he inhabits. But they do at least acknowledge the existence of that society. Because Minimal Art was so insistent on maintaining an absence of reference to anything outside the work itself, it greatly expanded the territory of sculpture at the expense of painting, which continued to have an inescapably referential side even at its most abstract. Any design on a flat surface runs the risk of being read as some kind of metaphor or sign.

The desire to produce a work which was inert, without affect, emotionally and intellectually closed, was central to the Minimalists of the first generation, though many of Minimalism's early supporters resisted this (somewhat to the irritation of the artists themselves) and produced a flood of words to prove that simple geometrical forms of the type the Minimalists first espoused, produced a 'good *Gestalt*', that is, a psychologically comforting environment for the viewer.

**112. Tony Smith: Cigarette**
1966. Sheet metal, ht. 15 ft
(4.6 m)

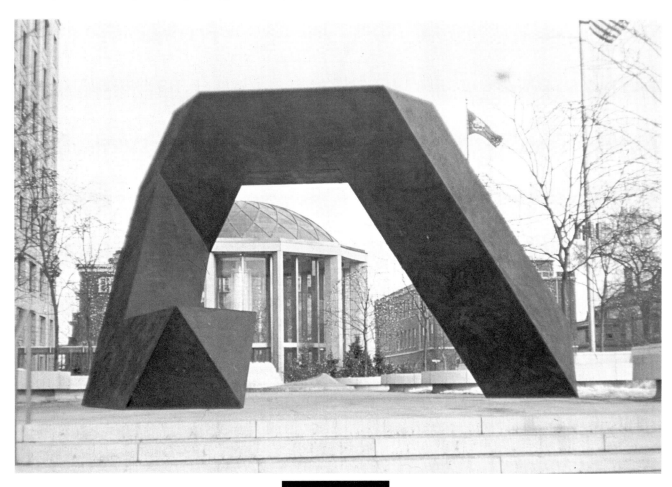

Though the style was so drastically reductive, it was not without roots in the art of the immediate past. Its debts were to Duchamp and Dada on the one hand, and to Constructivism on the other. In this it came from precisely the same background as Kinetic Art, though it pushed the implications of these common sources much further, to the point where the influence of Constructivism was at last almost discarded. But it was undeniably present to begin with. The American artist Tony Smith, born in 1912, represents the transition to Minimal Art from the kind of sculpture made in the early 1960s by his namesake, David Smith. Tony Smith received his first training from the New Bauhaus in Chicago. This institution was founded by Laszlo Moholy-Nagy, who had run the all-important Preliminary Course at the Bauhaus itself. Immediately after leaving the New Bauhaus Smith spent some time working as one of Frank Lloyd Wright's assistants. Architecture continued to influence his thinking throughout his career, and it is legitimate to see his sculpture, which was made comparatively late, as a kind of architectural work which has got rid of both the tiresome demands of the client and the actual necessity for function. In its espousal of geometric forms Smith's work remained close to the Constructivist idiom which the Bauhaus inherited and refined. What he produced has an impersonality which is reminiscent of the work of Max Bill. It is also informed by the conviction, prevalent if not universal in Bauhaus circles, that the idea is sufficient in itself. Just as Moholy-Nagy once ordered paintings by telephone from a manufacturer, using a standard colour chart and graph paper, so too was Tony Smith able to order one of his sculptures from sheet-metal fabricators simply by specifying the material and giving the required dimensions.

There is, however, a jokiness about some of Smith's work which differentiates it from the committed seriousness of his younger American colleagues. One piece, for example, is a vastly enlarged and geometricized version of a crushed-out cigarette, and stands on the very border of the world inhabited by Oldenburg.

The core of the Minimalist group in America consisted of four artists – Robert Morris, Donald Judd, Sol LeWitt and Carl André. Of these, Morris and Judd are the most clearly committed to the doctrine of 'objectness'. Morris has written:

Matter under the specific local conditions of a given material, a shape, size, placement, methods of fastening, etc., offers its own self-sufficiency and precision. Per-

ception of object-type work in actual space does not take in directly the information of ordering and planning ... Space is neither homogeneous with nor a constricting limit for objects ... Idealist-type thinking places so much importance on form because it is taken as a proof that the work is transcending itself as a mere thing by revealing structure. Object-type art is not involved in this particular dualism of form and thing because it exists without a boundary to which its parts are adjusted and partly because the perception of its relationships constantly varies. It should also be clear from the above that object-type work is not based – as has been supposed – on a particular, limiting, geometric morphology or a particular, desirable set of materials. Lumps are potentially as viable as cubes, rags as acceptable as stainless steel rods.

It should be clear from this that Morris's work specifically eschews all symbolic functions and, however bulky or physically dominating a particular piece may be, cannot be monumental in the sense that one might apply the adjective to Henry Moore's sculpture for UNESCO. Attempts to commission Minimal artists to make monuments

**113. Robert Morris: Untitled**
1961. Fir, 10½ × 25 × 74 in (26.7 × 63.5 × 188 cm). New York, Leo Castelli Gallery

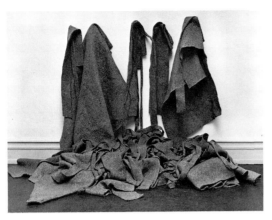

**114. Robert Morris:
Felt Piece**
1967–8. Felt. New York, Leo
Castelli Gallery

A shape, a volume, a colour, a surface is something itself. It shouldn't be concealed as a part of a fairly different whole. The shapes and materials shouldn't be altered by their context. One or four boxes in a row, any single thing or such a series, is local order, just an arrangement, barely order at all, the series is mine, someone's, and clearly not some larger order. It has nothing to do with either order or disorder in general. Both are matters of fact.

**116. Donald Judd: Untitled**
1969. Galvanized steel,
$26\frac{1}{2} \times 22\frac{1}{2} \times 4$ in
($67.5 \times 57.3 \times 10$ cm). Zurich,
Galerie Bischofsberger

seem wrong-headed, and so too do enthusiastic comparisons to Egyptian Pyramids, Babylonian Ziggurats etc. made by American critics. Minimalism's business is solely with the aesthetic perceptions of the individual and with the philosophical background to these. It is nevertheless ironic that Morris's sculpture implies the surrounding presence of a society with enough material superfluity to support a rarefied art of this type. The artist's own awareness of this may explain his recent rejection of Minimalism.

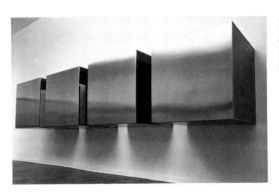

**115. Donald Judd: Untitled**
1969. Aluminium, glass,
$34 \times 160 \times 34$ in
($86.4 \times 406.4 \times 86.4$ cm).
London, Doris and Charles
Saatchi

Sol LeWitt is primarily interested in the idea of sequences of simple forms. For him, each work of art announces one possibility among an infinite variety that can be found in the same form: 'For each work of art that becomes physical, there are many variations that do not.' Like Morris, he believes there is no hierarchy of forms: 'Since no form is intrinsically superior to another, the artist may use any form, from an expression in words (written or spoken) to physical reality, equally.' But LeWitt has a different kind of stringency – his feeling is that the artist must take the first conception and follow it through without deviation to whatever conclusion it may lead him, without compromise, and also without trying to anticipate the result: 'The artist cannot imagine his art, and cannot perceive it until it is complete ... It is difficult to bungle a good idea.'

Donald Judd, though concerned with sequences and relationships of forms to a more noticeable extent than Morris, takes much the same position, and made one of the clearest statements of the values of Minimal Art in an article printed in the *Yale Architectural Journal* in 1967:

I wanted work that didn't involve incredible assumptions about everything. I couldn't begin to think about the order of the universe, or, the nature of American society. I didn't want work that was general or universal in the usual sense. I didn't want it to claim too much. Obviously the means and the structure couldn't be separate, and couldn't even be thought of as two things joined. Neither word meant anything.

**117. Sol Lewitt: Five
Modular Units**
1970. Enamelled steel,
$5\frac{1}{2} \times 5\frac{1}{2} \times 24$ ft
($1.7 \times 1.7 \times 7.3$ m). New York,
John Weber Gallery

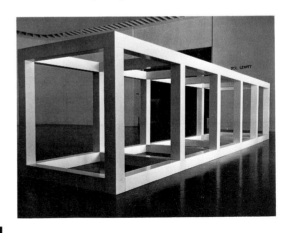

**1. Jacques Lipchitz:**
**Song of Songs**
1945–8. Bronze, $23\frac{3}{4} \times 38$ in
$(60.3 \times 96.5$ cm). Private
collection

**2. Henry Moore:**
**Leaf Figure**
1952. Bronze, ht. 9½ in (24 cm).
Private collection

**3. Alberto Giacometti:**
**Tête tranchante, Diego**
1953. Bronze, ht. 14¼ in (35 cm).
Private collection

**4. Jean (Hans) Arp:**
**Larme de galaxie**
1962. Marble, ht. 26 in (66 cm).
Private collection

**5. Jean (Hans) Arp:**
**Torse végétal**
1959. Marble, ht. $53\frac{1}{8}$ in
(135 cm). Private collection

**6. Barbara Hepworth:**
**Two Ancestral Figures**
1965. Iroko wood,
$49\frac{3}{4} \times 36 \times 18\frac{1}{8}$ in
$(126.4 \times 91.4 \times 46 \text{ cm})$.
Private collection

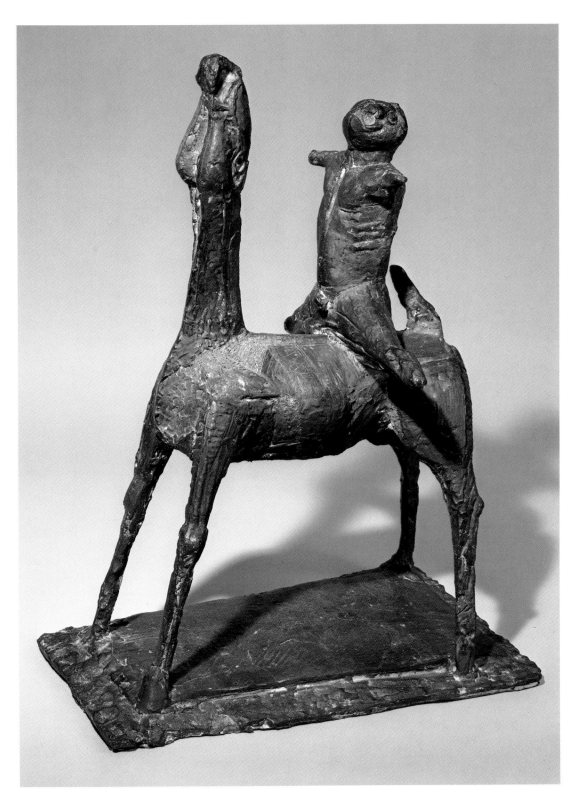

**7. Marino Marini:**
**Horse and Rider**
1951. Bronze, ht. 22 in. (55 cm).
Private collection

**8. Henry Moore:**
**Seated Woman**
1956–7. Bronze with green
patina on a copper covered
base, 63 × 56 in
(160 × 142 cm). Private
collection

**9. Giacomo Manzù:**
**The Cardinal**
1953–4. Bronze, ht. 26 in
(66 cm). Private collection

**10. Kenneth Armitage:**
**Richmond Oak**
1985–6. Bronze,
120 × 84 × 84 in
(300 × 210 × 210 cm).
Brasilia, British Embassy

**11. Alexander Calder:**
**La Grande Vitesse**
1969. Steel. Grand Rapids,
Mich., Vandenburg Plaza

**12. Alexander Calder:
Petite verticale hors de
l'horizontale**
1950. Metal, 47 × 52 in
(119 × 132 cm).
Private collection

**13. César Baldaccini:**
**Compressions**
1972. Painted metal. Paris,
Galerie Mathias Fels

**14. David Smith: Forest**
1950. Painted and welded
steel on wooden base,
40 × 38 × 4¾ in
(101.5 × 96.5 × 12 cm).
Private collection

**15. David Smith: V. B. XXIII**
1963. Welded steel,
69½ × 28¾ × 24 in
(176.5 × 73 × 61 cm).
Private collection

**16. John Chamberlain:**
**Pollo Primavera**
1981. Welded steel and
chrome, $44\frac{1}{2} \times 53\frac{1}{2} \times 40\frac{1}{2}$ in.
$(113 \times 135.5 \times 103$ cm).
Private collection

**17. Joseph Cornell:**
**Untitled**
*c.* 1953. Wood and mixed
media, $18 \times 12 \times 4\frac{3}{4}$ in
$(45.5 \times 30.5 \times 12$ cm).
New York, Estée Lauder, Inc.

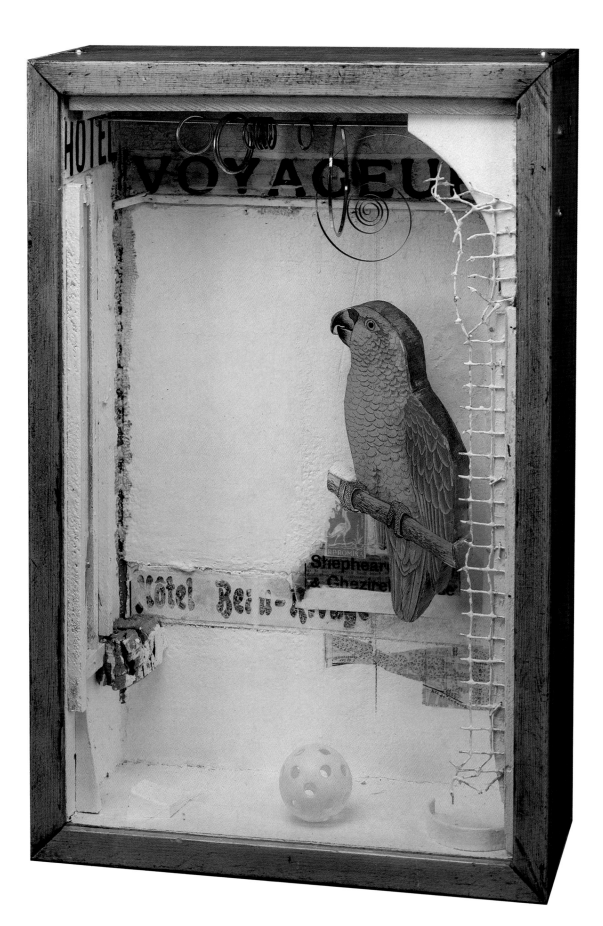

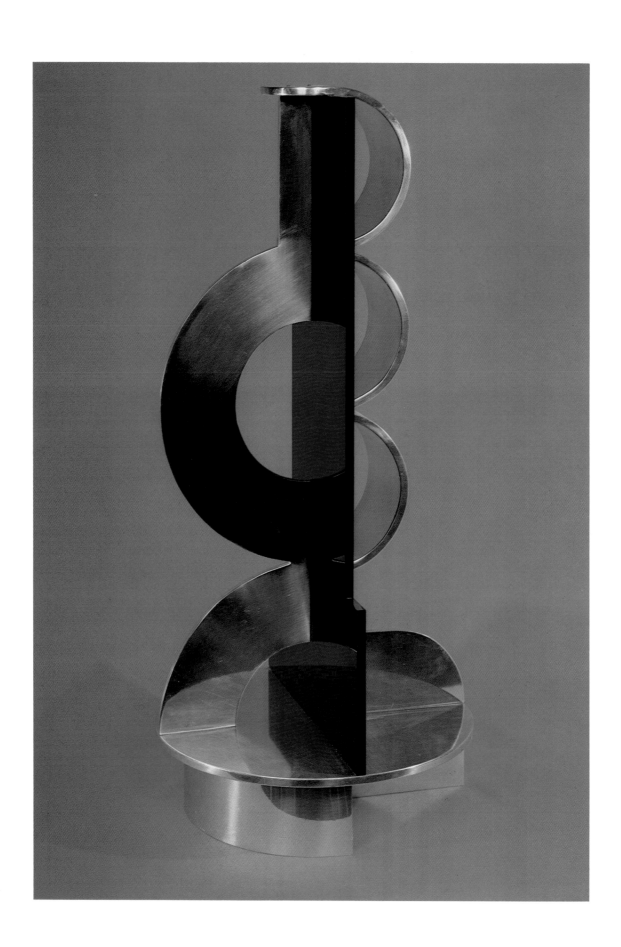

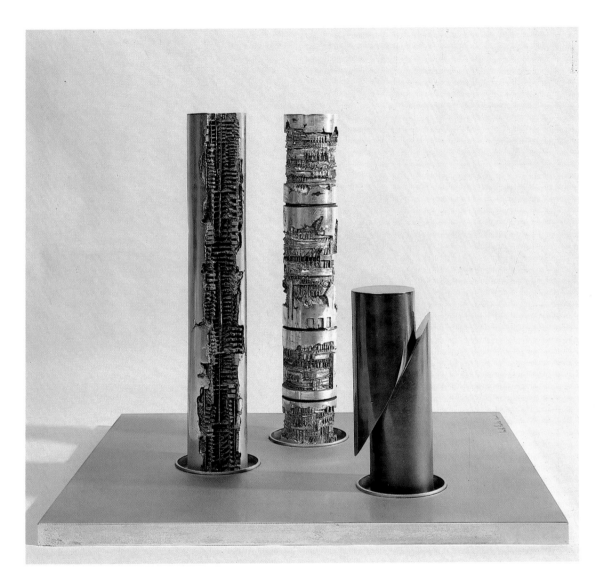

**19. Arnaldo Pomodoro:**
**Three Columns**
1969. Silver, gold and steel,
$15\frac{3}{4} \times 18 \times 19\frac{5}{8}$ in
($40 \times 45.6 \times 49.7$ cm).
Collection Oscar Carraro

*Opposite*
**18. Roy Lichtenstein:**
**Modern Sculpture with**
**Intersecting Arcs**
1968. Aluminium and
plexiglass, ht. $31\frac{1}{2}$ in (80 cm);
diam. $14\frac{1}{2}$ in (37 cm).
Private collection

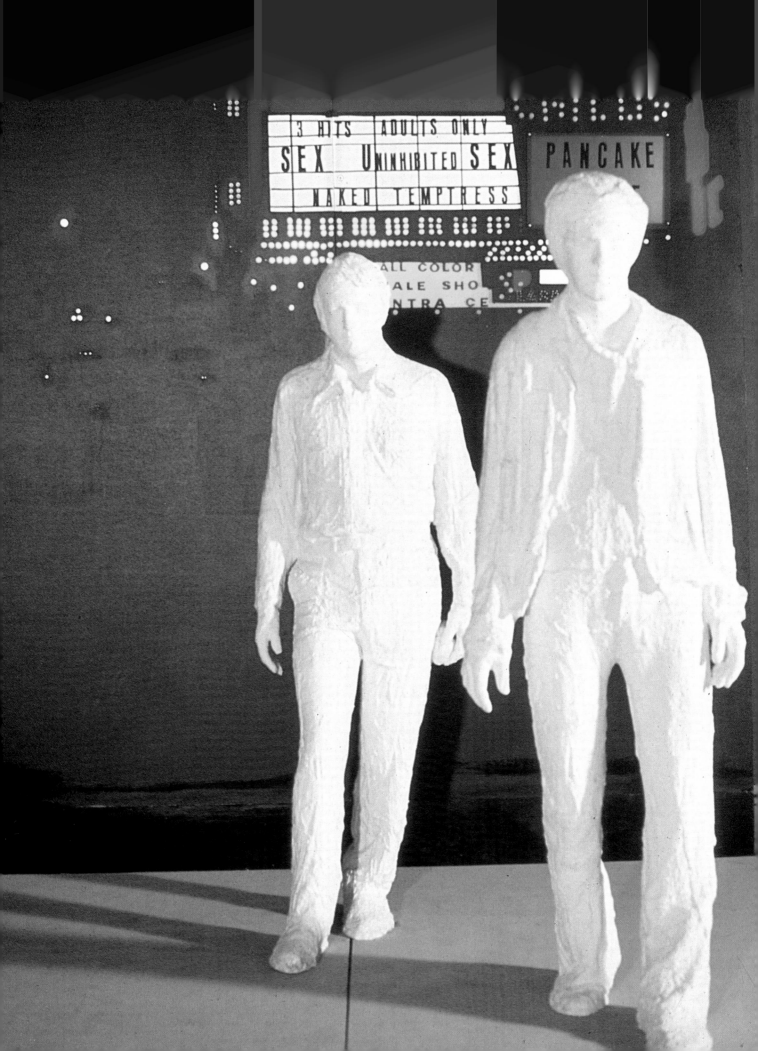

**20. George Segal: Times Square at Night**
1970. Omaha, Joslyn Art Museum

*Right*
**21. Duane Hanson: Woman Reading a Paperback**
1978. Polyvinyl, polychromed in oil, life-size. New York, O. K. Harris Gallery

**22. Jean Dubuffet:
Borne au Logos VIII**
1966. Transfer on polyester,
40 × 18½ × 19 in
(101 × 40.7 × 40.8 cm). Private
collection

**23. Arman (Armand
Fernandez): Subida al
Cielo**
1962. Sliced bass viol on
painted panel, 97¼ × 49 × 12 in
(247 × 124.5 × 30.5 cm).
Private collection

**24. Richard Serra: Olson**
1985–6. Steel, two plates, each
10 ft × 36 ft × 2 in
(3.5 m × 11 m × 5 cm). London,
Saatchi Collection

**25. Anthony Caro:**
**Month of May**
1963. Aluminium and steel,
110 × 120 × 141 in
(280 × 305 × 357 cm).
Private collection

**26. Christo (Christo Javacheff): The Pont Neuf by Night**
1986. Cloth. Paris (event)

*Opposite*
**27. Claire Zeisler: Coil Series II – A Celebration**
1978. 81 × 38 × 15 in (205 × 96 × 38 cm). New York, Hadler-Rodriguez Galleries

**29. Richard Long:**
**Six Stone Circles**
1981. Slate, diam. 24 ft (7.5 m)

*Opposite*
**28. John Newling:**
**The Rapid Plough**
1983. Mixed media.
Nottingham Castle
(installation)

**30. Italo Scanga:
Metaphysical II**
1985. Lacquered and painted
wood, 105 × 29 × 24 in
(266 × 74 × 61 cm). Private
collection

*Right*
**31. Barry Flanagan:
Acrobats**
1981. Bronze, ht. 66 in
(168 cm). Private collection

*Overleaf*
**32. Howard Ben Tré:
Column 39**
1986–7. Glass, gold leaf,
brass, patinated copper,
93½ × 28½ × 12 in
(238 × 72.5 × 30.5 cm).
New York, Charles Cowles
Gallery

Carl André, born in 1935 at Qumeg, Massachusetts, is currently the most notorious of the Minimalist group, but for reasons extraneous to his art. His stormy private life has recently been highly publicized and even before that he received much notoriety for his use, unaltered, of common materials, especially ordinary household bricks. He, like Sol LeWitt, is interested in creating sequences of form which can be infinitely extended or expanded. For him, blocks of wood and steel plates or bricks are simply neutral, identical units –

things which can be used to express his conviction that art should not, in the material sense at least, enjoy a privileged status. His sculpture is something which exists physically, but so too does a pile of building materials in the street (André once had a special series of photographs taken to make this point). The thing which enjoys a special status, in André's view, is the artist's conception, the pattern of thinking his modules are used to express, just as the movement of the chess pieces on a board expresses a particular opening variation.

*Left*
**118. Carl André: Equivalent VIII**
1966. 120 firebricks,
5 × 27 × 90 in
(12.7 × 63.5 × 229 cm).
London, Tate Gallery

*Right*
**119. Carl André: Hell Gate**
1981. Wood, 60 × 72 × 12 in
(152.4 × 182.9 × 30.5 cm).
London, Anthony d'Offay Gallery

**120. Carl André: Niner**
1981. 45 Steel plates, each
plate: 12 × 12 × $\frac{1}{2}$ in
(30 × 30 × 1 cm). London,
Anthony d'Offay Gallery

Around the core group of Minimalists whose works have been briefly described can be arranged a number of other artists. With some the Minimalist connection is fairly tenuous. The bold, simplified shapes created by the Canadian-born sculptor Ronald Bladen, for example, clearly show his connection with the art of Tony Smith, but essentially his pieces such as *Raiko I* and *Kama Sutra* are sculptural statements of a more traditional type.

**121. Ronald Bladen: Kama Sutra**
1977. Wood, 28 × 20 × 30 ft
(8.5 × 6.1 × 9.1 m). New York, Sculpture Now

Richard Serra, much younger than Bladen, has been described as a second-generation Minimalist. His large sculptures of metal plates or logs are structurally as well as visually reductivist – the various parts are held in position by their own weight [Col. Pl. 24]. This means they often seem precariously balanced and therefore threatening – ready at the slightest touch to fall and crush the viewer. Serra wants his work to be seen in public places, so that it can confront an unprepared audience. But his attitudes, unlike Bladen's, are untraditionally hostile to the audience, which often reacts accordingly. On those occasions when his ambition has been fulfilled there has frequently been violent controversy.

white as in *Monument for V. Tatlin*, sometimes coloured as *Untitled (to Barbara Lippe)*, for a kind of parody of reductivist ambitions. The kinship with Marcel Duchamp's ready-mades is strong – as Peter Scheldahl points out, in his introduction to the first volume of the Saatchi Collection catalogue: 'Flavin's art is a hothouse flower, abjectly reliant for its basic meanings on an institutional setting – a place where its non-art qualities can have piquancy and bite, as tacit assaults on conventions by which, for instance, lights on the ceiling illuminate art on the walls rather than the other way round.' The sculptor Larry Bell takes a different route, making elegant Minimal cubes and large L-shaped sculptures from coated glass orig-

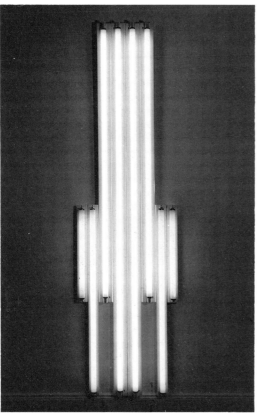

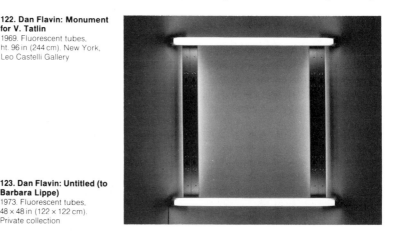

**122. Dan Flavin: Monument for V. Tatlin**
1969. Fluorescent tubes, ht. 96 in (244 cm). New York, Leo Castelli Gallery

**123. Dan Flavin: Untitled (to Barbara Lippe)**
1973. Fluorescent tubes, 48 × 48 in (122 × 122 cm). Private collection

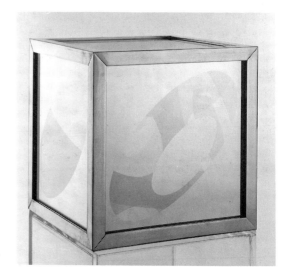

Minimal Art has had its moments of flirtation with technology, though this has never been as essential as it is to some forms of Kinetic Art. The relationship has taken two forms. One is the use of existing technological products as raw material for art; the other is the employment of new technological processes to give the work its distinctive appearance. Perhaps the best-known example of the former are the neon-tube sculptures of Dan Flavin. Flavin employs standard tubes, sometimes

**124. Larry Bell: Untitled**
1964. Metal, glass, 8½ × 8½ × 8½ in (21 × 21 × 21 cm). London, Tate Gallery

inally developed for the aviation industry. These are celebrations of the quality of a beautiful material, left to speak more or less for itself. What he shares with Flavin is something paradoxically luxurious and decorative.

Another artist who has made use of simple cubic forms is Jackie Winsor, born in Canada in 1941. Her chief points of difference from the Minimalist sculptors of the first generation lie in her choice of materials and her attitudes towards the way they are handled – she tends to use things which preserve a rawness of surface: twine, plywood, cement, sheetrock, nails. Her sculpture has a deliberately 'hand-made' look, alien to the work of the creators of Minimalism, and she frequently contradicts the unitary massiveness of her forms by, for example, making apertures in her cubes so that they can be read in two ways – as enclosed spaces, and as objects that occupy space. The leading American critic Hilton Kramer, in general

Minimalism back into the language of primitive feeling. The poignancy of the work is to be found in the fact that the only rituals available to the sculpture [*sic*] in this task are the rituals of esthetic ratiocination.

The odd woman out amongst the younger American Minimalists was the short-lived Eva Hesse. Her work seldom makes use of hard, geometric, unitary forms. On the rare occasions when it does, the surface is textured, or in some fashion disguised. Her art is essentially the record of a process rather than a result, a way of exploring her own subjectivity. In her notebooks, she wrote: 'I would like the work to be non-work. This means that it would find its own way beyond my preconceptions.' In an interview, she said:

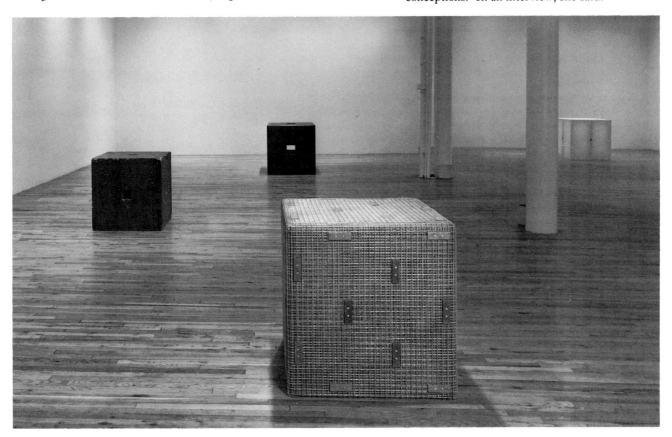

**125. Jackie Winsor:
Installation**
1982. Mixed media. New York,
Paula Cooper Gallery

hostile to Minimal Art, has had grudging praise for Miss Winsor's sculpture. In 1979 he wrote a long piece about her in the *New York Times*, and concluded it with the following judgement:

There is a yearning in this work for the kind of meaning that sculpture in a primitive culture could take for granted: the meaning that derives from a traditionally ordained ritual function. It is in this yearning that the true significance of Jackie Winsor's sculpture lies – a yearning that attempts to convert the slick forms of

I think art is a total thing. A total person giving a contribution. It is an essence, a soul ... In my inner soul art and life are inseparable. It becomes more and more absurd to isolate a basically intuitive idea and then work up some calculated system and follow it through – that supposedly being the more intellectual approach – than giving preference to soul or presence or whatever you want to call it ... I am interested in solving an unknown factor of art and not an unknown factor of life ... In fact my idea now is to counteract everything I've ever learned or been taught about those things – to find

something that is inevitable that is my life, my feeling, my thoughts.

The result has to be taken very much on trust – it has no obvious *raison d'être*, at least as far as the outside world is concerned. It succeeds only if the viewer feels that he or she is in mysterious rapport with the artist – in fact, if Hesse succeeds in arousing a kind of psychic echo.

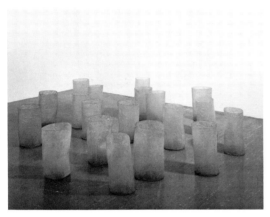

**126. Eva Hesse:**
**Repetition 19, III**
1968. Fibre glass, each unit:
ht. 12 in (30 cm); diam. 8 in
(20 cm). New York,
The Museum of Modern Art

One significant feature of her sculpture is its link to work by leading contemporary textile artists, especially those such as Leonore Tawney, Claire Zeisler and Françoise Grossen, who have experimented boldly with dimensional weaving. The difference between much of Hesse's work, made in mixed materials such as latex over rope, wire and string, and the objects produced at the same time by Claire Zeisler, is largely one of categorization, though it is true that Zeisler, with her more sophisticated knowledge of weaving techniques, shows considerably greater finesse in handling her materials [Col. Pl. 27]. In fact, Minimal Art's insistence on 'objectness' in art did much to abolish the traditional barrier between the fine arts and the crafts, especially in America, where ever since Abstract Expressionism the crafts had been increasingly attracted towards the fine arts and away from production work. Most craftworks are, by their very nature, essentially what Minimal Art claims to be – not symbolic statements, but objects added to a world of objects.

# CONCEPTUAL ART AND LAND ART

Minimal Art had a number of offshoots, apparently very different from one another, but in fact closely allied. One of these was Conceptual Art, which was Minimalism transferred to an entirely non-material level. Art became art-as-idea, or art-as-information.

One of the pioneers of Conceptual Art was Joseph Kosuth, and some of his works of the late 1960s are still amongst the most stringent of their

sort. Particularly noticeable is his hostility to the materialism of the art market, in fierce reaction against Pop Art's embrace of materialistic values. For example, Kosuth in his *Art as Idea* series, deliberately went from using mounted photostats, which could be sold in art galleries, to spaces booked in newspapers. He wrote:

This way the immateriality of the work is stressed and any possible connections to painting are severed. The new work is not connected with a precious object – it's accessible to as many people as are interested; it is non-decorative – having nothing to do with architecture; it can be brought into the home or a museum, but wasn't

**127. Joseph Kosuth: Titled (Art as Idea as Idea)**
1966. Photostat, 48 × 48 in (122 × 122 cm). New York, Leo Castelli Gallery

**128. Lawrence Weiner: Billowing Clouds of Ferrous Oxide Setting Apart a Corner on the Bottom of the Sea**
1986. $86\frac{1}{4} \times 17\frac{1}{2}$ in (219.5 × 44.5 cm). London, Anthony d'Offay Gallery

made with either of them in mind; it can be dealt with by being torn out of its public – and inserted into a notebook or stapled to the wall – or not torn out at all – but any such decision is unrelated to the work. My role as artist ends with the work's publication.

Another artist who works with words as his medium is Lawrence Weiner. In an interview recorded with me in December 1980 Weiner was quite specific about the way he sees his role:

I think the closest you could put it in some sort of art-historical terms would be sculpture, because the work is concerned with the relationships of human beings to objects, and objects to objects in relation to human beings. What one does then is to take language itself as immaterial. When you see a piece of sculpture, when you see a piece of wood lying on the ground with a piece of stone on top of it, you must translate that in your own head into language. What I try to do is present language itself as a key to what sculpture is about … It is a presentation of a piece of sculpture in language.

Offered a public situation, Weiner writes his sculpture on the wall, in block capital letters. But he is even happier to present it in a book, just as Kosuth presents his work in the columns of a newspaper. The work itself can consist of a single word – 'FOLDED' – or of a phrase – 'AN OBJECT TOSSED FROM ONE COUNTRY TO ANOTHER'.

Conceptual Art finds an unexpected twin in Land Art, which is as physically expansive as Conceptual art is immaterial. Land Art can (but need not) consist of enormous excavations and alterations to natural sites which have inevitably prompted comparisons with the tumuli and earthworks heaped up by primitive peoples. What are probably the two most celebrated examples of Land Art are of this sort – Michael Heizer's *Double Negative* of 1969–70, on the Virgin River, Mesa, Nevada; and Robert Smithson's *Spiral Jetty* of 1970, jutting out into the Great Salt Lake in Utah.

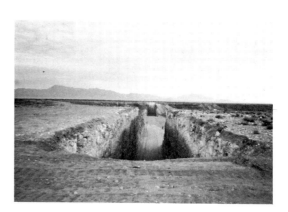

**129. Michael Heizer:**
**Double Negative**
1969–70. Displacement of 240,000 tons of rhyolite and sandstone, 1500 × 50 × 30 ft (457 × 15 × 9 m). Mesa, Nev., Virgin River

*Below*
**130. Robert Smithson:**
**Spiral Jetty**
1970. Stone. Utah, Great Salt Lake

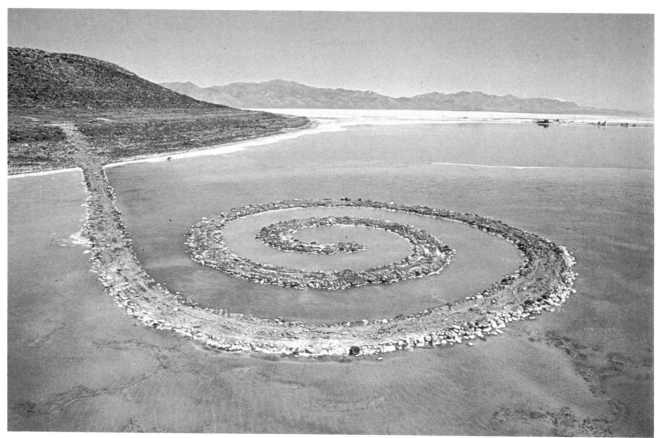

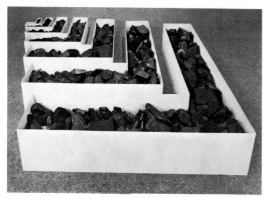

**131. Robert Smithson:**
**Nonsite – Site Uncertain**
1968. Coal, 15 × 90 × 90 in (38 × 239 × 239 cm) New York, Dwan Gallery (installation)

**132. Robert Smithson:**
**Partially Buried Woodshed**
1970. Woodshed, earth, 45 × 18 × 10 ft (14 × 6 × 3 m) New York, Dwan Gallery (installation)

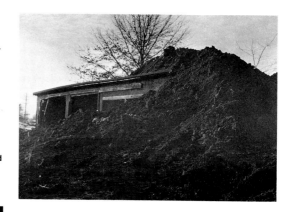

Obviously both have certain aspirations towards the mysterious and the primitive. Heizer speaks of the 'aura' of his vast sculpture but the concepts underlying it are purely intellectual – not social or religious. This trench, 1500 feet long, fifty feet wide and thirty feet deep, is seen by the artist as a negative mass, a void that refers to the prior positive mass and the energy required for its removal.

Similarly, Smithson's *Spiral Jetty*, though making use of one of the most ancient and universal of symbolic forms, is the invention of one man.

even with Smithson's less monumental works such as *Nonsite – Site Uncertain* and *Partially Buried Woodshed*. This audience has to take them on trust, as things recorded in still photographs, or on film or video. Probably a smaller proportion will see them than will see the Pyramids in Egypt, modern tourism operating as it does. With Land Art, it is sometimes rather difficult to draw a distinction between the work itself, and the photographic image it generates. This difficulty appears clearly in a number of works by Dennis Oppenheim. In the *Directed Seeding – Wheat* series of 1969 the

**133. Dennis Oppenheim: Directed Seeding – Wheat**
1969. Earth, wheat seed, 300 × 1000 ft (90 × 300 m). Finsterwolde, Holland

Both the spiral and its site are the result of conscious aesthetic choice.

These two are physically vast, but the remote locations chosen for them put them out of reach of most of the modern art audience, as is the case

rhythmic marks made by the artist on the land can be seen and appreciated only with the help of expert aerial photography, and where the design itself is edited by the height, angle and direction of the camera.

In terms of sheer size, the most ambitious Land Art projects, surpassing even those of Heizer, have been the work of the Bulgarian artist Christo (Christo Javacheff, born 1935). Christo first made an impact in Paris at the end of the 1950s with *Wrapped Objects*, which clearly owed a good deal from a philosophical point of view to some of Duchamp's ready-mades. Their most direct ancestor was Duchamp's *With Hidden Noise* of 1916, which consists of a ball of twine wrapped round a small hidden item that makes a rattling noise when the piece is shaken.

Christo's projects for wrapping things soon began to exceed the domestic scale. In 1961 he announced a project for packaging a public building, and in 1968 he was able to carry this out, wrapping the Kunsthalle in Bern. That same year he created an 'air package' 280 feet high for the fourth Documenta Exhibition at Kassel. In 1970 Christo wrapped the monument to Leonardo in the Piazza della Scala, Milan, and was sufficiently well-established to undertake a major project in the United States – the *Valley Curtain* in Colorado. This was 1368 feet long at its widest point, and 365 feet high at its highest. Four years later

**134. Christo (Christo Javacheff): Running Fence** 1972–6. Cloth, 18 ft × 24½ miles (5.5 m × 39 km). Sonoma & Marin Counties, California (event, 1977)

this was followed by the *Running Fence* in Calfornia only eighteen feet high, but no less than twenty-four and a half miles long. For this Christo used two million square feet of nylon fabric, ninety miles of steel cable and 2050 steel poles, each three and a half inches in diameter. In 1983 he undertook yet another enormous project – the *Surrounded Islands* in Biscayne Bay, Greater Miami, Florida, which called for six and a half million square feet of polypropylene fabric.

These projects are by their nature temporary – unlike Heizer and Smithson, Christo has never sought to leave a permanent impress on the landscape. Though they were carried out so recently, they survive today only in Christo's preliminary drawings, many of which are extremely elegant works of art in themselves, and in documentary photographs [Col. Pl. 26]. But they are also (because of the finance which has to be raised, the local help which has to be recruited, and the process of local consultation required) an effective means of propagandizing the public about the nature of contemporary art, and Christo has said that he regards the legacy left by this propaganda as an important part of their function.

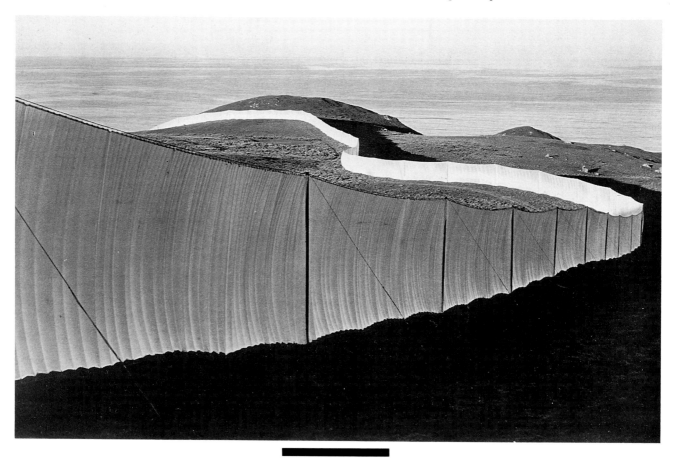

Appreciation of the Englishman Richard Long's work has also depended to a substantial extent on photography – and on Long's own skills with the camera. He makes it very plain, however, that the photographic image is not to be regarded as primary, and describes the pictures he takes as being simply 'facts that bring the right accessibility to remote, lonely or otherwise unrecognizable works. Some sculptures are seen by few people, but can be known about by many.' He continues thus (the line divisions are his own):

My outdoor sculptures are places.
The material and the idea are of the place;
sculpture and place are one the same.
The place is as far as the eye can see from the
sculpture. The place for a sculpture is found
by walking. Some works are a succession
of particular places along a walk, e.g.
*Milestones*. In this work the walking,
the places and the stones all have equal importance.

thus finds links both with Conceptualists such as Lawrence Weiner and with Minimalists such as Robert Morris and Carl André.

Yet there are also echoes, and powerful ones, in Long's work which are not present in that of the artists just named; and it is these echoes and adumbrations which account for his appeal to a much wider audience than one might expect, given the apparently esoteric nature of his activity. Long combines Zen Buddhist elements, a kind of meditative passivity in the face of nature, with others more traditional to Western art. One can connect him with the specifically British tradition of the landscape garden – nature subtly altered so as to come closer to her true self – and also to the broader tradition of Arcadian landscape painting from the seventeenth century onwards. It is symptomatic that enthusiasts for Long's work are often drawn from an urban official class (he has a particular appeal for museum officials). It was their seventeenth-century equivalents who most appreciated the art of Claude Lorraine and that of his innumerable followers. Long enters into the mysteries of nature on their behalf, and gives Arcadian freedom in surrogate form [Col. Pl. 29].

**135. Richard Long: A Line in Iceland**
1982. Framed photograph, 34¾ × 49 in (88 × 124 cm). London, Anthony d'Offay Gallery

**136. Nicholas Pope: White Arch**
1979. Chalk, 26 × 52 in (66 × 132 cm). London, Anthony Stokes

Long's most characteristic form of expression is a small alteration, made in a remote and lonely landscape; its existence is then verified by the camera. But in addition to showing his photographs in art galleries, Long exhibits other forms of record – for example, a map, with the route of a particular walk marked on it, or a brief written description of a series of actions. Or map, description and photograph can be combined. He also makes sculptures which are specifically for galleries. They often consist of stones (sometimes sticks or twigs) taken from a particular site and laid in a simple pattern on the floor. In his work one

Nevertheless there is one peculiarly contemporary feature of Long's art, and that is the way in which it shifts our focus away from the object and towards the man responsible for producing it. Long does divide his activity into separate actions or projects, each designated as an artwork, but he himself has become his own most finished product. He is not the only late modernist sculptor of whom this can be said – there are several who have pursued a similar line with even greater vigour. Among the most conspicuous are the English duo Gilbert and George, and the German artist Joseph Beuys.

Before moving on to these, it is worth noting the activity of another British sculptor whose work has something in common with that of Richard Long. Nicholas Pope (born 1936) shares Long's romantic feeling of unity with nature, and expresses it through rough-hewn sculptures such as *White Arch* that alter natural materials as little as possible. The difference is that Pope's sculptures, though hewn on the spot, are wrought in a way which Long's are not. It is not merely that there has been human intervention, but nature has actually been forced into new shapes. The link with traditional sculptural procedures is therefore much stronger, however primitive the results may appear.

Gilbert and George describe themselves as 'living sculptures', and assert that everything they do is sculpture – all the trivial gestures of daily living. Their explanation of how this situation arose is very simple: 'We left school, we didn't have anything to do, no studio. We were the art.

were thickly coated with bronze powder, and they stood on a table with the record-player beneath them, so that they vaguely resembled an automaton which incorporated a musical box.

A flood of unconventional artworks followed – other performances, postal sculptures (consisting of cards sent to friends and acquaintances), postcard sculptures (designs made by juxtaposing ordinary commercial postcards), large-scale drawings (still categorized as 'sculpture'), and photo-pieces. The photo-pieces, which grew steadily larger, more elaborate and more professional in finish, eventually became the artists' principal product. In their developed form these works are sometimes fully the size of the ambitious Salon paintings produced by academic artists of the nineteenth century. Frequently they incorporate images of Gilbert and George, as their art continues to be intensely autobiographical. The tone can be lyrical or lightly ironic. Alternatively it can be depressive or even starkly menacing. These photo-pieces are

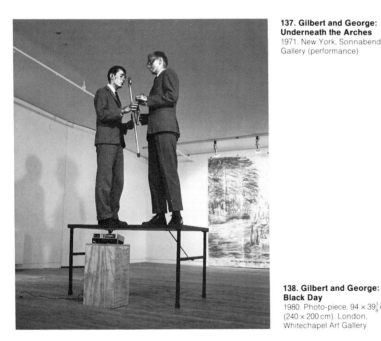

**137. Gilbert and George: Underneath the Arches**
1971. New York, Sonnabend Gallery (performance)

**138. Gilbert and George: Black Day**
1980. Photo-piece, 94 × 39$\frac{3}{8}$ in (240 × 200 cm). London, Whitechapel Art Gallery

That's how we started.' The work which first made them known was the performance piece *Our New Sculpture*, later retitled *Underneath the Arches*. This was first presented at two London art schools in 1969. The artists, wearing the formal suits which were to become one of their trade marks, manipulated two props, a single glove and a walking stick. Meanwhile a record-player ground out the music hall song 'Underneath the Arches'. At later performances other touches were added – their faces

full of ambiguities of all kinds. Things are hinted at but never fully stated – here there may be a hint of homo-eroticism, there an apparent endorsement of neo-Fascism, and there again references to old-fashioned fundamentalist religion. Gilbert and George's avant-garde admirers are noticeably reluctant to elucidate these references on their behalf, and the artists themselves maintain the stylized impassivity which fits the role they long ago chose for themselves. The mask, they

maintain, is all there is. 'It's our joint image that is interesting for us. That's the only thing we are interested in. It's an amazing power. It becomes like a fortress, much bigger than one person.'

Gilbert and George are exceptional in having maintained so close an identification between artist and artefact. Other avant-gardists who started their careers from much the same position have gone on, as their careers developed, to make sculpture where the conventional separation is restored. Examples of this progression are the American Bruce Nauman, and the German Rebecca Horn. Nauman made his original reputation with performance pieces, but these increasingly came to require settings which, as the artist pointed out in an interview given in 1979 to the Canadian magazine *Vanguard*, 'could be used to control the content, and became important ... If I can limit the kind of things that can be performed then I can control part of the experience.' His recent work seems to put the setting so much to the

**139. Bruce Nauman: Playing a Note on the Violin While I Walk Around the Studio Floor**
1968. 16mm film with soundtrack, approx. 400 ft (122 m). Los Angeles County Museum of Art (performance)

forefront that the presence of a live performer becomes unnecessary. The spectator physically or mentally enters the space provided, and performs as it directs.

Rebecca Horn, born in 1944, and thus only three years younger than Nauman, belongs to a different artistic generation. The whole of her activity as an artist belongs to the 1970s and 1980s. Her earliest 'sculptures' were items of costume – masks or gloves (these were over three feet in length), extensions of the sculptor's own body. Then came pieces such as *The Chinese Fiancée* (1978), where the co-operation of the spectator was required. He or she was invited to step inside a black lacquered hexagonal cabinet, which suddenly closed, leaving the participant in total darkness, listening to two girls having a conversation in Chinese.

More recent installation pieces have also been mechanical, but the mechanisms have been metaphors that require no spectator participation. The *Peacock Machine* of 1982, for example, was set in the middle of an eight-sided space, and, to the accompaniment of the shrill cries of the courting male peacock, it spread a fan of long metal spikes. These were then lowered to brush against the walls of the room, eventually filling the floor-space, symbolically closing it off.

The sculptures of the late Joseph Beuys were also metaphors – indeed it is probable that he is Rebecca Horn's inspiration in this respect. In fact his sculptures are so much dedicated to metaphoric discourse that they have no distinctive 'style', nor is it possible to describe a typical example, though certain materials, such as fat and felt, recur. What is much more important, however, is the fact that Beuys was throughout his mature career his own artwork, in an even more complete and dedicated fashion than Gilbert and George. Many of his sculptures now in museums are simply 'leftovers' – physical reminders of actions undertaken by Beuys on their premises. Of course, there were also important differences from Gilbert and George – Beuys's political convictions were much more overtly expressed and even more closely interwoven with the fabric of his activity. They were also more in line with the long-established avant-garde tradition of alliance with the Left.

Beuys, born in 1921, was old enough to fight in the Second World War. He served first as a dive-bomber pilot on the Russian front, then as a member of a scratch paratrooper unit which fought in Holland at the end of the war and then on

German soil. His war experiences were traumatic – one in particular was to be constantly recalled in his art: he crashed in a remote part of the Crimea and was tended by nomadic Tartars for eight days until found by a German search party. This experience of near death and miraculous rebirth seems to have triggered his desire to become a modern shaman, though this lay dormant for a period after the war.

The stages in Beuys's progress to world celebrity were as unorthodox as his art. After training as a sculptor during the years immediately after the war, and making a modest reputation for himself in and around Düsseldorf, he suffered a nervous breakdown in 1957, the delayed result of his wartime injuries and terrors; he returned to his native Cleves for some months to work in the fields and convalesce. This was the first turning point in his career. 'Illnesses', Beuys said later, 'are almost always spiritual crises in life, in which old experiences and phases of thought are cut off in order to permit positive changes.'

In 1961 Beuys was appointed to the professorial chair of monumental sculpture at the Düsseldorf Academy. This was a recognition of his increasing status – it was also part of the German tradition to link leading members of the avant-garde to the establishment by appointing them to such posts. Most of the major German Expressionists, for example, held important professorships before Hitler turned them out. But Beuys also happened to be an inspired pedagogue, with an irresistible attraction for the young and rebellious generation then just beginning to emerge in Germany after a long period of suppression. The Academy became a convenient base for his activities and for those of the avant-garde Fluxus group with which he now became connected, though he was not one of its original founders. The members of Fluxus were interested in performance and other ephemeral events, and violently opposed to the commercial gallery system.

Beuys now began to channel his creative activity into a series of performances or 'actions'. These were based upon an elaborate symbolism of materials which owed something to his wartime encounter with the Tartars, but perhaps even more to the way these materials could be used to provoke specific questions about the nature of art and its relationship to society. Beuys used felt (in which the Tartars had wrapped him when he was injured and semi-conscious), beeswax, iron, honey and gold. One of his most favoured materials was fat.

**142. Joseph Beuys: Finale of the Performance 'Celtic (Kinloch Rannoch) Scottish Symphony'**
1970. Edinburgh Festival (performance)

Beuys said, with reference to his *Fat Chair* of 1964 (an ordinary wooden chair with a large triangular lump of fat occupying its seat):

My initial intention in using fat was to stimulate discussion. The flexibility of the material appealed to me particularly in its reactions to temperature changes. This flexibility is psychologically effective – people instinctively feel it relates to inner processes and feelings. The discussion I wanted was about the potential of sculpture and culture. What they mean, what language is about, what human production and creativity are about. So I took an extreme position in sculpture, and a material that was very basic to life and not associated with art.

In 1967 Beuys's career changed direction for a second time in response to the changing political climate within Germany, and specifically in response to the demand that a place should be made available at the Academy to every student who applied, regardless of his or her qualifications or lack of them. He founded his own political party to support this demand, the 'German Student Party as Meta-Party' and came into increasingly bitter conflict with his colleagues in Düsseldorf, who condemned his 'presumptuous political dilettantism'. In 1972 Beuys led an occupation of the Academy's secretariat in support of students'

demands, and was dismissed from his post. A complicated series of legal actions followed, which lasted until 1978 when a compromise was finally agreed which would allow Beuys to retain his professorial title and studio, while ceasing to be a member of the institution's teaching staff.

**143. Joseph Beuys in his 'Information Office'**
1972. Kassel, Documenta 5

By then Beuys's activity as a peripatetic art-guru had long since overridden any constraints Düsseldorf might have tried to impose on him. He had become the most celebrated artist to have emerged in German avant-garde circles since the war. His German Student Party had been transformed and enlarged into the 'Organization for Direct Democracy through Referendum'.

At the 1972 Kassel Documenta this was provided with a special space of its own, designated an 'information office', but in reality a kind of shrine to Beuys as a living artwork. He showed no sculptures, but simply debated his ideas with all comers. It was probably the most popular feature of the exhibition. Asked why he brought politics into an artistic context in this fashion, Beuys replied: 'Because real future political intentions must be artistic. This means they must originate from human creativity, from the political freedom of man.' He undertook similar political dialogues elsewhere, significantly tending to use museums and art galleries as his fora. The blackboards on which he made his formulations and demonstrated his ideas were usually afterwards sprayed with fixative and cherished as artworks.

The work of Richard Long, Gilbert and George and Joseph Beuys was usually designated 'sculpture' both by the artists themselves and by those who analysed their work. It did undoubtedly come from a background of art training in sculpture schools – both Long and Gilbert and George trained at the very St Martin's School in London once dominated by Caro and his followers, and in British terms they represent a reaction against the doctrines of the group whom Caro dominated. But by pushing matters so far they created a confusion in the minds of the general audience for art which is felt to this day. The activity of apparently more conventional sculptors who have now arisen to challenge their ideas must be seen against the background provided by their careers during the late 1960s and the 1970s.

# ITALIAN 'ARTE POVERA' AND BRITISH SALVAGE ART

The extremism of the sculpture of the late 1960s created at least as many problems as it did opportunities for artists who felt that the development of modernism committed them to pushing forward the frontier. Indeed Minimal Art in its pure form seemed to propose a final solution of permanent stasis, a point from which no further development was possible. One escape route appeared in the work of Beuys, who proposed that the true role of the sculptor was to be a social catalyst rather than an object-maker. Significantly the purest Minimalists were American, whereas Beuys was European. If one tries to make a general distinction between the work of European avant-gardists and American ones at this time – the late 1960s and early 1970s – the most striking difference between them is the lack of social concern in America, and

Staccioli showed many quasi-Minimal works in Italian urban settings. The shock of their presence in a setting of historic buildings was responsible for a large part of their effect. American Minimalists could not rely so heavily on the historical context.

The *Arte Povera* group of artists in Italy was perhaps the first to provide a collective European response to some of the questions posed by American Minimalism. Like the Nouveaux Réalistes in France, this group was largely the creation of an influential critic, Germano Celant, and its unity was in this sense artificial. Celant organized an *Arte Povera* exhibition in Bologna in 1968, and followed it with a book of the same title the next year. *Arte Povera* is an ambiguous phrase – it can mean either 'poor art' or 'impoverished art'. In any case the allusion was not to the actual quality of

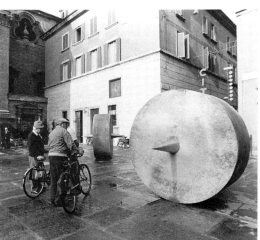

**144. Mauro Staccioli: Sculpture in Urban Setting**
1973. Cement, 87 × 87 × 94 in (220 × 220 × 240 cm). Parma, Piazza della Steccata

**145. Livio Marzot: Ventrello di Stoccafisso**
1970. Dried cod, life-size. Milan, Galleria Salone Annunciata

also the reduction if not total abolition there of the play of allusion. The cultural resonances in the work of European avant-gardists allied to Minimalism but not wholly identified with it were an inevitable consequence of the very different context in which their work was presented. In the 1970s, for instance, the Italian sculptor Mauro

the work but to the common or everyday materials selected by the artists, which was supposed to be to some extent a political gesture. Sometimes the preference for what was visibly humble was carried to exaggerated lengths. In 1970 Livio Marzot presented two pieces of dried cod (in an edition of thirty-three examples) as 'sculpture' at a gallery in Milan. Two years later, at the John Weber Gallery in New York, Giovanni Anselmo showed a projector with one slide, inscribed with the word *tutto* – 'all'. The projected word, not the mechanism, was the artwork.

Yet *Arte Povera* could encompass large and complicated physical structures as well as complicated ideas. In 1972 Mario Merz exhibited an ambitious group of works at the Kassel Documenta. They included a large igloo-like structure and a motorcycle fitted with ram's horns in the place of handlebars. In his own mind, Merz binds together the various elements to be found in his work by reference to the spiral of natural growth which can be observed in objects such as

**146. Mario Merz: Objects**
1972. Mixed media. Kassel, Documenta 5

**147. Jannis Kounellis: Horses, Horses**
1969. Life-size. Rome, Galleria l'Attico (event)

a snail shell or a pine cone. This spiral can be expressed mathematically by the numerical sequence 1, 1, 2, 3, 5, 8, 13, 21, which was first recognized by the medieval mathematician Leonardo Fibonacci.

Other artists connected with *Arte Povera* are the Italian-domiciled Greek Jannis Kounellis and the native Italian Giulio Paolini. What the two have in common is something curiously literary, especially in comparison to their American counterparts. Kounellis is best known for a single

work – the grand gesture of filling a gallery in Rome with a stableful of horses. Another, earlier 'sculpture' consisted of a pianist seated at a grand piano in an otherwise empty room, playing a transcription of 'Va, pensiero', the patriotic chorus from Verdi's early opera *Nabucco*, which became the anthem of the Risorgimento in Italy. Paolini is less inclined to use a sledgehammer to achieve his effects. His works often make self-conscious allusions to the art of the past. *Early Dynastic* is a group of Tuscan columns, a smaller version placed directly on top of a larger. Italy's historic past thus continues to haunt the artist. It is significant that Paolini sees himself chiefly as a manipulator of language, a word whose meaning has been stretched almost as far as the meaning of the word 'sculpture'. The artist hastens to add:

To put it in rather an extreme way, perhaps this great respect I have for language goes hand in hand with a certain lack of faith in it. I have never considered language as a vehicle for communicating something else, but simply as a fact in itself.

**148. Jannis Kounellis: Va, pensiero, sulle ali dorate**
1971. Pianist at a grand piano playing chorus from Verdi's *Nabucco* (event)

**149. Giulio Paolini: Early Dynastic**
1971. Wood. Milan, Studio Marconi

*Arte Povera's* dependence both on the Italian past and the Italian present (it attempted to straddle the deep fissures in Italian society, being simultaneously élitist and democratic), plus the continuing strength of the New York art scene, meant that it did not travel well. A group of English artists who emerged somewhat later, but who shared some of *Arte Povera's* social and intel-

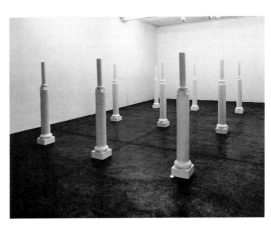

lectual concerns, were more fortunate. It was not merely that the dominance of America was increasingly challenged in the late seventies and early eighties, but that they fitted better into a heavily industrialized society.

The pioneer figure in this group is Tony Cragg, who held his first one-man exhibition in 1979. Cragg's interest is in detritus, the rubbish of industrial civilization – broken and discarded objects

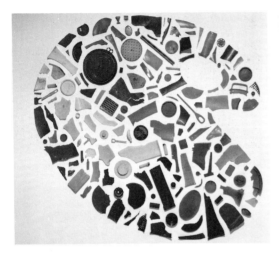

**150. Tony Cragg:**
**Plastic Palette I**
1985. Plastic, 69 × 65 in
(175 × 165 cm). London,
Lisson Gallery

**151. Tony Cragg:**
**Black and White Stack**
1980. Mixed media,
81 × 144 × 15 in
(206 × 366 × 38 cm). London,
Lisson Gallery

made of plastic, metal, rubber, plywood and other everyday materials. Unlike the Surrealists and their successors, who had already made modest use of such materials, Cragg proclaims that he is indifferent to 'magic, alchemy or mystification':

I am not interested in romanticizing an epoch in the distant past when technology permitted men to make only a few objects, tools, etc. But in contrast to today I assume a materialistically simpler situation and a deeper understanding for the making processes, function and even metaphysical qualities of the objects they produced. The social organizations which have proved to be most successful are productive systems. The rate at which objects are produced increases; complementary to production is consumption. We consume, populating our environment with more and more objects, with no chance of understanding the making processes because we specialize in the production, but not in the consumption.

Some of Cragg's pieces consist of simple emblematic designs made on the wall – a Union Jack or artist's palette made from plastic scraps, for instance. Others are stacks or heaps of found material, from which the spectator must disentangle his own set of associations.

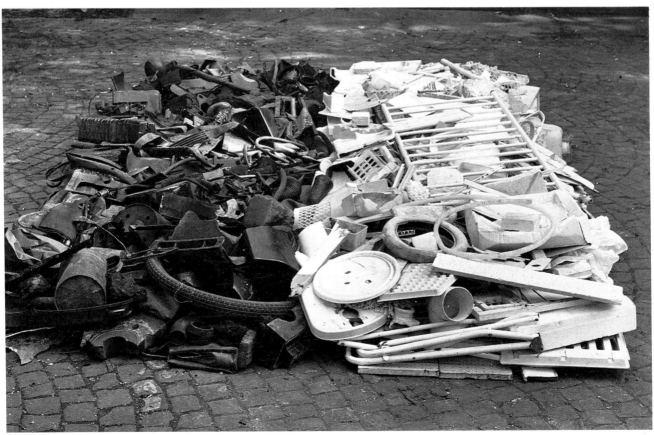

Another recycler of detritus left by the consumer culture is Bill Woodrow. He can be compared with both César and John Chamberlain in a particularly direct way because he makes frequent use of material from wrecked automobiles. It will immediately be seen that his approach is more distanced and more ironic. But Woodrow does not confine himself to automobiles alone. Many things are grist to his mill: old washing machines, dead television sets, a duplicator, some metal lockers, a pail, an armchair, a perambulator –

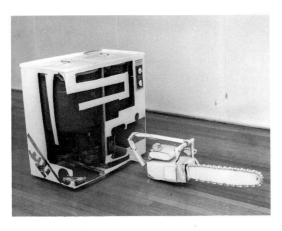

152. Bill Woodrow:
Twin-Tub with Chainsaw
1981. Metal, life-size. London,
Lisson Gallery

153. Richard Wentworth:
Saving Daylight
1984. Glass, metal, twine, steel,
with dud lightbulbs,
18 × 12 × 12 in
(45.7 × 30.5 × 30.5 cm).
London, Lisson Gallery

new or old. All are pressed into service. His work differs from that discussed previously in this chapter because it is unabashedly figurative. His found objects give birth to recognizable images while still retaining their own original character –

a painted metal fish flops from the bottom of the pram from whose belly it has been cut; a twin-tub similarly gives birth to a chainsaw. What is new is not merely the presence of figurative imagery but that of a sense of humour.

This quality recurs in the work of another British sculptor of the same generation, Richard Wentworth. But Wentworth is closer to Duchamp. Typically he subjects common objects to metamorphosis, rather than recycling them. But this metamorphosis involves a kind of double vision.

154. Richard Wentworth:
The Marriage of Babar and
Celeste
1983. Linen, duck-down,
gilded aluminium, life-size.
London, Lisson Gallery

An early work consisted simply of a pillow with a tool lying on top of it. The tool was of a kind used for cutting bricks, known in the building trade as a bolster. Visual/verbal puns of this type are central to Wentworth's activity. *Babar and Fido* consists of two objects – a dogbowl (Fido), and a gilded crown made from a precisely similar dogbowl (Babar, the royal elephant in a children's story). *The Marriage of Babar and Celeste* is also from this series.

Young sculptors found they could move in several directions from the experiments made by Cragg, Woodrow and Wentworth, within the general framework provided by Minimal Art, Conceptual Art and *Arte Povera*. For example, the accumulation of detritus could be manipulated so as to provide a more directly polemical result than Cragg's work usually yields. A notorious example was the life-size mock-up of a Polaris submarine constructed from 30,000 old car tyres loosely wired together by the British sculptor, David Mach, on the occasion of an ambitious survey show of sculpture organized by the Arts Council of Great Britain in London in 1982. This, with its antinuclear message, provoked a member of the public sufficiently to make him set fire to it. The vandal died of burns as a result.

Yet another British sculptor, John Newling, has tried to extend Wentworth's symbolic concerns so as to create a viable language with a continuity of meaning linking one sculpture to another [Col. Pl. 28]. His sculptures are often made of combinations of standard symbolic elements – castle, crown, house, church, rocket, fish. These can be read in different ways, and may be heavy or light, solid or

**155. David Mach: Polaris**
1983. 3,300 car tyres (event)

flimsy, and made of a variety of materials such as wax or lead (here Newling has taken something from Joseph Beuys).

There are increasing indications that British sculptors are trying to break out of what they now regard as the Minimalist/Conceptualist straitjacket. As a result the art of sculpture has never shown greater diversity than it does in the 1980s.

# THE PLURALISM OF THE 1970s

Sculpture in the late 1970s and in the 1980s followed a general tendency towards artistic pluralism. It was no longer possible, as it had once been, to talk of a dialectic of modernist styles, with one style responding to another, either to contradict the assumptions upon which it had been based, or else to extend them. This pluralist tendency was particularly conspicuous in the United States, which still provided by far the biggest market for contemporary art; but it also made itself felt elsewhere.

Some aspects of recent sculpture have amounted to a contradiction of Minimalist assumptions about the independent and wholly self-contained nature of both the art object and the art process. But sometimes this contradiction has been inadvertent. America has continued to build; and with ambitious buildings, both public and commercial, there has been a continuing demand for public

A number of American abstract sculptors have embraced the opportunities thus offered to them, but both they and their patrons have been unwilling to go to the extremes indicated by Minimalist dogma, since this might result in the production of work which is not immediately recognizable as 'art' to the general public. Instead, commissions have gone to highly professional sculptors working in a neo-Constructivist idiom. That Constructivism, originally the child of the Russian Revolution, should thus become the servant of capitalism implies a deep historical irony, even though an unconscious one. A good example of the current neo-Constructivist public style is the work of Lila Katzen. Her steel sculptures such as *Delphi* and *Guardian*, with their boldly sweeping ribbon-like forms, are very successful in animating large spaces, both indoor and outdoor, even though they are by no stretch of the imagination avant-garde.

**156. Lila Katzen: Delphi**
1975. Steel, 17 × 14 × 5 ft
(5.2 × 4.3 × 1.5 m). New York,
Lila Katzen Studio

sculpture. The fragmented nature of contemporary society, its multiplicity of creeds and beliefs, and its wide spectrum of aesthetic prejudices and political opinions has meant that much of this sculpture must be abstract. The 'modernity' of abstract art – still offensive to some – is offset by the fact that it is by its very nature non-specific.

**157. Lila Katzen: Guardian**
1979. Bronze, 35 × 15 × 3 ft
(10.7 × 4.6 × 0.9 m). Saudi
Arabia, private collection

158. Paul von Ringelheim:
Continuum III
1971. Metal. Worcester, Mass.,
Worcester Center

number of his more important works have been designed for heavily trafficked spaces, for example, in the Worcester Center, a large redevelopment project for downtown Worcester, Massachusetts. Here von Ringelheim's sculptures are tall faceted columns of polished metal, suspended in space under the barrel vault of the atrium. The forms are not fussy, but the polished metal of which they are made gives them the necessary dazzle and shimmer to stop them from seeming inert. Von Ringelheim often uses reflective surfaces as a way of breaking up mass, making his work take on some of the energy of environment. Another instance is the set of three polished stainless steel sculptures made for Texas Eastern Corporation's One Houston Center. These are located where there are most people – at the lobby and mezzanine levels of the building.

A veteran of many public commissions who has been willing to learn more from Minimalism than Katzen is the Austrian-born Paul von Ringelheim. Von Ringelheim takes Minimal forms and finds ways of animating them and of making them respond to the nature of their surroundings. A

It is not surprising, given the character of Latin American society, with its need for dramatic gestures and visible symbols, that sculptors there should have received many large-scale public commissions in recent years. One of the most experienced Latin American sculptors in this field is the Mexican Helen Escobedo, who is also a former director of the Museum of Modern Art in Mexico City. Escobedo's concerns are specifically environmental, she says that her approach 'involves an

159. Paul von Ringelheim:
Quantum I, II and III
1977. Steel, aluminium, each:
17 × 30 ft (5.2 × 9.1 m).
Houston, One Houston Center

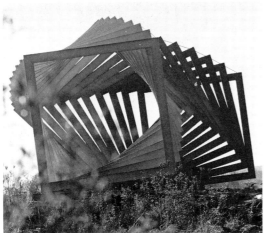

Above
**160. Helen Escobedo:**
**Falling Fence**
1982. Painted concrete,
ht. 26 ft (8 m). National
University of Mexico Cultural
Centre

**161. Helen Escobedo:**
**Snake**
1980–1. Painted steel, 49 ft
(15 m). National University of
Mexico Cultural Centre

if she feels frustrated when her non-permanent environmental sculptures are demolished:

My considered reply is 'no', in view of the fact that so much change occurs in present-day life – buildings are razed almost as often as new ones are constructed, urban environments change from day to day, as do many natural ones ... so much in life is ephemeral, leaving only memories; travel experiences, friendships, sounds and smells, stories told.

These sculptors can be thought of as having chosen to return to a situation before Minimal Art existed. Many more have elected to deal with the difficulties it poses by what can only be described as a strategy of avoidance. A good starting point for any discussion of their work is the art of the American sculptor Mary Miss, an innovator who has not entirely been given her due. Miss could be categorized as a practitioner of Land Art, but she has chosen to develop it in a new and highly original direction. She makes use of excavation, just as Michael Heizer does, but adds a series of constructions, primarily in wood, which are allusions to architecture rather than independent

attempt to fuse hard-edge geometric forms with nature's organic manifestations', and this has been seen in works such as *Snake* of 1981 and *Falling Fence* of 1982. She has also been a specialist in sculpture which is site-specific but not intended to be permanent, a form popular in Latin America long before the recent fashion for it in the United States. She gives an interesting answer when asked

**162. Mary Miss: Perim/DAV/Decoys**
1977–8. Excavation, ground level: 16 sq ft (5 sq m); below ground: 40 sq ft (12 sq m)

**163. Siah Armajani: Bridge over a Nice Triangle Tree**
1970. Wood, tree, 4 × 85 × 11 ft (1.2 × 26 × 3.3 m)

abstract works. Miss, in her notes, makes use of the metaphor of the stage set; it is clear, too, that she thinks in terms of a traditional garden architecture. One of her catalogues contains quotations from James Dickie's *The Islamic Garden in Spain*, and from J.C. Loudon's *The Suburban Garden and Villa Companion* (the latter published in 1836), as well as from Stuart Culin's *Games of the North American Indian*. This third source suggests, albeit obliquely, that there is a strong feeling for play and playfulness in what she does, and this is borne out by the work itself.

Siah Armajani, doing work which is in some ways closely related to that of Mary Miss, has a more learned and self-conscious relationship to architecture, and a greater complexity of aim. In an introductory essay for Armajani's exhibition *Red School House for Thomas Paine* (Philadelphia College of Art, 1978) Janet Kardon puts things as follows:

Armajani shifts among diverse identities in his investigations. As sculptor he uses architectural forms as paradigms for philosophical enquiries. As architect, his program requires that he build models for art spaces, with foundations based upon philosophical tenets. As philosopher, he constructs three-dimensional enquiries, which dissect architecture. As teacher, he draws from the vocabulary of architecture, sculpture, philosophy, linguistics, social concern and perception. His discourse subtly organizes and disorganizes American pragmatism.

These are large claims, and their inclusiveness indicates the distance already travelled from the art of Morris and André. In her reference to 'American pragmatism' Kardon also points to one important peculiarity of Armajani's work (though the artist is Iranian-born, he concentrates on American sources and specifically American qualities) – his art arises from the vernacular of American building, which it throws round its philosophical concerns like a disguise.

This disguising or masking of intention, under the pretence that the activity is in fact only marginally artistic, has become typical of much American sculpture in the 1980s. It reaches an exaggerated pitch in the work of Scott Burton.

**164. Scott Burton: Pair of Two-Part Chairs**
1983–4. Granite, each approx. 33½ × 24 × 30 in (85 × 61 × 76.5 cm). Minneapolis, Minn., Walker Art Center

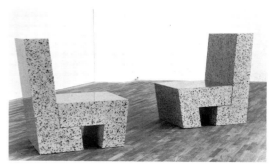

Burton is known for his chairs, presented as sculpture. He began his career as a Conceptual Performance artist, and his chairs and other items of furniture were originally props for his performances. More recently (in November 1983), he was able to declare, to an interviewer from the glossy magazine *Metropolitan Home*:

In a sense, I'm an impersonator – I'm impersonating a furniture designer. Now I know that will make some people uncomfortable, but I've come to furniture in the way Andy Warhol came to film when he began making movies in the sixties. There's this space, this gap between me and the furniture people.

Burton's chairs cover a wide spectrum – some are rough chunks of marble, or aggressive blocks of polished granite. Others, in plastic, leather, metal – the typical materials of the modern industrial designer – are indistinguishable from the high-style items turned out by regular practitioners in this field. Burton gets the best of both worlds as a

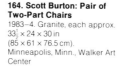

*Above*
**165. Alice Aycock: The Angels Continue Turning the Wheels of the Universe**
n.d. Private collection

*Left*
**166. Alice Aycock: The Miraculating Machine in the Garden (Tower of the Winds)**
1981. Mixed media, ht. 16 ft (4.9 m). Private collection

*Right*
**167. Alice Aycock: One Thousand and One Nights in the Mansion of Bliss**
1983. Private collection

result: his chairs have been acquired for the sculpture collection of the Museum of Modern Art, New York, and exhibited at the Tate Gallery, but he has also been able to patent some of his designs for production purposes. It is not possible to take out a patent on an artwork, under US law. Here, then, is a career which in itself makes a curious commentary on the condition of contemporary sculpture.

The work of Alice Aycock is more immediately recognizable as sculpture, though its non-art sources remain plainly visible. Aycock's earlier pieces incorporated references to architecture which suggest a comparison to both Miss and Armajani. One was a version of the huge observatory in Jaipur, whose instruments are stone-built and the size of buildings. More recent sculpture has taken technology for its reference point, though in an unashamedly subjective way, Aycock has said that, like Tinguely and Duchamp, she has

a penchant for 'false inventions':

I'm not in any way trying to place myself in the position of a scientist or anything like that . . . it's more like using science as a muse. So ideas, especially ideas that have been thrown out like the perpetual motion machine or the ether wind, that are poetic just to think about, become a source of fantasy for me.

A specific example of what Aycock means by this description is a piece entitled *The Miraculating Machine in the Garden* (*Tower of the Winds*), executed for Douglass College, New Brunswick, New Jersey, in 1981. It consists of a structure sixteen feet high, which incorporates 268 antenna, bells ringing in a vacuum, and a cyclotron pipe system for sending vibrations. The sculptural form is a cage for a series of fantasies and ideas, not, for all its elaboration, something with a definite plastic force of its own.

# ETHNOGRAPHY, ARCHAEOLOGY AND CRAFT

Ethnography and archaeology have been an even more fruitful source of the 'disguises' just mentioned than pure science – this is natural enough, since modernism has drawn on ethnographical and archaeological source materials from its beginnings. The interest in architecture is compatible with these; so too is an interest in psychological theory, which can be traced ultimately to the Surrealists. One of the most interesting of the sculptors to have borrowed from such sources in his recent work is the American, Robert Stackhouse.

168, 169. Robert Stackhouse: Running Animals, Reindeer Way 1976. Wood, 12 × 6 × 66 ft (3.7 × 1.8 × 20.1m). New York, Sculpture Now

His originality lies in his ability to create 'places' as well as forms. His sculptures are often mechanisms designed to involve the spectator in a ritual. A spectacular instance was a piece called *Running Animals, Reindeer Way*, made in 1976. This consisted of a curving corridor built of wooden laths and inconspicuously adorned with a pair of reindeer antlers at either end. The corridor was a symbol of the migratory track of the reindeer – individuals moving within it seemed, when glimpsed through the laths by those outside, to be animals moving stealthily through a forest.

Stackhouse has also made apparently literal references to archaeological source material, for example to Norse ship burials as in *Mountain Climber*. But here, too, there is a metaphysical

170. Robert Stackhouse: Mountain Climber 1982. Wood, approx 20 × 12 ft (6.1 × 3.7 m). New York, Max Hutchinson Gallery

element – the ship is perceived as a universal symbol of transition. One reason why this and other metaphors succeed in making their effect is that the artist remains visibly contemporary in his *Angst*-ridden pursuit of the self. The present-day audience automatically identifies his elaborate constructions as an attempt to objectify unconscious experiences and to synthesize these with conscious knowledge about the world and its past.

**171. Anish Kapoor:**
**Six Secret Places**
1983. Mixed media,
45¼ × 256 × 23⅝ in
(115 × 425 × 60 cm). London,
Lisson Gallery

**172. Stephen Cox:**
**The Fiery Kind**
(from the *Ecstasies* series)
1982–3. Marble, 39⅜ × 43¼ in
(100 × 110 cm). London,
British Council

*Opposite*
**173. Anne and Patrick**
**Poirier: Archaeological**
**Model**
1986. Bath International
Festival

A similar endeavour can be sensed in the otherwise very different work of Anish Kapoor, born in India but domiciled in England. The motivating force in Kapoor's work is the desire to come to terms with his Indian heritage. As he himself says, it has been part of a process of 'learning how to be Indian' – how to get to grips with Hindu mythology, art and architecture without being openly imitative. Kapoor makes objects which are shaped like large fruit or sea-shells (though without closely imitating the forms of either), or which are geometrical, or symbols for parts of the body, or simplified emblems of landscape. Many are tinted with powder pigments in bright, matt hues of the kind associated with Indian crafts. At one stage Kapoor used to let the powder pigment spread from the form itself and create a kind of halo around it, but now he is content simply to colour the object. In *Six Secret Places* the various forms, their colours and the way they are arranged in a particular space, make up the equivalent of an Indian tantric diagram – a focus for meditation, and also a means of living through a particular mythological experience. Obviously in these circumstances the effect of Kapoor's work is even less precisely measurable than that of most works of art. He himself says:

Working is something to do with contemplation, which itself is an act of prayer. The most important thing that one is doing is making a transformation. That act of transformation is the same as an act of prayer, consecrating a particular time which is separated from one's ordinary life. The same is true of the transformation of the character of the place in which work is made or shown.

The references in Kapoor's work are Jungian, those in that of the English sculptor, Stephen Cox, are Kleinian, thanks to the considerable influence exercised over him by the writings of Adrian Stokes. In particular, Cox has often made the part, and especially a part of the body such as a breast, stand for the whole. At the start of his career his work was Minimalist, flat planar slabs of marble or plaster, with faint perspective designs incised in them, which were then propped against a wall so as to echo the surrounding space. More recent works have been inspired by the sculpture and painting of the Renaissance, and particularly by the carved reliefs of the quattrocento sculptor Agostino di Duccio, made for the Tempio Malatestiano in Rimini. In the early 1980s Cox produced a sereis of 'broken' reliefs, with pictorial

imagery deliberately reduced to shattered fragments. These make an appeal to the archaeological taste that finds pleasure in the partial reconstructions of certain Roman frescoes and mosaics now on display in museums, where the continuity of the image is sacrificed to an imposed standard of authenticity.

Archaeological reconstruction as a language for sculpture finds its most ambitious expression in the work of a French couple, Anne and Patrick Poirier. The Poiriers construct archaeological models, of sites both real and imaginery, and also make architectural collages, often employing mouldings made from genuine classical fragments. They make free use of mythological allusion. Anne Poirier says:

We always try to lead the spectator to a sort of 'poetic' space, not in the sense of poetry but of unreality. By that we mean spaces of a different nature than that of everyday life. But we also put the spectator on a stage. And scale plays an important part here, whether it be in the miniature models of sites where the spectator must mentally shrink in order to walk through it as though in a town, or in the gigantic works which he must walk around.

**174. H. C. Westermann: Death Ship USS Franklin Arising from an Oil Slick Sea**
1976. Painted and enamelled ebony, 33¼ × 7¼ × 10½ in (84.5 × 18.4 × 26.7 cm). New York, Xavier Fourcade Inc.

**175. H. C. Westermann: Soldier**
1976. Wood, 24½ × 24 × 35 in (62 × 61 × 89 cm). New York, Xavier Fourcade Inc.

Works making ethnographical, archaeological and architectural references are not, however, the only alternative now offered to Minimal and post-Minimal Art. There is also sculpture which comes from a very different source, which is generally more direct than the work just described. It finds its escape from late modernist dilemma via an involvement in craft. Some sculptors in this group have been, in attitude if not truly in fact, autodidacts, working in isolation, protected from critical theorizing by the strength of their personal obsessions. An important and early example of this tendency is the Chicago artist H. C. Westermann, whose meticulous *Death Ships* embody the terror Westermann suffered during the war against Japan

in the Pacific. Dennis Adrian, the doyen of Chicago School critics, notes correctly that his work has no clear stylistic antecedents. It uses craft and hobbyist techniques to present the spectator with a series of savage visual paradoxes – images of horror which have emerged, in all their trim neatness, from a gifted model-maker's workshop.

When, at the very end of his career, the English sculptor/toymaker Sam Smith was offered a retrospective exhibition at the Serpentine Gallery in London, a prestigious official space, he made it a condition that the event should be shared with Westermann, the artist whom he most admired among his contemporaries. Smith's own career pattern was unorthodox, even more so than Wester-

mann's, and his work was deeply marked by it. Born in 1908 in Southampton, he trained at art school but could not support himself as an artist or illustrator because of the Depression. He worked as a handyman, and later drifted into being a craft toymaker. In the 1960s Smith's toys became more and more elaborate, and with works such as *No. 3 Mermaid House* evolved into something recognizable as sculpture, though his work was never on a large scale. He always remained very modest about what he did, saying that he had 'stopped having pretensions about being an artist', and had instead become 'an ordinary person, making things about ordinary people who would get as wet as I would in the rain'. In fact, all his

creations have delightful fantasy and humour, but also communicated moral and social ideas with a directness which has became quite unusual in contemporary art. Smith wrote, in the preface to his retrospective show:

As I get older I get less interested in the way a thing looks and more interested in the spirit that hides within it; so the things are meant to be looked into, rather than looked at. When working, I start with an idea but ideas can develop wills of their own and take off in directions unplanned by me. It is all a great mystery. I am thinking about people all the while, and I find I begin to act out the parts of the people I am making. I try to find the real people, behind the pretences and vanities of everyday life.

**176. Sam Smith: No. 3 Mermaid House (There may be other Mermaid's Houses, but never another like this)**
1961. Wood, string, velvet, paper, ht. 7¾ in (19.7 cm).
Private collection

**177. Sam Smith: Witz**
1979. Wood, mixed media, ht. 13½ in (34.5 cm).
Private collection

**178. Robert Arneson: Captain Ace**
1978. Glazed ceramic, 45 × 24 × 18 in (114.3 × 61 × 45.7 cm). Amsterdam, Stedelijk Museum

**179. Robert Arneson: A War Memorial**
1983. Glazed ceramic, 37 × 38 in (94 × 96.5 cm). New York, Allan Frumkin Gallery

*Below*
**180. Viola Frey: Ceramic Figures**
1983–4. Fired clay. Los Angeles, Asher Faure

Another moralist with a background in the crafts is the American ceramic sculptor Robert Arneson, Arneson comes from, and has remained identified with, the California art scene, where the boundary between the fine arts and the crafts has traditionally been much less firmly drawn that it is in the east of the United States. One of his first public appearances as an artist was in the *Funk*

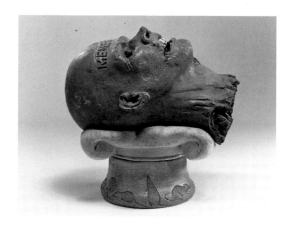

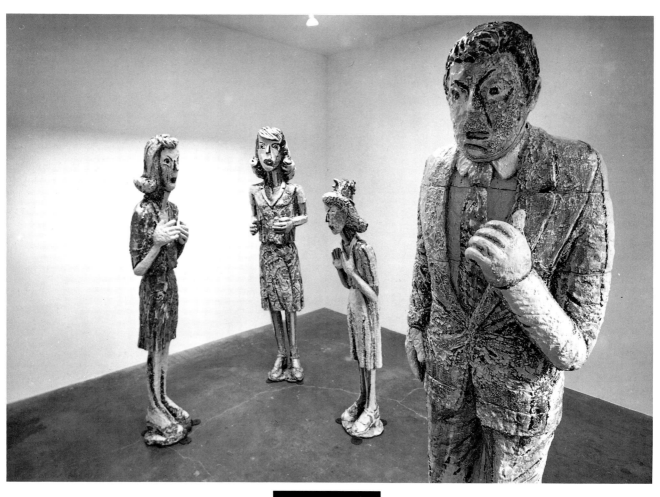

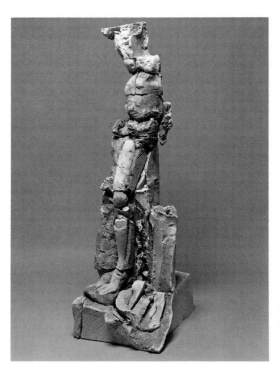

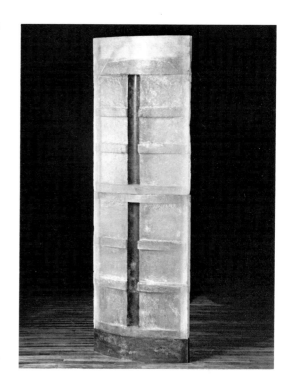

**181. Stephen de Staebler:
Right-sided Woman,
Sitting**
1985. Clay, 63½ × 21 × 25 in
(161.3 × 53.3 × 63.5 cm).
Private collection

**182. Howard Ben Tré:
Second Figure**
1986. Cast glass, copper,
brass, 80 × 28 × 11 in
(203 × 71 × 28 cm). New York,
Charles Cowles Gallery

*Art Show*, at the Institute of Contemporary Arts in Boston, which served to identify a particular kind of California temperament, related to but not identical with the cast of mind which produced the rise of Pop Art in New York. One difference between the two, however, was that the practitioners of Funk were simultaneously more up front and more laid back. These qualities Arneson has retained to this day. His original reputation was founded on a self-mocking attitude towards the artist's vocation expressed through a series of ever more inventive self-portraits. A comparatively recent work, *California Artist* of 1982, spells out his contempt for East Coast prejudices – one New York critic had just been inveighing against the 'thinness and spiritual impoverishment' of cultural life in California. Arneson riposted by showing himself half-length, denim shirt revealing a bare torso, arms folded, with a blue emptiness of his skull visible through the non-existent lenses of the dark glasses he was wearing. The half figure was placed on a peeling plinth with a marijuana plant growing up it.

In recent years Arneson has become an impassioned anti-nuclear campaigner, and this preoccupation has become the major subject of his art – horrific images of the victims and makers of a nuclear holocaust, executed in a style whose forthright rhetoric is at the furthest pole from the willed neutrality of still-surviving Minimalists.

Arneson, however, is important not only for his subject-matter but his technique. He is a brilliantly gifted ceramicist, and clay (after a long hiatus) is again a major medium for American sculpture, especially in California. Its last epoch of popularity was in the 1930s, under the WPA, and the populist implications of choosing this, the most common of all material, were the same then as they are now. Other major ceramic sculptors are Viola Frey and Stephen de Staebler. The latter brings this chapter full circle because he makes monumental but apparently crumbling ceramic figures like *Right-sided Woman, Sitting* which have tantalizing, though never quite specific, resemblances to Ancient Egyptian art. The Ancient Egyptian influence is also, though perhaps only coincidentally, visible in the work of Howard Ben Tré, probably the most distinguished artist now working in the overcrowded and congenitally mediocre field of sculpture in glass, an uneasy territory located somewhere between craft and fine art. Ben Tré's monumental cast-glass columns with simple capitals make obvious reference to Ancient Egyptian architecture [Col. Pl. 32].

# THE RETURN TO FIGURATIVE IMAGERY

The late 1970s and early 1980s witnessed yet another revolutionary change in contemporary art: a return to imagery, together with a renewed interest in expressiveness. This was accompanied by a renewed assertion of the rights of painting, as opposed to those of sculpture, then established for more than a decade as the dominant form of art. The new painters were mostly European rather than American: artists of the new German school of neo-Expressionists – Georg Baselitz, A. R. Penck, Anselm Kiefer, Rainer Fetting, Markus Lüpertz, Jorg Immendorf and others; and a similar but somewhat smaller group of artists from Italy – Mimmo Paladino, Sandro Chia, Enzo Cucchi and Francesco Clemente. America did not give up her rights altogether – associated with these Europeans were one or two painters from across the Atlantic, the most notable of them being the prodigiously energetic Julian Schnabel. But despite the presence of these among the elect, it was plain that American superiority in the visual arts was faced with its most serious challenge since the rise of Abstract Expressionism.

The traditional prestige of American art and the power of the American art market were such that many of the new European artists flocked to New York and increasingly made their careers in that city. Similarly, sculpture did not lose its glamour overnight. Many of the new painters began to experiment with three-dimensional work – though of course they did it on their own terms. Their exemplars were not the sculptors who had established themselves since the war, but certain masters of the first modernism – painters who had nevertheless made considerable quantities of sculpture, such as Matisse, Picasso and Miró.

Particularly important to this new generation was Picasso's unconventional and impatient approach to working in three dimensions. It was he, more than any other individual, who had liberated the actual practice of sculpture, by breaking down the existing hierarchy of materials. In Picasso's sculpture, anything could be pressed into service, from a dilapidated basket to a toy car. For Picasso, making sculpture involved a constant process of metamorphosis, a promiscuous mating of thoughts, ideas and images. He was thus entirely opposed to the didactic impulse which typified so much of the avant-garde sculpture of the late 1960s. And, by contrast, he remained wholly in touch with one of the fundamental impulses of modern art, which is to challenge the spectator's habitual perception of appearances.

Yet the sculpture actually produced by members of the new group of painters strikes me as less interesting than the impulse which led them to produce it. One of the best known of those who have essayed a double role is Georg Baselitz, who made his debut as a sculptor with a large wood

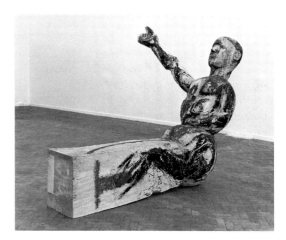

**183. Georg Baselitz: Model for a Sculpture**
1980. Wood, ht. 80 in (200 cm). Vienna, Museum des 20 Jahrhunderts

carving entitled *Model for a Sculpture*, which was shown at the Venice Biennale of 1980. It is an indication of the artist's prestige that he was thus able to begin at the top. But the piece hardly lived up to the circumstances in which it was shown. Large, roughly hewn, with its lower part still embedded in the block, it invited comparisons

with the sculptures made by the original German Expressionists, particularly Ernst Kirchner, and failed to sustain them. The primitivism of Baselitz's work in three dimensions was not the sophisticated primitivism of African art, but the feigned amateurism of Dubuffet's *Art Brut*. Dubuffet, whom Baselitz admires greatly, often extracted real poetry from the awkward handling of apparently unsuitable materials. This and subsequent carvings by Baselitz are an unhappy combination of awkwardness and rhetoric.

The willed awkwardness of Baselitz's work does, however, find frequent echoes in the work of contemporary sculptors who are not painters – for example, in recent work by the Englishman Barry Flanagan. Flanagan's career has reflected the recent history of sculpture. In the 1960s he was making Minimal works with common materials – sacks, lengths of rope, hessian bags filled with sand. Later he used incised and carved stone. In *A Nose in Repose* it has been given the characteristically fragmentary, primitive, gnomic look

**184. Barry Flanagan:
Installation**
1969. Painted rope, projected light. London, Hayward Gallery

**185. Barry Flanagan:
A Nose in Repose**
1977–9. Stone, elm;
$35\frac{1}{2} \times 30\frac{1}{2} \times 13\frac{3}{4}$ in
$(90 \times 77 \times 35$ cm). London, Waddington Galleries.

which seems to relate his creations to archae-
ological finds. Finally, in 1979, Flanagan began to
produce cast-bronze sculptures. The chief charac-
teristic of sculptures such as *Acrobats* [Col. Pl. 31]
is the way the naïveté of the modelling, the almost
child-like simplicity of the approach, seems to
contradict the sophistication of the technique.
Flanagan is well aware of this. In a brief preface
to an exhibition of his work in bronze at the Wad-
dington Galleries in London, he said:

By the close of the seventies, fashion and aspirations
had been continuously qualified by larger external
events, and expedients of production put into perspec-
tive. The introduction of some concept of trade, drawing
on the traditional resources of practice to produce sculp-
ture, became necessary. When out of the garret one no
longer works alone, but finds a place in the scheme of
things.

I am glad to point out that in the production of these
pieces in bronze the *work* has been done by others,
leaving only the modelling to me, as author. Thank you.

Another British artist who returned to tra-
ditional bronze-casting at this time, though in a
less conspicuously ironic spirit than Flanagan, was
Michael Sandle. Sandle's favourite image is that
of a tomb, which can also be a bridge, a sledge or
a raft – all means of passing over from one place
or set of conditions to another. His tombs are
generally small – models for monuments rather
than the monuments themselves – but they are
ambitiously dedicated to great concepts and great
men: the engineer Isambard Kingdom Brunel and
the composer Anton Bruckner. Sandle not only

reverts to a traditional technique, but looks back
nostalgically beyond modernism to nineteenth-
century sculpture. One small but telling detail
brings his attitudes home – the mouldings on his
tomb-bases are often quotations from the works of
Alfred Gilbert, now best remembered for the
statue of *Eros* in Piccadilly Circus.

In Sandle's work one notes a deliberate search
for literary meaning and a liking for the discordant
rather than the unitary. The same elements appear
in Flanagan – for example in a piece which shows
a monkey clinging precariously to the back of a
copy of one of the horses of San Marco.

Among American artists, the sculptor who has
most spectacularly exploited the possibilities
offered by bronze casting is Nancy Graves. Her
polychrome bronzes are made of many separate
parts welded together. Often these parts are cast

**186. Nancy Graves: Fayum**
1982. Polychrome bronze,
77$\frac{1}{2}$ × 78 × 57 in
(197 × 198 × 145 cm). New
York, Knoedler

*Below*
**187. Michael Sandle:
Proposed Monument to
Isambard Kingdom Brunel**
1981. Bronze, 33 × 10 in
(84 × 25 cm). London, Fischer
Fine Art

from life – leaves, bean pods, vegetables, small fish, palm fronds – thus reviving a tradition known both to Italian Renaissance bronze casters and to the Japanese. Sometimes the components are cast from manufactured objects, such as paper fans, or pairs of scissors. The polychrome represents another aspect of the artist's virtuosity, since it is patination rather than paint. The results are exuberantly decorative; though Graves's plant-like forms are very different from Sandle's bronzes in both appearance and mood, both sculptors are moving in a direction which can be described loosely as post-modernist.

The nervously parodistic element which so often surfaces in Flanagan's sculpture now makes frequent appearances elsewhere. It plays a large role in the work of the American artist Jonathan Borofsky, whose mechanized figures, nattering ceaselessly to themselves on a taped soundtrack,

seem both a satire upon and a confession of the inanity of a great deal of modern art.

A more substantial American sculptor, in some ways directly comparable to Flanagan, is Joel Shapiro. Shapiro's sculpture is famous for being small, in a category where so many artists strive to be overwhelming and end by being overween-ing. His earliest works were shelves displaying neatly finished slabs of material – these were shown in 1969. By 1972 he had begun making small, very simplified images, first in balsa-wood, then in cast iron, but the figurative element disappeared again by the middle of the decade. At this point the small, dense shapes of Shapiro's works such as *Untitled* (1977) seemed to imply, as Carter Ratcliff wrote, that the established Minimalists were both 'excessive' and 'overbearing'. The figurative ref-erences, as it transpired, could not be held at bay indefinitely, and Shapiro's recent sculpture is not

only figurative, and in bronze, but depicts the human figure – modestly sized, dancing stick-men who seem to look back at the Cubists with a certain affectionate scepticism.

The much praised young British sculptor, Richard Deacon, alludes to Constructivism in much the same way that Shapiro alludes to Cubism – ironically, keeping the original style at

**190. Joel Shapiro: Untitled**
1986. Bronze, $50\frac{1}{2} \times 35\frac{3}{4} \times 30\frac{1}{4}$ in ($128.3 \times 90.8 \times 76.3$ cm).
Beverly Hills, Alan Shayne

*Left*
**189. Joel Shapiro: Untitled**
1977. Bronze, $10 \times 18 \times 9\frac{3}{4}$ in ($25.4 \times 45.7 \times 24.8$ cm). New York, Paula Cooper Gallery

*Below*
**191. Richard Deacon: For Those Who Have Ears**
1983. Laminated wood, $144 \times 108 \times 60$ in ($366 \times 275 \times 152$ cm). London, Lisson Gallery

arm's length. His sculptures come out of the now well-established tradition of 'process art' – that is, the final appearance of the piece is also a record of the way in which it has been made. But there are also figurative allusions which undermine the stringent Constructivist ethos. Deacon has been strongly influenced by the poetry of Rainer Maria Rilke, a writer whose subtle, ambiguous and often

*Left*
**192. Richard Deacon:**
**Tooth and Claw**
1986. Galvanized steel, carpet.
London, Lisson Gallery

*Right*
**193. Tom Otterness:**
**Fountain**
1984. Cast bronze,
59 × 35½ × 35½ in
(150 × 90 × 90 cm). New York,
Brooke Alexander Gallery

deliberately elusive art is at the opposite extreme from the Constructivist demand for plain statement or 'concreteness'. For Deacon it is not appearance itself which counts, but the resonance or after-echo of the experience of looking at the piece.

A far more elaborate parody of early modernism can be found in the work of Tom Otterness. In fact, he parodies not only aspects of modernism, but modernism's implied relationship with the 'high art' of the past. Everything is grist to the mill – Otterness is an incredibly fluent and prolific inventor of narrative scenes. One finds things borrowed from the classical heritage, and others taken from African civilizations, such as Benin. A wide range of archetypes is processed and reduced to a single convention – that of an energetic, roly-poly figure, a kind of Michelin Man. These figures are restlessly combined and recombined; at one time Otterness thought of them as sculptural decoration which could be sold by the yard – now he seems to take them more seriously. A comparison with the work of the Poiriers is in order, as Otterness, too, seems intent on creating an imaginary civilization.

Perhaps the most significant thing to be happening in contemporary sculpture is the return to early modernist roots. Visible but not always primary in the work of Shapiro and Otterness, it plays a major role in recent work by Italo Scanga,

Glynn Williams and Bryan Illsley. The striking thing is that all three achieve such different results while apparently pursuing the same direction.

Scanga's intricate constructions of painted wood have been described as 'post-modern'. In the *Metaphysical* series he in fact explores established modernist ideas – one might say the clichés of modernism – without preconceptions and without undue respect [Col. Pl. 30]. Common objects – toys, pieces of rope, musical instruments – are part of the material for the intricate collages with which he makes standing figures. One obvious source for Scanga's work is the three-dimensional Cubist collage of Picasso. But he also owes a lot to Picasso's theatrical designs of the Cubist period. Scanga's constructions are closer to the figures of the 'managers' in the ballet *Parade* for which Picasso designed the decor in 1917, than they are to any actual Picasso sculpture. Another important source is the metaphysical period of Giorgio De Chirico, not merely De Chirico's personages but the architecture that surrounds them, with its compressed, tilting perspectives. Scanga's art is exuberant, full of high spirits, not in the least solemn. Yet it breathes a confidence in the artist's power to create and transform that was missing from much of the sculpture of the 1970s.

Glynn Williams has been a hugely controversial figure in the British art scene of the 1980s because of his decision to turn his back on some of its most

cherished assumptions. It is not so much that he commits the fault of being figurative – England now has plenty of figurative sculptors – but that he uses the figure as a vehicle for very basic human emotions in a way that has been unfashionable since the Second World War, portraying the affection of two sisters, the love of a mother for her child, or, in *Kneeling, Holding, Protecting*, a man's protective attitude towards the infant riding on his shoulders. When the Whitechapel Art Gallery in London staged a two-part survey of British sculpture in 1981, Williams was the maverick figure who attracted attention – most of it hostile – in the second part, which surveyed the recent past and the present. He clearly called into question nearly all the values embraced by the other exhibitors. Worse still was the fact that he was known to know better. Williams had been a figurative sculptor in his student days, and after a long period of abstract experiment suddenly decided to return to the figure. He is an exceptionally gifted stone carver in a purely technical sense, and the feeling that this skill was not being used to its fullest in his abstract work may have played a part in his decision. The convention he found for his work was an Expressionist one, but not in the sense that one would use that adjective of Baselitz. The obvious ancestors of his forceful carvings of the 1980s are the stone sculptures of Jacob Epstein – the occasional works, such as *Genesis, Adam* and *Consummatum Est* which Epstein produced at intervals in the inter-war period.

A revival of early modernist ideas also plays a part in the sculpture of Bryan Illsley, another gifted English artist. Like Sam Smith, Illsley owes his reputation to the craft scene, to toymaking in particular. He worked as a jeweller in the somewhat enclosed artistic community of St Ives in Cornwall, then branched out into making wooden toys, much rougher in finish than Sam Smith's, and also harsher in meaning. From there he moved to making sculpture which has no pretence to be toy-like. Some is in wrought iron, often partly made up of bits of agricultural implements found in the fields; some also makes use of rough pieces of wood and other elements. It is clear from the forged and wrought iron pieces that Illsley has a feeling of affinity and even reverence for the work of early modernists such as Picasso, Gonzalez and Miró. What is interesting is the way he subverts their work while apparently imitating them. A female bust with the strongest links to Picasso in the various conventions used for representing parts

of the body, will, on closer examination, turn out to be more like a Picasso drawing than any Picasso sculpture. The effect is mannerist and disturbing. Some of the mixed-media pieces have a brutal directness whch has been missing from most post-war sculpture. One called *A Woman Carrying* consists essentially of a rough log supported by two pairs of equally rough iron legs. Slung around the middle of the log, and dangling from it on a frayed rope, is the large, pierced stone which represents the woman's pregnancy.

**194. Brian Illsley:
A Woman Carrying**
1980. Wood, iron, stone, ht. 49 in (125 cm). Private collection

It is artists such as these, with their sophisticated knowledge of the modernist past and the multiple stylistic possibilities it offers, who seem to offer the best hope for contemporary sculpture. Modernism has now, after many struggles, established itself as the legitimate expression of twentieth-century culture in the visual arts, and this, together with the tremendous growth of museums mentioned in the preface, means that at the moment avant-garde sculptors are being offered enormous opportunities. But much modern sculpture is dehumanized, and additionally much of it seems content to work out highly specialized stylistic problems on a disproportionately vast scale, so that the nineteenth-century rhetoric that the early modernists renounced comes creeping in by the back door. It is these artists who are once again interested in conveying simple human feeling who seem to represent the best of the multiple futures now available to sculpture.

*Opposite*
**195. Glynn Williams:
Kneeling, Holding, Protecting**
1984. Ancaster stone, ht. 88 in (223.5 cm). Japan, Hakone Open Air Museum

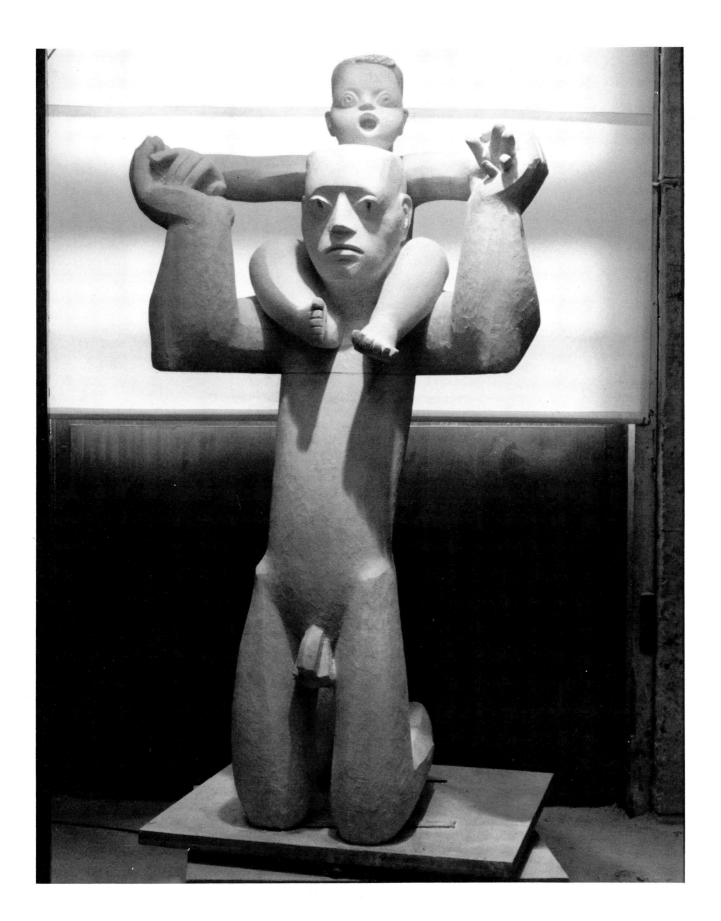

# BIBLIOGRAPHY

Götz Adriani, Winfrud Kannertz and Karim Thomas, *Joseph Beuys, Life and Works*, Barron's, New York, 1973

*American Sculpture of the Sixties*, catalogue of an exhibition, Los Angeles County Museum of Art, 28 April–25 June 1967

*Carl André: Sculpture 1959–1978*, catalogue of an exhibition, Whitechapel Art Gallery, London, 17 March–23 April 1978

Valentina Anker, *Max Bill, ou la recherche d'un art logique*, Editions l'Age d'Homme, Lausanne, 1979

*Kenneth Armitage*, catalogue of an exhibition, Whitechapel Art Gallery, London, July–August 1959

H. H. Arnason, *Theodore Roszak*, Walker Art Center, Minneapolis, 1956

H. H. Arnason, *Calder*, Thames & Hudson, London, 1971

*Jean Arp at the Metropolitan Museum of Art*, Metropolitan Museum, New York, 1972

Artes Visuales 8, *Escultura en Mexico, de 1920 a la fecha*, Museo de Arte Moderno, Mexico D.F., 1975

Stephen Bann, Reg Gadney, Frank Popper and Philip Steadman, *Kinetic Art*, Motion Books, London and New York, 1966

Gregory Battcock (ed.), *Idea Art*, Dutton, New York, 1973

Graham W. J. Beal, George W. Neuburk, *Robert Graham: Statues*, Walker Art Center, Minneapolis, 1981

*Max Bill: oeuvres 1928–1968*, catalogue of an exhibition, Centre National d'Art Contemporain, Paris, 30 October–10 December 1969

*Louise Bourgeois*, The Bellport Press, New York, 1986

Guy Brett, *Kinetic Art, the Language of Movement*, Studio Vista, London, and Reinhold Book Corporation, New York, 1968

Richard Buckle, *Jacob Epstein, Sculpture*, Faber, London, 1963

Martin H. Bush, *Duane Hanson*, Wichita State University, Wichita, Kansas, 1976

*Reg Butler*, catalogue of an exhibition, Tate Gallery, London, 16 November 1983–15 January 1984

Ernesto Caballo, *Marino Marini*, Zwemmer, London, 1980

Alexander Calder, *Alexander Calder, an Autobiography with Pictures*, Pantheon, New York, 1966

*Lynn Chadwick*, catalogue of an exhibition, Musée d'Art Moderne, Paris, 7 February–10 March 1957

*Chamberlain*, catalogue of an exhibition, Kunsthalle, Bern, 12 October–18 November 1973

Michael Compton and David Sylvester, *Robert Morris*, catalogue of an exhibition, Tate Gallery, London, 28 April–6 June 1971

Mario De Micheli, *Scultura Italiana del Dopoguerra*, Schwarz Editore, Milan, 1958

Albert Elsen, *Seymour Lipton*, Abrams, New York, 1977

David Finn, *Henry Moore*, Thames & Hudson, London, 1977

Lucio Fontana, *Archivio Lucio Fontana*, Milan, 1974

*Fontana*, catalogue of an exhibition, Palazzo Pitti, Florence, April–June 1980

Richard Francis, *Jasper Johns*, Abbeville, New York, 1984

Margaret Gardner, *Barbara Hepworth: a Memoir*, Salamander Press, Edinburgh, 1982

*Alberto Giacometti*, catalogue of an exhibition, Tate Gallery, London, 17 July–30 August 1965

*Alberto Giacometti*, catalogue of an exhibition, Solomon R. Guggenheim Museum, New York, 1974

*Gilbert & George, 1968–1980*, catalogue of an exhibition, Municipal Van Abbemuseum, Eindhoven, November 1980

John Gordon, *Isamu Noguchi*, Whitney Museum of American Art, New York, 1968

*Robert Graham*, catalogue of an exhibition, Whitechapel Art Gallery, London, 21 May–21 June 1970

Pierre Guéguen, *Témoignages pour la Sculture Abstraite*, Editions A. A. Boulougne-sur-Seine, and Denise René, Paris, 1956

A. M. Hammacher, *Barbara Hepworth*, Thames & Hudson, London, 1968

A. M. Hammacher, *The Evolution of Modern Sculpture*, Thames & Hudson, London, 1969

A. M. Hammacher, *Marino Marini: Sculpture, Painting, Drawing*, Thames & Hudson, London, 1970

Anne d'Harnoncourt and Kynaston McShine (eds.), *Marcel Duchamp*, Museum of Modern Art, New York, 1973

Barbara Hepworth, *A Pictorial Autobiography*, Moonraker Press, Bradford-on-Avon, Wiltshire, 1979

*Eva Hesse*, catalogue of an exhibition, Solomon R. Guggenheim Museum, New York, 1972

Timothy Hilton, *Picasso*, Thames & Hudson, London, 1975

J. D. Hodin, *Emilio Greco, Sculpture and Drawings*, Adams & Dart, Bath, 1971

*Rebecca Horn*, catalogue of an exhibition, Centre d'Art Contemporain, Geneva, 30 April–30 May 1983 (also shown in Zurich, Southampton, London and Chicago)

*Bryan Illsley*, catalogue of an exhibition, Crafts Council Gallery, London, June–July 1984

*In Tandem: the Painter-Sculptor in the Twentieth Century*, catalogue of an exhibition, Whitechapel Art Gallery, London, 27 March–30 May 1986

Ionel Jianou, *Brancusi*, Adam Books, London, 1963

Ellen H. Johnson, *Claes Oldenburg*, Penguin, Harmondsworth, Middlesex, 1981

*Allan Jones*, catalogue of a retrospective exhibition, Walker Art Gallery, Liverpool, 17 March–25 April 1979

*Don Judd*, catalogue of an exhibition, Whitney Museum, New York, 27 February–24 March 1968

Donald Judd, *Complete Writings, 1954–1975*, New York University Press, New York, 1975

*Philip King*, catalogue of an exhibition, Hayward Gallery, London 24 April–14 June 1981

Diane Kirkpatrick, *Eduardo Paolozzi*, Studio Vista, London, 1970

Jean Lipman, *Nevelson's World*, Hudson Hills, New York, 1983

Edward Lucie-Smith, *Art in the Seventies*, Phaidon, Oxford, and Cornell University Press, Ithaca, NY, 1980

Edward Lucie-Smith, *American Art Now*, Phaidon, Oxford, and William Morrow, New York, 1985

*Lumière et Mouvement; art cinétique à Paris*, catalogue of an exhibition, Musée d'Art Moderne de la Ville de Paris, May–August 1967

Garrett McCoy, *David Smith*, Allen Lane, London, 1975

Kynaston McShine (ed.) *Joseph Cornell*, Museum of Modern Art, New York, 1980

Robert Maillard (ed.), *A Dictionary of Modern Sculpture*, Methuen, London, 1962

Robert Melville, *Henry Moore, Sculpture and Drawings*, Thames & Hudson, London, 1970

Ursula Meyer, *Conceptual Art*, Dutton, New York, 1972

Edwin Mullins, *The Art of Elizabeth Frink*, Lund Humphries, London, 1972

*The New Generation*, catalogue of an exhibition, Whitechapel Art Gallery, London, March–April 1965

Isamu Noguchi, *A Sculptor's World*, Thames & Hudson, London, 1967

Frank O'Hara, *Nakian*, Museum of Modern Art, New York, 1966

*Dennis Oppenheim*, catalogue of an exhibition, Musée d'Art Contemporain, Montreal, 1978

Carmen Ortega Ricuarte, *Dicionario de Artistas en Colombia*, Playa & Janes, Editores Colombiana Ltda., Bogatá, 1979

Harold Osborne (ed.), *The Oxford Companion to Twentieth Century Art*, Oxford University Press, London and New York, 1981

*Paolini: Opere 1961/73*, Studio Marconi, Milan, 1973

*Eduardo Paolozzi*, catalogue of a touring exhibition, Arts Council of Great Britain, April 1976–February 1977

*Eduardo Paolozzi, Recurring Themes*, catalogue of an exhibition, Musée Saint-Pierre, Lyons, 11 October–18 November 1985

Roland Penrose, *The Sculpture of Picasso*, Museum of Modern Art, New York, 1967

*Pioneers of Modern Sculpture*, catalogue of an exhibition, Hayward Gallery, London, 20 July–25 September 1975

Anne and Patrick Poirier, *Domus Aurea*, Les Presses de la Connaissance, Paris, 1977

*Arnaldo Pomodoro*, catalogue of an exhibition, Galerie Internationale d'Art Contemporain, Paris, 19 May–20 June 1962

*Arnaldo Pomodoro, Scultura nella Città*, catalogue of an exhibition, Commune di Pesaro, summer 1971

Carlo Ludovico Ragghianti, *Giacomo Manzù, Sculptor*, Edizioni del Milione, Milan, 2nd edn., 1957

H. Rand, *Seymour Lipton*, National Collection of Fine Arts, Washington D.C., 1979

Herbert Read, *Lynn Chadwick*, Bodensee-Verlag, Amriswil, Switzerland, 1958

Herbert Read, *Arp*, Thames & Hudson, 1968

Pierre Restany, *César*, Editions André Sauret, Monte Carlo, 1975

Brenda Richardson, *Gilbert & George*, Baltimore Museum of Art, Baltimore, 1984

*Germaine Richier*, catalogue of an exhibition, Musée d'Art Moderne, Paris, 10 October–9 December, 1956

*Germaine Richier*, Galerie Creuzevault, Paris, 1966

A. R. Ritchie, *Sculpture of the Twentieth Century*, Museum of Modern Art, New York, 1952

*Theodore Roszak*, catalogue of an exhibition, Pierre Matisse Gallery, New York, 17 April–12 May 1962

German Rubiano Caballero, *La Escultura en America Latina (Siglo XX)*, Ediciones de la Universidad Nacional de Colombia, Bogotá, 1986

William Rubin, *Anthony Caro*, Museum of Modern Art, New York, 1975

Roberto Salvini, *Modern Italian Sculpture*, Oldbourne Press, London, 1962

Paul Waldo Schwartz, *The Eye and Hand of the Sculptor*, Pall Mall Press, London, and Praeger, New York, 1969

Leonardo Sciascia, *Emilio Greco 'Il Cigno'*, Edizioni d'Arte, Rome, 1971

William C. Seitz, *The Art of Assemblage*, Museum of Modern Art, New York, 1961

William C. Seitz, *George Segal*, Thames & Hudson, London, 1972

Peter Selz, *The Work of Jean Dubuffet*, Museum of Modern Art, New York, 1962

Willoughby Sharp, *Gunther Uecker*, Kineticism Press, New York, 1966

*Sam Smith*, catalogue of an exhibition, Serpentine

Gallery, London, December 1980–February 1981

*Soto, Cuarenta Años de Créacion,* catalogue of an exhibition, Museo de Arte Contemporáneo de Caracas, June 1983

Caroline Tisdall, *Joseph Beuys,* Solomon R. Guggenheim Museum, New York, 1979

Eduard Trier, *The Sculpture of Marino Marini,* Thames & Hudson, 1961

W. R. Valentiner, *Origins of Modern Sculpture,* Wittenborn, New York, 1946

Coosje van Bruggen, R. H. Fuchs and Claes Oldenburg, *Claes Oldenburg: Large Scale Projects, 1977–1980,* Rizzoli, New York, 1980

*Vanguard American Sculpture, 1913–1939,* catalogue of an exhibition, Rutgers University Art Gallery, Rutgers, New Jersey, 1979

Kirk Varnedoe, *Duane Hanson,* Abrams, New York, 1985

*Lawrence Weiner, Works,* Anatol AV und Filmproduktion, Hamburg, 1977

# INDEX

# ACKNOWLEDGEMENTS

The publishers wish to thank all the sculptors, owners, photographers, museums, commercial galleries and others who have contributed towards the reproductions in this book.

All the works of art reproduced are © the artists (or their estates). The works of Hans Arp, Constantin Brancusi, Alexander Calder, Jean Dubuffet, Marcel Duchamp, Pablo Gargallo, Alberto Giacometti, Julio Gonzalez, Robert Jacobsen, Julio Le Parc, Germaine Richier, Nicolas Schöffer and Jesus-Rafael Soto are © ADAGP 1987. The works of Carl André, Arman, Joseph Beuys, Louise Bourgeois, Pol Bury, Nancy Graves, Jasper Johns, Lila Katzen, Roy Lichtenstein, Aristide Maillol, Henri Matisse, Pablo Picasso, Robert Rauschenberg, Richard Serra, David Smith, Niki de Saint Phalle, Andy Warhol, H. C. Westermann and Ossip Zadkine are © DACS 1987.

Photographs are courtesy of the following: 35 (Charles Clifton Fund, 1967), 55 (A. Conger Goodyear Fund, 1956), 57 (A. Conger Goodyear Fund, 1968), 62 (Gift of Seymour H. Knox, 1959), 77 (Gift of the Seymour H. Knox Foundation, Inc., 1962): Albright-Knox Art Gallery, Buffalo; 193: Brooke Alexander, New York (photo—Ivan Dalla Tana); 41, 42, Col. Pl. 10 (Government Art Collection): © Kenneth Armitage; 56: The Art Institute of Chicago, Edward E. Ayer Fund, 1954.958; 97, 155, 166, 167: © the artists; 14, 184: Arts Council of Great Britain; 173: Artsite, Bath International Festival, 1986 (photo—Graham Parish, Bristol); 108: Belgian National Tourist Office, London; 16: Museum Boymans-van Beuningen, Dienst Gemeentelijke Musea, Rotterdam; 79, 80, 81, 113, 114, 122, 127: Leo Castelli Gallery, New York; 144: photo—Enrico Cattaneo; 43, 58, 76, 96, 102, 107, 176, jacket, Col. Pls. 1–9, 12, 14–19, 22, 23, 31: Christie's; 125, 188, 189: Paula Cooper Gallery, New York; 182, Col. Pl. 32: Charles Cowles Gallery; 61: Gift of the Gardner Cowles Foundation in memory of Mrs Florence Call Cowles; 195: Crafts Council (photo—David Cripps); 119, 120, 128, 135, 140, 141, Col. Pl. 29: © Anthony d'Offay Gallery, London; 131, 132: Dwan Gallery; 5, 6: © Epstein Estate (photos—Paul Laib, © Courtauld Institute, University of London); 17: © Epstein Estate (photo—Stanley Travers, Cardiff); 163: photo—Avice Erickson; 39, 90, 101: Gimpel Fils Gallery, London; 109, 186: Fischer Fine Art, London; 174, 175: Xavier Fourcade; 178: Alan Frumkin Gallery, New York; 110: photo—David Gahr, Brooklyn; 133: photo—John Gibson Commissions, Inc., New York; 166: photo—Wenda Habenicht; Col. Pl. 27: Hadler-Rodriguez; 93, 95, Col. Pl. 21: O. K. Harris Gallery; 25, 26 (Barbara Hepworth Museum, St Ives), 27, Col. Pl. 6: © Barbara Hepworth Estate; 170: Max Hutchinson; 82, 83, 86: Sidney Janis Gallery, New York; 134: Annely Juda, London (photo—Wolfgang Volz); 157: Lila Katzen Studio, New York; 187: Knoedler; 150–4, 171, 191, 192: Lisson Gallery, London; 88: photo—E. Lucie-Smith; 89: Collection Ludwig; 27, 100: Marlborough Fine Art, London; 38: Pierre Matisse Gallery, New York; 181: photo—Scott McCue; 71: David McKee Gallery; 52: Metropolitan Museum of Art, Fletcher Fund, 1953; 98: Robert Miller Gallery; 2, 78: Moderna Museet, Stockholm; 4: Montreal Museum of Fine Arts, Gift of the Ladies' Committee, 1972; 21–4: © The Henry Moore Foundation; 48: cliché Musée Nationale d'Art Moderne; 51: The Museum of Fine Arts, Houston, Museum Purchase; 13 & 18 (Purchase), 87, 126 (Gift of Charles and Anita Blatt): Collection The Museum of Modern Art, New York; 11: National Gallery, Washington, Gift of Eugene and Agnes Meyer, 1967; Col. Pl. 24: photo—Jenny Okun; frontispiece, 30: © Open-Air Museum of Sculpture, Middelheim; 32, 34, 36: Musei Pontificie, Archivio Fotografico; 115, Col. Pl. 24: Saatchi Collection; Col. Pl. 26: Sander/Frank Spooner Pictures/GAMMA; Col. Pl. 30: Italo Scanga Studio, La Jolla, Cal.; 121, 168, 169: Sculpture Now; 137: Sonnabend Gallery, New York (photo—Nick Sheidy); 136: Anthony Stokes; 8, 9, 15, 33, 37, 40, 45, 64, 66, 67, 69, 70, 73, 74 (McAlpine Gift), 75, 103, 104, 111, 118, 124: Tate Gallery, London; 53, 54: UNESCO; 143, 146: photos—Manfred Vollmer, Essen; 185: Waddington Galleries, London; 72 (Gift of the T. B. Walker Foundation, 1964), 164 (Gift of Butler Family Fund and Art Center Acquisition Fund): Collection Walker Art Center, Minneapolis; 47: photo—John Webb, FRPS; 117: John Weber; 138, 183: Whitechapel Art Gallery, London; 59: Collection of Whitney Museum of American Art, Purchase.